The Bow

LIVING WITH A RIVER

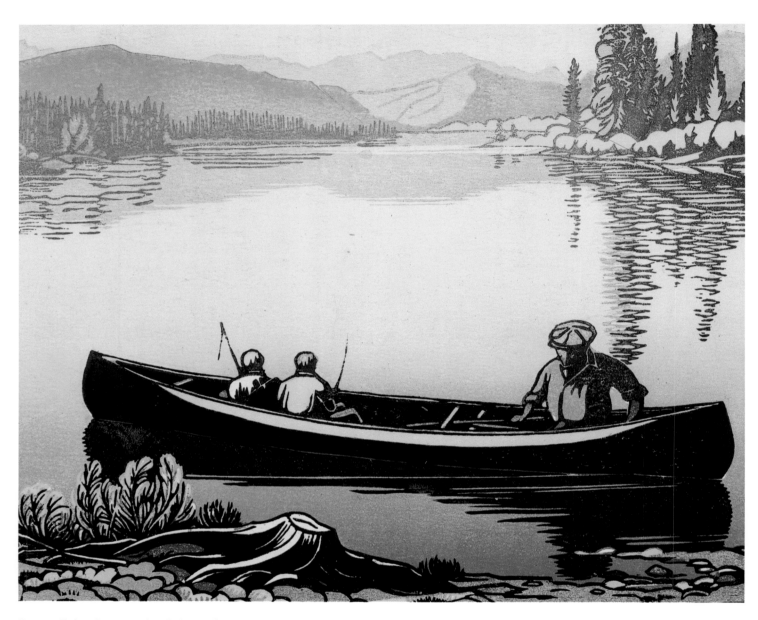

Margaret Shelton (1915–1984)
Fishing on the Bow, 1945
Fishing on the Bow is arguably Margaret Shelton's most stunning image of the Bow River. Clearly it was one she was proud of because she showed it in the 1946 national exhibition of the Canadian Society of Painters, Etchers and Engravers. Complex in its use of some six separate blocks for each of the main colours, this print conveys a peaceful setting with calm, still water and reflections. Fishing remains one of the most important sporting pasttimes on the Bow.

The Bow

LIVING WITH A RIVER

Essays by Gerald T. Conaty, Daryl Betenia, and Catharine M. Mastin

Glenbow Museum
WHERE THE WORLD MEETS THE WEST

KEY PORTER BOOKS

Library and Archives Canada Cataloguing in Publication

The bow : living with a river / essays by Gerald T. Conaty, Daryl Betenia and Catharine Mastin ; edited by Gerald T. Conaty.

ISBN 1-55263-634-8

1. Bow River Valley (Alta.)—History—Pictorial works. I. Conaty, Gerald Thomas, 1953– II. Betenia, Daryl III. Mastin, Catharine M., 1963–

FC3695.B67L58 2004 971.23'3 C2004-905362-0

The publisher gratefully acknowledges the support of the Canada Council for the Arts and the Ontario Arts Council for its publishing program. We acknowledge the support of the Government of Ontario through the Ontario Media Development Corporation's Ontario Book Initiative.

We acknowledge the financial support of the Government of Canada through the Book Publishing Industry Development Program (BPIDP) for our publishing activities.

A portion of the proceeds from the sale of this book supports exhibits and programs at Glenbow Museum.

Key Porter Books Limited
6 Adelaide Street East, 10th Floor
Toronto, Ontario
Canada M5C 1H6

www.keyporter.com

Text design: Peter Maher
Electronic formatting: Jean Lightfoot Peters

Printed and bound in Canada

04 05 06 07 08 5 4 3 2 1

Contents

Acknowledgements

Many people helped in the development of this book. We wish to thank Mary Beth Laviolette and Rosemary Powers at the Canmore Museum; Bruce Gleig and E. Melanie Watt, Biosphere Institute of the Bow Valley; Ted Hart, Lisa Christensen, and the staff of the Whyte Museum of the Canadian Rockies; Gwyn Langemann and Shannon Angell of Parks Canada; Lee O'Donnell of Num-Ti-Jah Lodge; Bob Sandford; Dave Hill; John Gilpin; Gerry, and Joy Oetelaar; Linda Fraser, Architecture Archives, University of Calgary; Yin Deong, Ken Voss, John Sealy, and Nancy Stalker, City of Calgary; TrépanierBaer Gallery, Virginia Christopher Gallery, Masters Gallery, and the National Gallery of Canada Library; and Glenbow staff Doug Cass, Shona Gourlay, Lindsay Moir, Jennifer Hamblin, Lorain Lounsberry, Frances Roback, Robert McKaskell, Quyen Hoang, Owen Melenka, Patricia Ainslie, Jocelyne Daw, and our photographer, Ron Marsh.

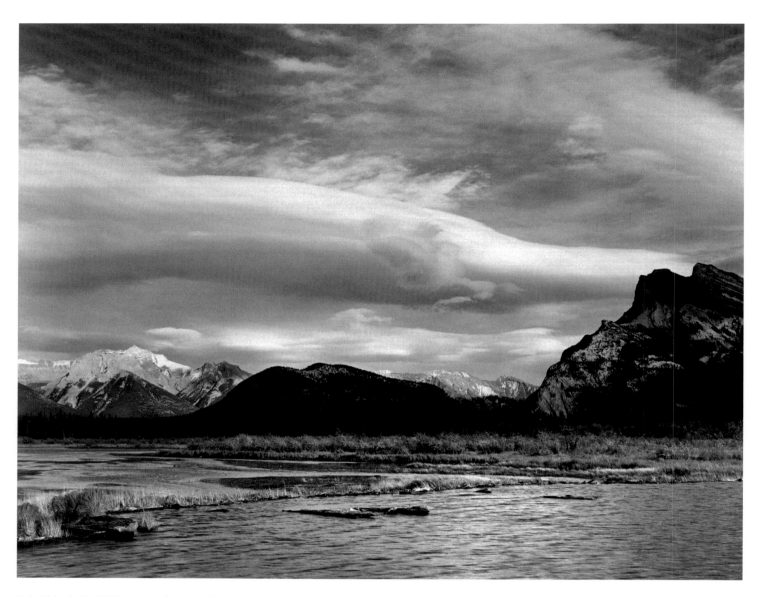

Craig Richards (b. 1955)
Vermilion Lakes, Mount Rundle,
Banff National Park, 1984
The contemporary artist
Craig Richards has observed
that "both the violence and
the calm of the mountain
landscape are of equal
interest. It is not just the
beauty but also the tension
between the two forces. It is
a challenge to take this
three-dimensional 10,000-
foot grand panorama
and reduce it to a two-
dimensional photograph and
make it sing, make it say
something about how I
feel about this landscape."
The Bow River, from its
headwaters at Bow Glacier,
downstream past Mount
Rundle and the Vermilion
Lakes area, has long been
of interest to Richards.

The Bow: Living with a River

Foreword from the Presenting Sponsor

The Bow River is one of Alberta's true treasures. It nurtures and sustains much of southern Alberta, has been an important part of our history, and has inspired artists and attracted outdoors enthusiasts for decades.

As an avid fly fisherman, I have regarded the Bow as a special place for many years: I understand firsthand why it is internationally recognized for its excellent trout fishing, wildlife habitat, and beauty.

The Bow River, as an early transportation route for explorers and settlers, played an integral role in the historical development of Alberta. Enbridge, as the major transporter of Western Canadian crude oil for over fifty years, has played an integral role in the energy development of Alberta. We both call Alberta home, and we both have a proud past and an exciting future.

That is why Enbridge is proud to be the presenting sponsor of the book and the title sponsor for the related Glenbow Museum exhibition—*Our River: Journey of the Bow*. Both the book and the exhibition tell the story of the Bow from many perspectives—geological, cultural, historical, and artistic. Both enable us to partner with the Glenbow to support responsibility, sustainability, and the environment, all of which are very important to us. Both allow us to participate in an important educational initiative, one that helps tell the history of a river, of the people who travelled it and settled along it, and of southern Alberta itself. Both fit well with our commitment to good environmental stewardship in all human endeavours and the protection of our vital freshwater resources.

We at Enbridge are pleased to be a part of this important initiative, and hope you find this book and this exhibition informative and entertaining. We also hope that the Bow River continues to be an inspiration and a clean, free-flowing resource for southern Albertans for generations to come.

Patrick D. Daniel
President & Chief Executive Officer
Enbridge Inc.

May 17, 2004

Marion Nicoll (1909–1985)
Bow River, 1934

Marion Nicoll maintained a nearly lifelong interest in the Bow River. This image was painted when she was a young woman, more than a decade prior to her and her husband choosing the district of Bowness as their home in 1945. Like so many artists of her era, Marion Nicoll initially followed the lead of her teachers in developing her skills in landscape painting.

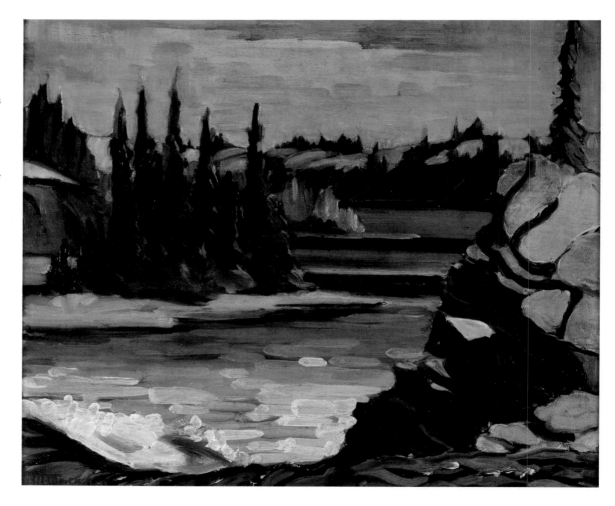

The Bow: Living with a River

Preface

As a Calgary resident for nearly thirty years now, I am accustomed to thinking of the Bow as that stretch of river that flows from Bowness Lagoon to the Calgary Zoo. Every working day my wife and I cross this river twice on the Crowchild Bridge, and in summer I ride my bike to work along the Bow River pathway after crossing Prince's Island bridge from Hillhurst-Sunnyside. Only in the last few years have I really begun to connect to the source of the river because of hikes up to Bow Hut on the littoral edge of the Bow Glacier, high above Jimmy Simpson's Num-Ti-Jah Lodge on the shores of Bow Lake. A favourite memory of one overnight stay at Bow Hut revolves around chipping glacial ice chunks for gin and tonics right at the drip zone where ice becomes water: the precise source of the river.

How we relate to the Bow is for many a highly personal matter. If you fly-fish from a drift boat, sketch along the banks, birdwatch amongst the willows, canoe or raft with friends, or take solitary walks along the Bow's course, you connect through your experience. Over time, many friends of the Bow develop an appreciation that truly runs from Bow Hut to the confluence with the Oldman River. Such people often talk of the river in a spiritual sense, knowledgeably, thoughtfully, and, increasingly, protectively. Seasonal variances in its flows, the timing of ice-up and breakup, and the fluctuating population of bugs and birds—these

changes in its water colour and fish habitat are all topics of reflection and wonder.

To live along the Bow's course is a gift. It becomes the core indicator of our seasonal progress through each year, and the daily connection many of us have with the pulse of the natural world. In this way the Bow connects landscape and society, wilderness and city, and past and present. If you want to understand southern Alberta's future, you would be well advised to study the Bow today because the river's health is a metaphor for our own. When we all embrace this fluvial truth, we become stewards of the river that flows through us. And in this way we come closer to understanding that the river's water runs in the veins of southern Albertans in so many ways. *The Bow: Living with a River* is really a book about us all.

Michael P. Robinson
President and CEO
Glenbow Museum

Glenbow Museum
WHERE THE WORLD MEETS THE WEST

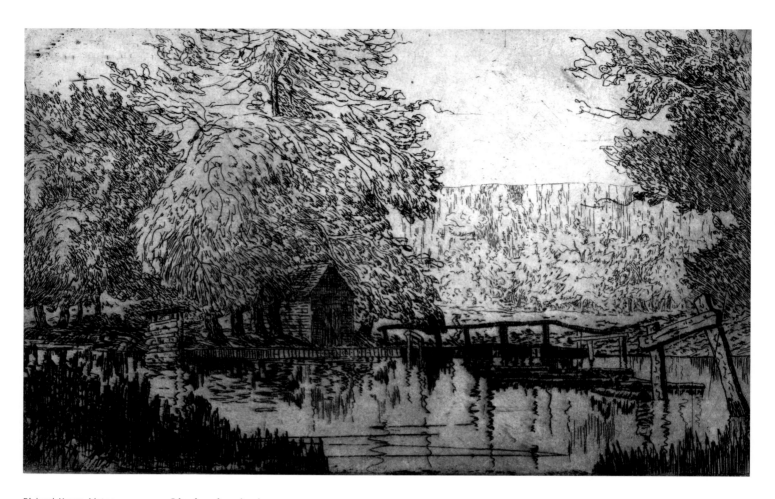

Richard Moore (dates unknown)
Eau Claire—Prince's Island, n.d.
This etching is part of a series that once served as Christmas greeting cards. Depicting several sites on the River that have become important ones today, the group includes St. George's Island where the Calgary Zoo is now located, and Prince's Island, a charming inner city park unique for its island location on the Bow. These etchings indicate an increasing desire for images of Calgary as the city grew. With their soft and gentle lighting and pastoral subjects, they actually evoke a more European setting than the harsher conditions that exist here.

Introduction: Ribbon of Hope, Ribbon of Life

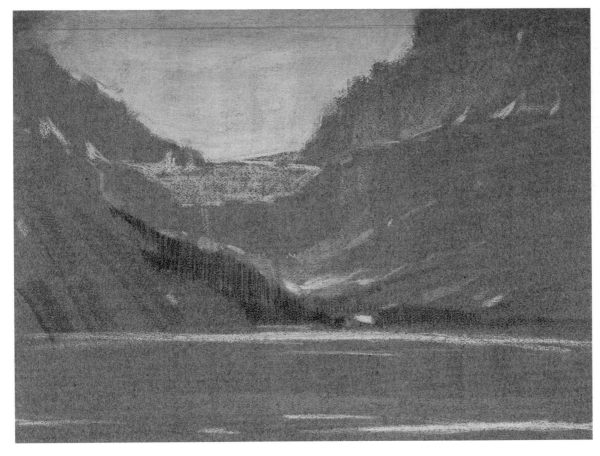

Alfred Crocker Leighton (1901–1965)
Bow Lake, n.d.
A.C. Leighton was a conservative painter and a consummate draftsman who steered clear of modern influences and abstraction. He preferred a more representational style as is shown in this pastel drawing of Bow Lake, which includes a view of Bow Glacier in the distance.

For thousands of years the Bow River has been essential to the people of Alberta. It is a sacred place for Niitsitapi (Blackfoot-speaking people), Tsuu T'ina, and Nakoda. Its course was the route that the Canadian Pacific Railway chose to follow through the mountains. Its water nourishes cattle and crops. Over four million people rely on it for safe drinking water and countless more experience its beauty and serenity as campers, fishers, and cyclists.

The Bow became one of Canada's most important rivers when Sir John A. Macdonald, the

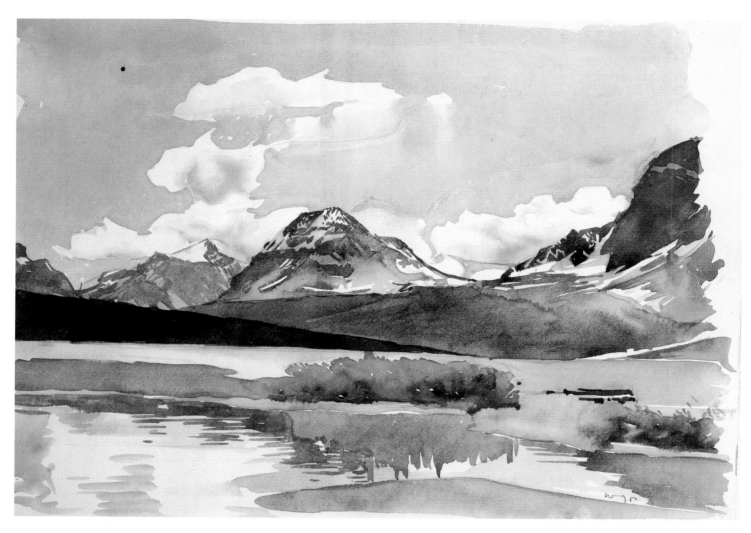

Walter J. Phillips
(1884–1962)
Bow Lake, 2 August 1953
This sketch was probably
done while Phillips was
staying as a guest at Jimmy
Simpson's Num-Ti-Jah
Lodge, Bow Lake. In his
sketchbooks, Phillips took a
much looser approach to the
watercolour medium with
quick, semi-abstract sweeps
of brushwork. This style
contrasts with that of his
larger studio watercolours
where his brushwork is often
tightly controlled.

country's first prime minister, acquired Rupert's
Land from the Hudson's Bay Company in 1870.
This vast expanse included all the land of British
North America that drained into Hudson Bay. It
was also a space that had few non-Native people.

Macdonald was anxious to have the land settled
by Canadians to forestall American hegemony, and
the Canadian Pacific Railway (CPR) was to be the
steel link that joined Canada from coast to coast.
With several routes through the mountains from
which to choose, the CPR decided to follow the Bow
River. Coal and water were plentiful on this route
and the railway's presence would assert Canada's
claim to the southern part of the territory.

With the railway came cattlemen, homestead-
ers, businessmen, tourists, land speculators, coal
miners, and many others. Clear regulations
controlling access to land, water, and other
resources were important for the orderly
development of the territory.

William Pearce, more than any other man,
developed and implemented these regulations. As
the federal Inspector of Land Agencies, he was
responsible for the allocation of land, and water
and mineral rights. Contrary to the era's predomi-
nant attitude of laissez-faire development, Pearce
believed that resources should be developed for
the benefit of the majority of the population.

The Bow: Living with a River

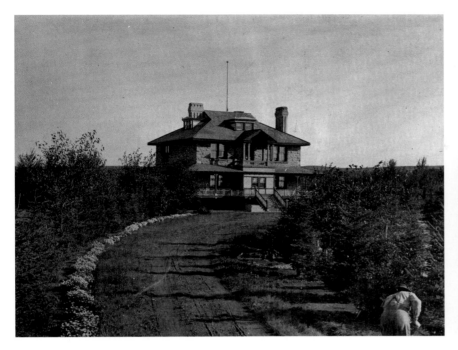

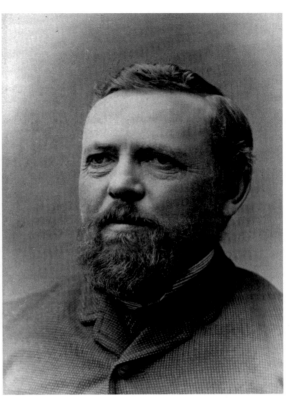

This vision shaped the unique nature of Canadian water rights, placing control in the hands of the government rather than individuals. He helped establish Rocky Mountain National Park, influenced the pattern of ranching, initiated massive irrigation projects, and helped beautify Calgary.

The history of the Bow River is, of course, more than the story of one man. Many people have used, and sometimes misused, the river. Some of their stories are presented here. Today, there is a growing awareness that the river is a scarce resource that may be disappearing. Once more, the river is drawing together people from across political, economic, and social spectrums as we look for solutions that will sustain this most valuable of resources for future generations.

William Pearce (right) was instrumental in the development of resource policies in western Canada during the late nineteenth and early twentieth centuries. He had a deep love for the prairies and a firm belief in their agricultural potential. The Pearce Estate, (left) southeast of Calgary, was devoted to experimental agricultural methods, and his irrigated land produced crop yields 70 per cent higher than the neighbouring land.

From Serendipity to Deliberation: Artists and the Bow River Valley

Introduction

Since the mid-nineteenth century, a wellspring of imagery depicting the Bow River has emerged through the eyes and hands of professional and amateur artists alike. It was largely the element of chance that initially brought the Bow River to the attention of the early artists who travelled westward from central and eastern Canada, and from Britain. Few consciously chose it from afar, instead discovering it in the course of their journeys to the Rocky Mountains or to Banff National Park. For many early twentieth-century and modern artists, awareness of the Bow River gradually became a more conscious pursuit. This transition occurred as the visual arts community began to formally

Allan Harding MacKay
(b. 1944)
An Icon for the Independent Spirit, 1998
In 1997–1998 Allan Mackay was artist-in-residence at the Banff Centre for the Arts, during which time he began working on this video, based on the Bow Falls, in Banff. Inspired by the Rocky Mountain art of Walter J. Phillips, and the isolated single tree as an icon in Canadian landscape painting, Mackay has focused on a lone pine tree at the falls that leans steeply over the Bow River. The two subjects are fascinating for the dichotomy they represent as the precarious stasis of the tree is contrasted with the endless movement of the river. Given the challenges of representing water in still media like painting, Mackay has chosen in video a most effective medium to convey the feeling of moving water.

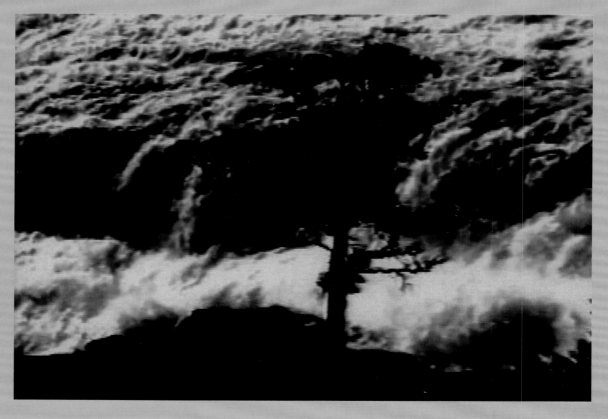

establish itself in southern Alberta and artists began to hone in on certain aspects of the Bow River. In more recent years, many contemporary artists have deliberately chosen the Bow River and Bow Valley as subjects. Because of their individual experiences, and their various reasons for being interested in the Bow River, the responses it evokes are increasingly personalized ones.

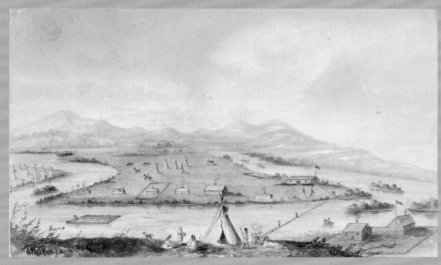

Hawksett (dates unknown)
Calgary in 1875, 1875
This image is one of a number of views of the city of Calgary during its inception. It may depict the confluence of the Bow and Elbow Rivers, but with the artist's imaginative, somewhat composite approach to image-making we can't be exactly certain. In *Calgary*, he forces pertinent details of the scene into the picture, even when they might not have been visible from the artist's vantage point. For instance, his nearly circular representation of the river is an inaccurate depiction of the river's actual shape. Likewise, the mountains in the background would not have been so clearly visible from this vantage point, but their presence creates a more picturesque and engaging image. Consistent with popular illustration of the day, the artist also noted several buildings, which indicated to viewers the expanding notion of "civilization." In the right foreground are the buildings of the Hudson's Bay Company. This image was reproduced in the Calgary Special Issue of *Dominion Illustrated*, June 28, 1890.

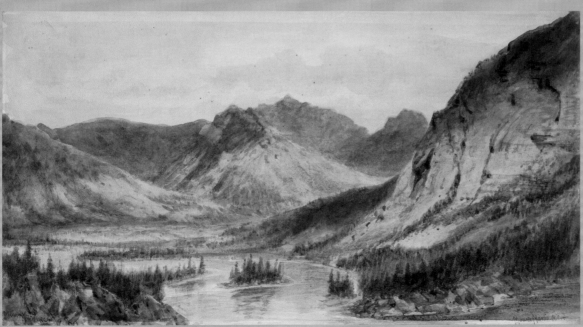

T. Mower Martin (1838–1934)
The Bow River from the Banff Hotel, n.d.
Courtesy of free CPR travel passes, Thomas Mower Martin made several trips to the Rockies. This watercolour is notable for its viewpoint, situated in the CPR's Banff Springs Hotel and overlooking an inspiring vista of mountains and the curve of the Bow River as it makes its way around them.

Marion Nicoll (1909–1985)
Bowness Road, 2 am, 1963
Marion Nicoll's depiction of Bowness Road, in the Bowness community located in the northwest of Calgary, where Marion and Jim Nicoll lived, is one of the most personal and unique interpretations of the Bow Valley landscape. This remarkable artist was the first woman to seriously advance abstract art in the province. By indicating the time of day in her title, she suggests that the darkness of the city is her subject. While other artists would have chosen daylight, sunrise, or sunset, so they could depict form, Nicoll chooses just the opposite. For her it is the depth of night when darkness creates abstract patterns not associated with simple description, and roads, streets, architecture, and lights can be reduced to geometric forms.

The Changing Image of the Bow River

The first generation of European-trained artists to depict the Bow River were those associated with the military-topographical movement charged with charting the landscape, documenting its salient features, and gathering information. As most of these artists were of European descent, they were either complete newcomers to Canada, travellers, or early settlers. Images by them from the middle and late nineteenth century that included the Bow River often concentrated on the depiction of the newly established city of Calgary and the areas to its east, as we see in works by Melton Prior and T.B. Strange (see pages 93 and 98). These works are important documents of sites that have since become significant. Probably in the interests of promoting the notion of an emerging "civilization," these scenes emphasized both the apparent availability of land and the construction of significant civic structures indicative of colonial progress in the West. Detail was essential since so many of these early works were done for the purpose of being turned into popular engravings. The images are precise, exacting, and minimal in colour to allow for easy transfer to black and white. However, although celebrated for their accuracy, such images as Hawksett's *Calgary* (see page 17), were often imaginative in their inclusion of topographical details that would not have been visible from the artist's vantage point but were added to impart a picturesque quality to the scene.

Subsequent to the topographical artists were those who came west with free passage under the auspices of the Canadian Pacific Railway (CPR), such as Marmaduke Matthews, T. Mower Martin,

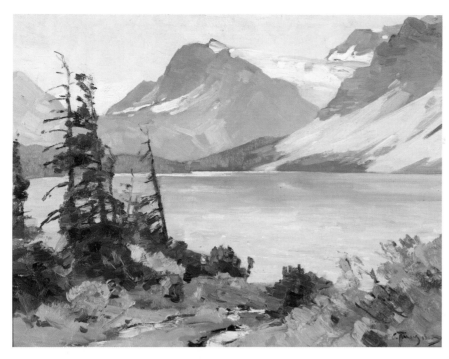

Carl Rungius (1869–1959)
Bow Lake, Alberta, n.d.
This painting of Bow Lake was probably the result of one of Rungius' trips to hunt and sketch with outfitter Jimmy Simpson. Their friendship became the cornerstone of today's artist-in-residence program that continues at the Num-Ti-Jah Lodge. As well, it was the beginning of an ongoing exchange between Simpson and Rungius where hunting trips were exchanged for art depicting the landscape and game. This painting presents a classic example of Rungius' loosely applied brushwork and his use of rich blues and greens characteristic of the area in summer.

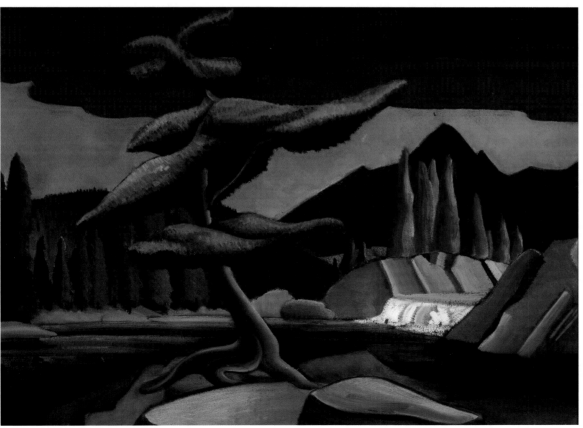

Helen Barbara Stadelbauer (b. 1910)
Tree at Bow Falls, n.d.
Helen Stadelbauer's rich and dramatic pictures of the Rockies, notably this one of Bow Falls, show the impact of her Canadian teachers in painting at this early stage in her career (probably the 1940s). Her contacts with W.J. Phillips, A.Y. Jackson, and H.G. Glyde, among others, would have been at the Banff School of Fine Arts, where they no doubt imparted their aesthetic concerns for bolder and simpler handling of form, which was characteristic of the front-runners in the modern painting movement in Canada. Though dark and brooding in quality, this painting is especially interesting for its inclusion of near-perfect representation of a chinook arch in the sky. The warm chinook winds brought from the Pacific Coast are cherished throughout the winter to relieve cold stretches.

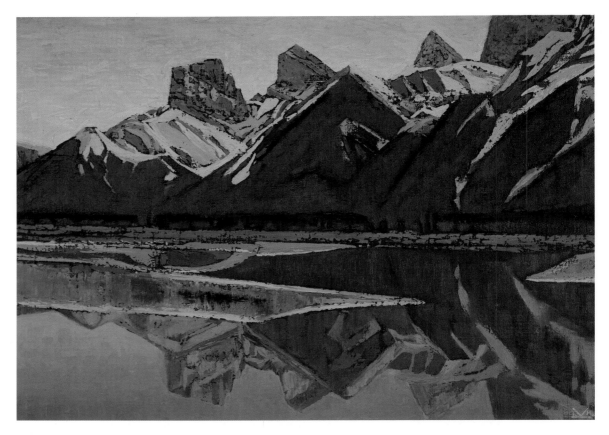

Illingworth Kerr (1905–1989)
Ice and Still Water, 1969
This painting depicts the Bow River near Canmore, including the Three Sisters mountain in the background. The near-perfect mirror reflection of them in the calm Bow River shows Kerr's love of abstract patterns found naturally in the landscape. These were concepts he was spurred on to pursue following his studies with the American abstractionist Hans Hoffman in 1954.

F.M. Bell-Smith, and Melton Prior. As the track followed the Bow Valley so closely between Calgary and Lake Louise, the river fortuitously presented itself as a sketching subject for the artists who joined the railway's efforts to promote the Rockies. As it had for the topographical artists, the Bow thus became part and parcel of their explorations of western Canada.

It is largely because of these painters that the more celebrated and awe-inspiring aspects of the Bow have dominated its pictorial representation —interpretations of the river as it courses its way through Banff National Park being among the most popular. Sensual in its beauty, stunning in its mountainous surroundings, unique in its ever-changing lighting, this region seemed especially compelling. Areas of the Bow near Banff and Lake Louise where the CPR had strategically located some of its most luxurious hotels—the Banff

Springs Hotel and the Château Lake Louise—were key sites. T. Mower Martin's *The Bow River from the Banff Hotel* (page 17) and Bell-Smith's *Morning Lake Louise* (page 22) present classic vistas from these two historical resorts. The sublime, awe-inspiring quality of the landscape was the feature that most strongly appealed to these artists' imaginations.

Throughout the first half of the twentieth century, many artists happened to discover the attributes of the Bow River during their employment as teachers at the region's notable art institutions. From the 1930s to the 1950s, there were summer programs at the Banff School of Fine Arts, where W.J. Phillips, A.C. Leighton, H.G. Glyde, A.Y. Jackson, George Pepper, and others taught, and the Provincial Institute of Technology and Art (now Alberta College of Art and Design) also brought numerous teachers and students to the Bow Valley.

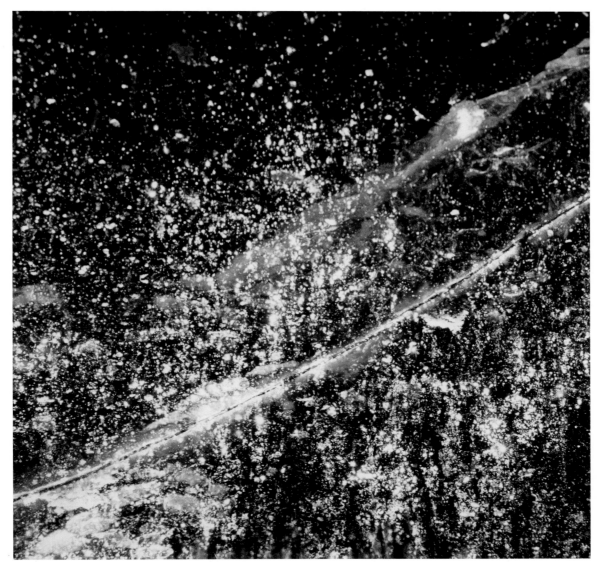

Laura Millard (b. 1961)
An Ordinary Evening, 2003
Laura Millard's recent work combines colour photography and mixed-media painting in response to a detailed examination of the Bow River. Evoking a myriad of possible meanings, *An Ordinary Evening* at once embraces the macrocosmic and microcosmic. The image appears at first like a spray of comet-like debris flying through space, yet its original photographic source is a tiny view of the frozen river's ice cracks, reflected light, and air bubbles. Perplexing in its sense of spatial depth, this image in fact records a quite limited, shallow space, which can be perceived as infinite through the dark water beneath. The tiny air bubbles are also suggestive of the very beginnings of life itself. Millard's combination of photography and painting leaves us pondering the boundaries between the real and the abstract.

Some artists discovered the Bow through someone else. The painter Carl Rungius, for instance, visited Bow Lake because of the outfitter Jimmy Simpson's endless prodding after seeing Rungius' work in illustration. Others already lived in its vicinity, and resident artists like Jim and Marion Nicoll knew the Bow River well by the good fortune of their birth-place. From his home in Bowness, west of Calgary, Jim Nicoll noted, "I am constantly exhilarated and excited by nature, especially living here—our clouds and our rivers and our trees" (1986).

This modern era generally saw a move away from the government and corporate commissions of the previous two generations of artists towards more personal explorations. Focusing on their own unique and identifiable styles, they tended to remain independent of anyone's agenda but their own. Coinciding with this change was also a growing consciousness of the Bow Valley as a subject of importance. Among the earliest of these artists was C.W. Jefferys, who in 1907 and 1924 made trips to work in the Bow River basin,

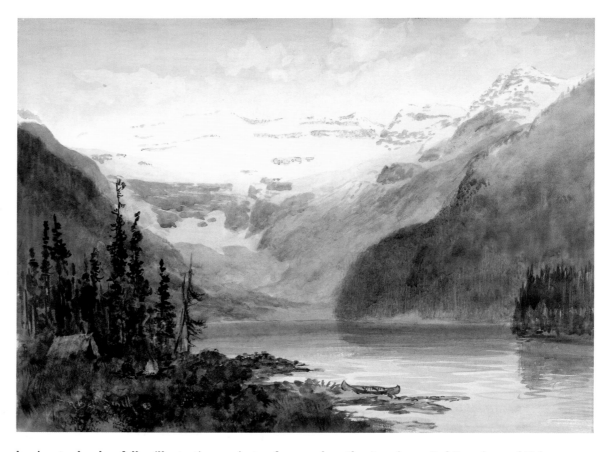

hoping to develop fuller illustration projects of the region's historical events. Other visitors to the Bow Valley, such as Kathleen Daly and George Pepper, began concentrating on the areas around Canmore. Resident artists, such as Peter and Catharine Whyte, Lars Haukaness, Walter J. Phillips, and Margaret Shelton, began including the Bow Valley as part of their artistic repertoire, with specific areas of it becoming increasingly significant.

Within Banff National Park, such locales as Bow Lake, Bow Falls, Mount Rundle/Vermilion Lakes, and Canmore have been of considerable interest to modern artists. Peter and Catharine Whyte were drawn to Bow Lake and the surrounding peaks, glaciers, vegetation, skies, and valleys. They depicted the region in literally hundreds of paintings.

Banff's importance was in part reinforced

when the Americans Carl Rungius and Belmore Browne set up studios there for extended periods so that they could develop substantial bodies of work, including Bow Valley subjects. During the 1930s and 1940s, the Banff School of Fine Arts program placed a heavy emphasis on landscape art, encouraging students to sketch and explore the surrounding terrain—Bow Falls, Mount Rundle, Vermilion Lakes, and Canmore. Works by several artists who attended to these subjects reveal their unique visions: for Margaret Shelton it was distinctive swirling rhythms and high contrasts; for Helen Stadelbauer it was strong, vibrant colours and simplified forms. Farther downstream, the area that included Mount Rundle, Tunnel Mountain, and the Vermilion Lakes interested Walter Phillips, E.J. Hughes, Carl Rungius, and Belmore Browne. Phillips' works suggests a feeling

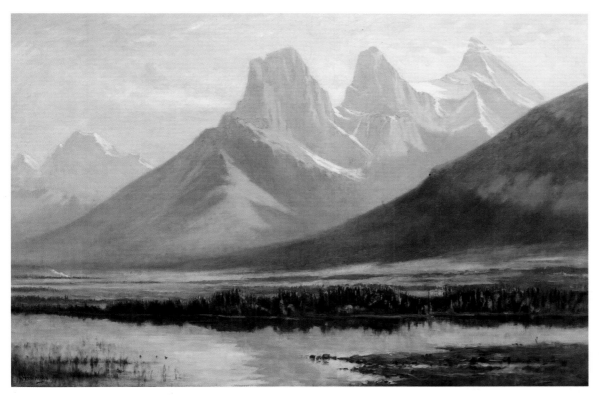

John Hammond (1843–1939)
The Three Sisters, c. 1890
Depicting the Bow River valley near Canmore, this canvas is dominated by the Three Sisters with the Bow River in the foreground. With all its serenity, beauty, and romantic evocation of the untouched wilderness, the CPR officials must have been pleased with the message of this substantial oil painting. The tiny train, barely visible in the middle ground, puffs its way through the Bow Valley, symbolizing the impending rapid colonization of the West during the late nineteenth century as the railway continued its progressive westward expansion. For many years, this work hung in the CPR's Palliser Hotel in Calgary and is one of the most important paintings Hammond did of the Rockies.

of tranquility and peace, while Browne's conveys the cold atmosphere of the winter-spring season, when snow and ice still dominate the scene. Through his distinctive broken, expressive brushwork, Rungius reveals his fondness for light, while Hughes accentuates the minutae of nature. At the Three Sisters, near Canmore, both John Hammond and Illingworth Kerr produced paintings that evoke the serenity of the setting, one with soft forms, the other more abstract.

In the foothills, east of Banff, were several other lesser-known areas that attracted artists. Roland Gissing spent many years living on the Ghost River, and Browne and Leighton spent time at Seebe, the latter running painting excursions there for students. Leighton's classes at Seebe were the beginnings of what later became the Banff School of Fine Arts summer classes. Jim and Marion Nicoll chose the neighbourhood of Bowness, in northwest Calgary, as their home, and

they based much of their art on scenes of the surrounding area. Jim Nicoll's work often emphasized the distinctive coulees formed by the ancient glaciers and erosion, while Marion Nicoll's work spanned both representation and full abstraction. Many of the later nineteenth and early twentieth-century images of Calgary that tie it to the Bow indicate a particular fascination for the more important bridges that link the north and south sides of the city. Documenting various points in Calgary's architectural development, the works of E.J. Hughes, Myrtle Jackson, and Stanley Turner give a central place to the Bow River and chart the changes that have occurred.

Today, as we wrestle with our relationship to nature and the "wild," we are increasingly aware that our so-called wilderness experiences are as much constructed realities as the cities many of us inhabit. With such a rich history of imagery by artists through the 1950s, celebrating the sublime

James Nicoll (1892–1986)
Bow River, c. 1940
For Jim Nicoll, the Bow River was a constant subject throughout his painting career. The Nicolls' two-acre lot and home in Bowness, which he and Marion Nicoll moved into in 1945, provided easy access to the Bow River. Predominantly a watercolour painter, Nicoll used this unpredictable medium with great precision and control. He was one of the few to take on the challenge of representing reflections on moving water effectively. While other artists essentially freeze the water's motion in time, Nicoll eagerly captures its shimmering quality through purples, blues, yellows, and greens. His paintings also carry the full effect of the region's unique, and sometimes quite intense, foothills lighting.

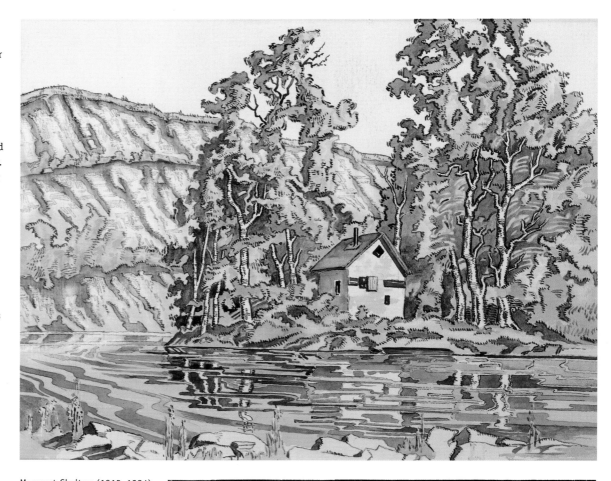

Margaret Shelton (1915–1984)
Bow River, 1939
Shelton produced about six prints related to the Bow River during her career. This image is the earliest of them. It is quite likely that the Bow prints were made while she was enrolled in summer sessions at the Banff School of Fine Arts, which she attended in 1935 and 1941. This black-and-white print is made all the more appealing by the hand-coloured blue wash she has applied to convey the illusion of water.

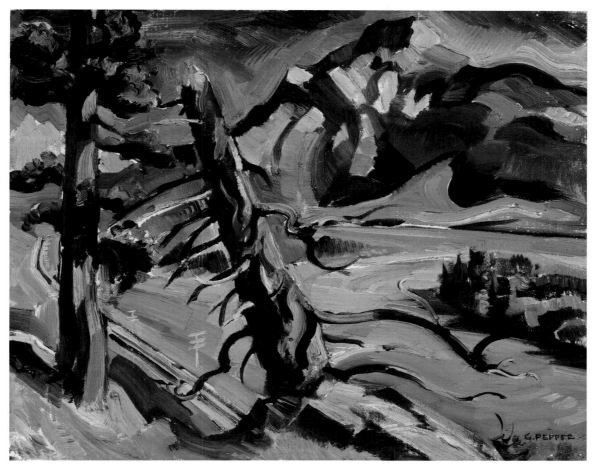

George Douglas Pepper
(1903–1962)
Bow River Valley, n.d.
George Pepper came to Banff
to teach at the Banff School
of Fine Arts summer art
programs during 1942, 1947,
1957, and 1962. During these
trips he explored the Bow
Valley, Moraine Lake, and
Lake O'Hara areas with his
lifelong partner and
sketching companion,
Kathleen Daly Pepper. This
highly textured, semi-
abstract interpretation of
the landscape reflects his
fondness for the more
modern tendencies of
Canadian landscape painting
at the time.

and romantic aspects of the Bow River valley, it has become increasingly challenging to interpret the subject in innovative ways. In more recent years a very select number of artists have chosen the Bow with this larger challenge in mind. They carefully consider the content of their work equally with the medium that best meets their goals. Two key examples of this approach are found in the works of Laura Millard (page 21) and Mario Reis (page 27). Millard has merged the arts of both painting and photography to create a highly evocative body of work that concentrates on small ice-frozen areas of the Bow. For Mario Reis, there is no medium more preferable than the river itself. As he immerses his canvases within the river, the sediment makes its own abstract patterns on the canvas, giving new meaning to the traditional art term "watercolour."

Over the years, for the most part, artists have chosen to represent water in traditional media like painting, drawing, and printmaking. In essence such imagery is about creating the illusion of water. Yet the very qualities that make water unique and expressive—movement, change, flow, rhythm—are in these media represented in stasis, with the artists literally freezing their scenes in time. As artists have wrestled with these challenges over the past half century, many have questioned their medium and their approach

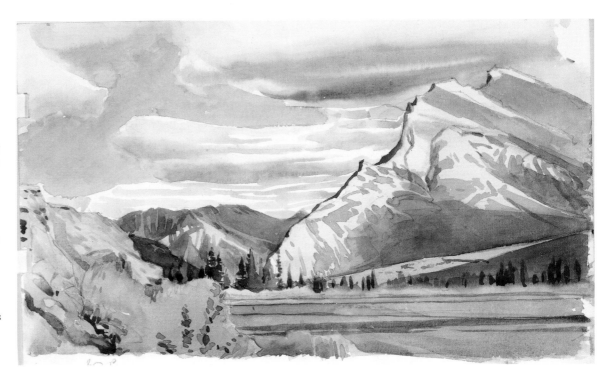

to the subject. Perhaps because of such challenges there appears to have been a temporary lull of interest in landscape art of the Bow Valley during the 1960s and 1970s. Given the challenge of representing a subject in constant flux, however, Allan Harding MacKay's *An Icon for the Independent Spirit* (page 16) seems a most fitting medium to convey the river's endless movement and sound.

Conclusion

The body of work outlined here, created over an extensive time frame, reflects the fact that artists' experiences of the Bow River have been and continue to be increasingly unique and personal ones. Building on the long legacy of originality before them, recent artists have proved that unique viewpoints on the Bow River are still possible, and that the river itself can be not only an engaging subject, but—as Mario Reis suggests—even an actual participant in the creative process. These works show that the Bow River has been and continues to be many things for artists, and that equal consideration must be given to both content and medium. For most, the Bow has become more than the river itself; it encompasses the environs of the Bow Valley, the surrounding mountains, summits, hoodoos, foothills, coulees, floodplains, and grasslands. In all its diversity, this hard-working lifeline has consistently appealed to many artists—from mountain-park wilderness to cityscape to irrigation canal. As both source and resource, it remains expressive, challenging, replenishing, and inspirational.

As Walter Phillips once observed: "Water is the most expressive element in nature. It responds to every mood from tranquility to turbulence. The bubbling spring engenders and supports life; the raging torrent and the remorseless flood may be the instruments of its destruction."

Mario Reis (b. 1953)
Bow River, Banff, Alberta, Canada from the *Nature Watercolors Series*, 1994

For more than two decades now, the German artist, Mario Reis, has been developing a large body of work addressing the unique qualities of rivers from around the world. As part of his *Nature Watercolours* series, he has consciously sought out the Bow River as subject. The *Nature Watercolours* give an entirely new meaning to the traditional medium of watercolour, which is usually made with prepared pigments. Instead, Reis immerses the stretched canvases in actual rivers. After an appropriate period of time, sedimentary deposits accumulate on the canvas to form visually abstract yet real portraits of the river's minerals and deposits. Each work in the series is thus a unique reflection of the chosen river and site as the colours, textures, and depth of the accumulated sediment, and the flow and speed of the water cause patterns to form on the canvas.

The world would not be the same one without water.

Mario Reis,
no date

Origins

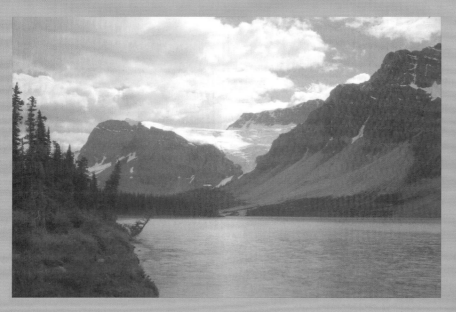

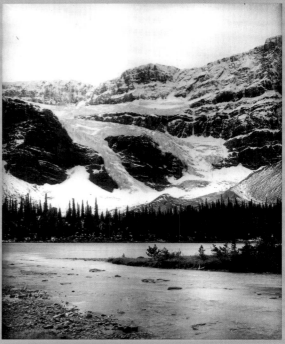

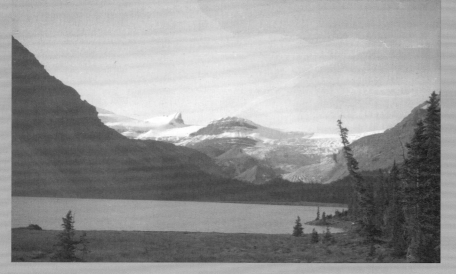

The origin of the Bow River lies high in the Main Range of the Rocky Mountains. An ephemeral stream rises from a saturated bog and flows southward into Bow Lake. More water comes from Bow Glacier (top left and left), along the western shore of the lake. Crowfoot (top right) Glacier and other icefields contribute volumes of water, and the Bow continues to grow. As these glaciers recede, the source of the rivers becomes threatened.

A Geological History of the Bow Valley

The Bow River flows from the Main Ranges of the Rocky Mountains, eastward through the foothills and across the plains of southern Alberta. Throughout its course, the river cuts through deposits of sand, gravel, and clay that were left by the glaciers. Beneath these layers are other sediments that were deposited millions of years ago and then transformed into rocks by heat and pressure. This is the Western Canadian Sedimentary Basin, and it shapes our modern world in many different ways.

To the east of the mountains, in northern Saskatchewan and most of Manitoba, the Western Sedimentary Basin thins into a slender boundary with the Canadian Shield. The undulating topography of the plains is largely a function of the horizontal bedding of the underlying sedimentary strata. The convoluted landscape in the foothills reflects the folds and thrusts of these layers beneath the surface.

Much of our economy is linked to these strata. Agriculture has been very successful, in part, because of the gently rolling surface that enabled large-scale irrigation projects to be developed. Many of the sedimentary rocks in the basin were deposited under ancient seas or in swamps near the sea margins. As a result, there are extensive oil, gas, and coal deposits throughout the Bow River drainage. Even the surface exposures of the basin are economically important. The foothills and mountains have become scenic recreation areas, attracting thousands of tourists and millions of dollars to the region each year.

Peter Whyte (1905–1966)
Bow Lake, Crowfoot Glacier, n.d.

The Bow Lake area figured prominently in Peter Whyte's work and he made literally dozens of paintings depicting the region's salient features, Bow Lake, Crowfoot Glacier, Bow Summit, Bow Peak, and Mounts Hector, Nicholas, and Thompson. Among the largest paintings Whyte ever did, this scene was probably taken from Bow Summit (as suggested by an earlier title), offering him a wide panoramic vista encompassing Bow Lake and Crowfoot Glacier in the far distance.

The Bow: Living with a River

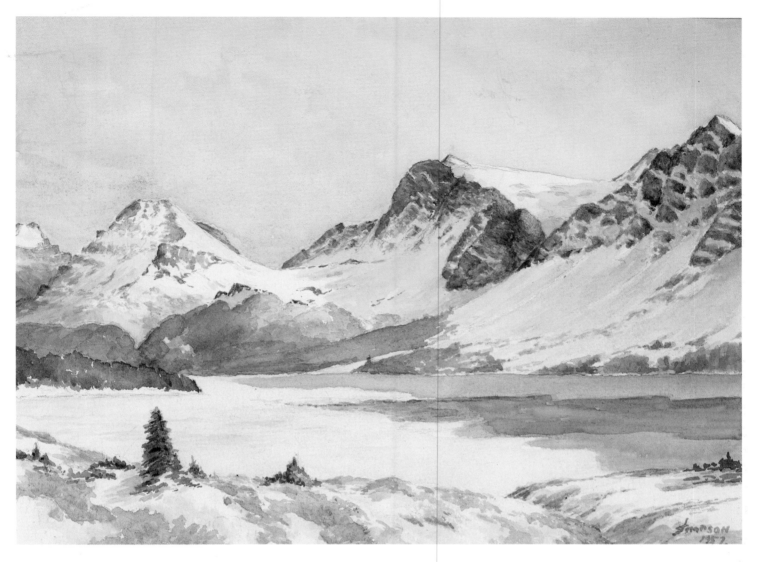

James Simpson (1877–1972)
Signs of Spring, Bow Lake, 1957
Simpson's paintings often celebrate the glory of the land that he came to love in the Bow Lake area, where he established the well-known Num-Ti-Jah Lodge. Largely self-taught, he surrounded himself with other artists from whom he learned techniques and styles, including Carl Rungius, Peter and Catharine Whyte, and A.C. Leighton.

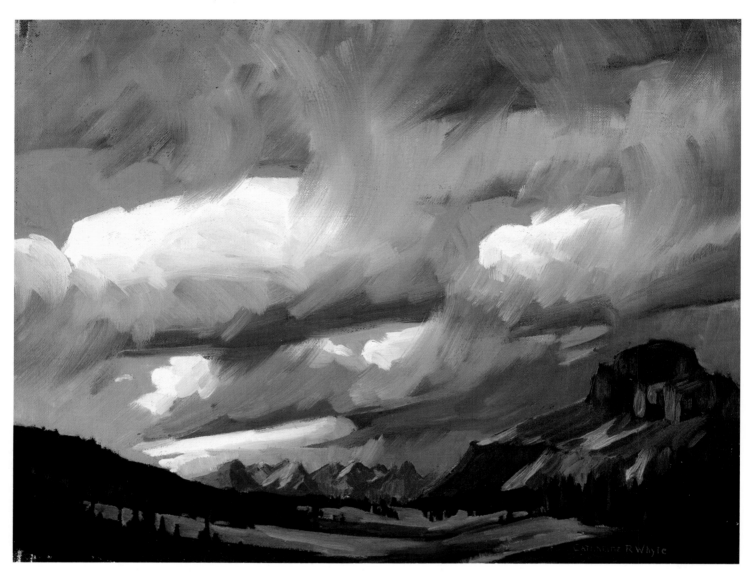

Catharine Whyte (1906–1979)
North Towards Bow Summit,
n.d.

Catharine Whyte made various places along the Bow River's path an intrinsic part of her art. Bow Lake, Peak, and Glacier; Crowfoot Peak and Glacier; and Thompson, Molar, and Hector Mountains; and the Bow Summit all figured in her work. This painting was done on one of the many trips that Catharine and her husband Peter made to Num-Ti-Jah Lodge, where they spent time with Jimmy Simpson. With some three-quarters of the sketch devoted to the sky, it shows her affection for the often dramatic cloud formations in these high altitudes.

Our Modern Landscape

The topography we see around us today is largely the result of the ice sheets that covered this land more than 10,000 years ago. The Ice Age began when a complex interaction of geological, climatic, and astronomical factors changed the global climate. Soon, snow accumulation at high altitudes and in the Arctic exceeded the rate of snow melt. Gradually, ice formed under the weight of the growing snowfields.

This ice was plastic, scouring and gouging the surface as it moved across the land. The glaciers also left deposits in river channels flowing beneath the ice. Geologists examine these deposits, or tills, to determine the regions from whence the gravels originated. This helps reconstruct the path of the glaciers and indicates when—or if—the mountain and continental ice sheets met. These signs can be contradictory, leading to different models of glacier movement.

About 20,000 years ago, massive amounts of ice flowed out of the mountains just as a huge glacier spread from a centre near Hudson Bay. At Calgary, this continental glacier would have been more than 5 kilometres thick.

A torrent of water exploded across the landscape when the ice melted. But, since parts of the ice sheets melted at different rates, these streams and rivers often found their courses blocked by glacier lobes. These ice dams impounded the meltwater, creating some very large lakes. The water rushed forth when the ice melted, often gouging deep channels where it ran. The large coulees throughout southern Alberta are the remnants of these channels. This high volume of water also carried a large sediment load that was deposited downstream as the water's velocity diminished. The intensity of the meltwater streams also eroded the landscape near the glacier. This land had little

Glaciers form when layers of snow accumulate over long periods of time. The weight of the snow exerts pressure that transforms the lower levels into ice.

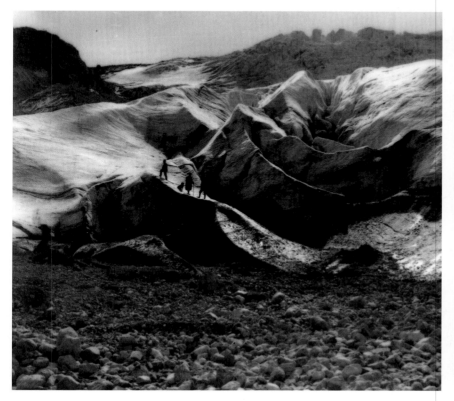

or no vegetation and a minimal network of roots to hold the soil in place.

Archaeologists and geologists have reconstructed the history of the Bow River between Cochrane and Calgary. They have identified five alternating episodes of downcutting and deposition. The first event began as the glaciers retreated and the meltwater cut a channel through bedrock deposits from pre-glacial times. Then, between 11,500 and 10,000 years ago, the climate cooled and the ice advanced once more. The increased weight of the growing ice sheets depressed the earth's crustal plates and created a more gradually sloped bed that reduced the velocity of the water. At the same time, as the landscape was saturated and sparsely vegetated, both the amount and the size of sediments eroding into the river increased. The river deposits accumulated, or aggraded.

Between 10,000 and 9,000 years ago, the climate warmed and the ice sheets once again began to melt. The earth's crusts once more rebounded, creating steeper river gradients and higher stream velocities. By now there was more vegetation and extensive root mats stabilizing the soil, reducing erosion. This was a time of downcutting as a deep channel sliced through the gravels deposited during the previous phase. Vegetation became more sparse and stream flow decreased as the warming trend developed into a prolonged drought. This aggrading episode reflects the increased sediment load and reduced carrying capacity.

This history has been developed for one small section of the river. The processes may not have affected the entire river drainage in the same ways. As one moves downstream, the grade of the riverbed and the nature of the load change. So too does the vegetation. This single example illustrates the complexity of the Bow's life, and introduces us to a living river.

The River Today

The remnants of the massive cordilleran glaciers now form the ice caps of the Rocky Mountains. Meltwater from the Bow Glacier feeds Bow Lake, creating the source of the Bow River. It is hard to imagine the reedy outflow of the lake as the initial stage of the same river we see flowing through Calgary. But numerous mountain rivulets join the main stream near its source and, downstream, other rivers such as the Kananaskis, Spray, Highwood, and Elbow, add significant volumes of water. All of this water originates in the high-altitude icefields. While snow melt contributes important moisture during the spring runoff, it is the water from the glaciers that sustains the flow of the river during the critical dry periods of late summer and autumn.

This is ancient water that has been locked in glaciers for hundreds of thousands of years. As it melts, the ice transforms into the water that is so vital to our life. The ice caps, which have grown and contracted many times throughout the earth's history, now seem to be retreating at an increasingly rapid rate. As they disappear, so too does the source of Alberta's rivers.

Climatologists who have studied this melting rate attribute it to a change in the balance of energy in the earth's atmosphere. Many suggest that the causes are rooted in modern industrial practices that release large amounts of greenhouse gases into the atmosphere while at the same time removing trees and other plants that absorb these gases. If we alter our strategy for using natural resources, we may be able to slow global warming, reduce glacier melting, and conserve our source of water.

Global Energization

The earth's climate is a complex interaction of solar radiation, the production of carbon-containing gases, and the release of other chemicals into the atmosphere. Solar radiation enters our atmosphere as light and is converted to heat once it encounters the earth's surface. This heat is then radiated back through the atmosphere.

Carbon-containing gases, such as carbon dioxide and methane, trap this radiating heat, warming the earth's atmosphere. This is necessary for life on earth. However, as these gases become more plentiful, they create a condition that resembles a greenhouse, preventing warmed air from leaving the earth's atmosphere. The results are far-reaching and not completely predictable. The northerly areas may experience warmer and drier climates. This results in longer growing seasons at a time when the water necessary for crops may be a scarce resource. Elsewhere, the climate may become cooler and wetter. Sea levels may rise and ocean storms become more destructive.

The increase in the amount of greenhouse gases has been attributed to many of our western industrial practices. The use of hydrocarbons as fuel releases great quantities of carbon into the atmosphere. Livestock, especially cattle, contribute methane. At the same time that these gases are increasing, our forests are being heavily logged. These are trees that can absorb carbon, reducing the greenhouse effect.

Readjusting the atmospheric balance will be a complicated undertaking. It is necessary if our water source is to survive.

David Pugh (1946–1994)
Bow Falls, 1982
Contrary to its title, this image does not actually depict the famous Bow Falls at Banff. Instead its topography is probably Bow Glacier Falls, where we know Pugh worked during these years. Fascinated by the geology, structure, and scale of the mountains, he used a heavy application of graphite to convey these concerns and express his fondness for strong contrasts of light and dark.

Banff

In the mountains, the Bow Valley provided both a transportation route and resources for people who stayed there. The complex ecology includes alpine, sub-alpine, and montane ecoregions.

For more than 10,000 years people have lived and travelled through the region we now call Banff National Park. They have regarded the Bow Valley in different ways at different times. Native peoples saw it as a homeland. In the early days of development, European and American tourists regarded it as the last vestige of a wild North America and a source of moral and physical healing. There have also been businessmen who provided support for tourists, sportsmen, and outdoor adventurers.

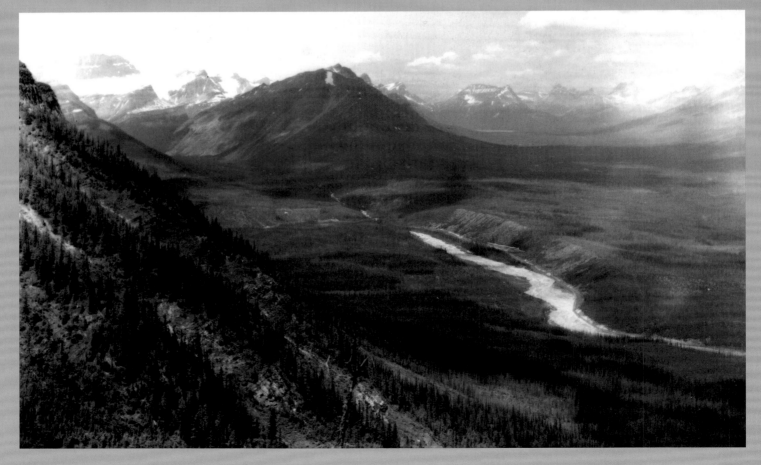

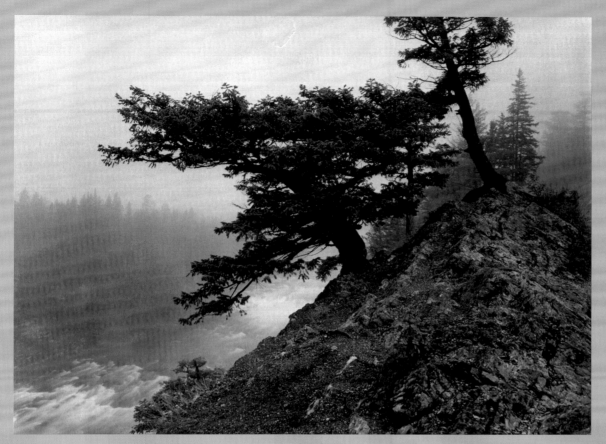

Craig Richards (b. 1955)
Douglas Fir, Fog, Bow River, Banff National Park, 1982
Inspired by the turn-of-the-nineteenth-century black and white photography Craig Richards uses a 4 × 5 inch camera and explores the vast tonal range between black and white. His art emphasizes a sharp-focus, unique view of the landscape, combined with attention to the spectacular effects of lighting and weather. This photo was taken across the river from the Banff Springs Hotel. Downstream, or slightly beyond the bottom left corner is the Bow Falls.

Patterns of Native Use

The ecology of the Bow Valley changes in Banff from alpine and sub-alpine environment in the upper reaches to a montane ecoregion in the lower sections. These mountain environments have a very rigid structure of seasonally available resources. Summer changes into winter in a blink of an eye. Plants bud, bloom, and wither within a very short period of time.

The upper sections of the Bow were used much less intensely than the lower parts of the valley. In fact, no archaeological sites have been found in the vicinity of the river's source, where the alpine and sub-alpine environments support only small transient herds of elk, mountain goats and, occasionally, woodland caribou. Still, the rarity of sites is surprising, as the neighbouring valleys and passes were all used by these First Peoples.

There is more evidence of human occupation further downstream. Boulder Pass contains a large number of sites, reflecting its importance as a route linking the Bow and Red Deer valleys. The area near Castle Junction was also important, although these first inhabitants do not seem to have frequented either Lake Louise or Moraine Lake. The numerous archaeological sites on the shores of Vermilion Lakes and Lake Minnewanka and in the Banff townsite reflect the intense use of the diverse resources of the montane region.

There is a variety of types of archaeological sites in the Bow Valley. Small, isolated sites with just a few artifacts have been found at high elevations and lookout sites occur on promontories with sweeping vistas. The alluvial fans along the

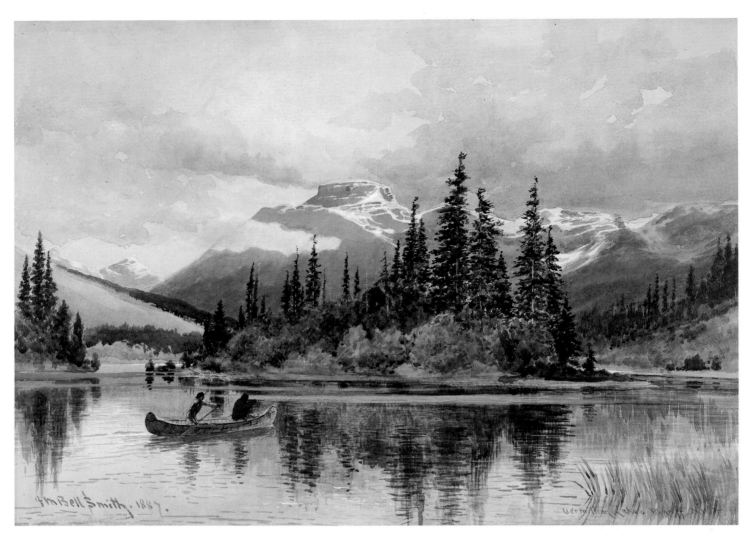

Frederic M. Bell-Smith
(1846–1923)
Vermilion Lakes, Banff, North West Territories, 1887
This watercolour depicts the Vermilion Lakes, west of Banff at the base of Mount Norquay, with the Fairholme Range in the background. Bell-Smith's first trip to the Rockies was in 1881, but this work was probably based on his two-month visit to the Rockies in 1887. The Bow River and Valley were obvious subjects for him, since the rail line cut through the Bow Valley, in essence making it an intrinsic part of the artist's travel itinerary.

lower Bow often have larger sites on them. These well-drained deposits on south-facing slopes would have been dry and warm campsites. House pits have been found in and around the Banff townsite. These large depressions are the remains of semi-subterranean dwellings. Such houses were typically used by people living in the Columbia and Fraser river valleys.

There remain many unanswered questions about the Native use of the Bow River valley in the Park. The artifacts indicate that people from both the Plains to the east and the Plateau to the west were using the valley. Were they after the same resources? We know that plants were important to these people, but we do not know how they were harvesting them in this area. Nor do we understand how they were stewarding the resources of the valley: were they intentionally burning the forest in order to maintain open, grassy pastures for bison?

The Vermilion Lakes create a unique wetland environment along the Bow River. The grassy edges are prime waterfowl habitat and the fish attract eagles, osprey and other birds of prey. For thousands of years, people used the area as a hunting place and campground.

As rock debris loosens and slides downhill, it creates alluvial fans where the slopes meet the valley floor. These well-drained sites were preferred camping places for the people who visited this part of the Bow Valley thousands of years ago.

These depressions are all that remain of pit houses that were occupied over 2,000 years ago. People crossed the mountains from the Columbia River basin to the area near the Banff townsite. They may have been hunting bison or coming to trade with people living in the foothills. Today, this site lies under the Banff Springs Golf Course.

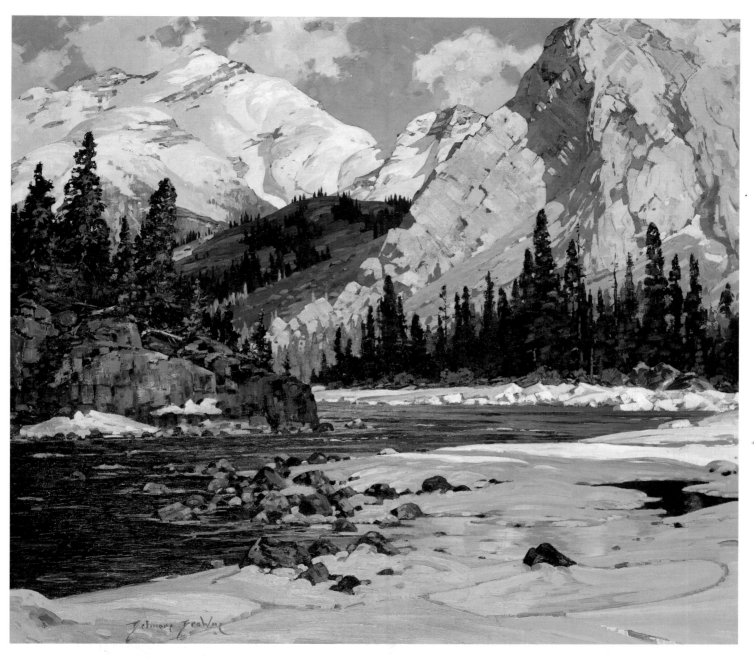

Belmore Browne (1880–1954)
Under the Cliffs of Rundle,
c. 1929
The Bow Valley formed a central axis throughout much of Browne's art. He especially loved this region in winter-spring and travelling by packhorse in the Banff area appealed to him. His works appeal most to those with a taste for the luscious romanticism of the Rockies, and an appreciation for nature's beauty. Here, Browne shows us the many colour possibilities in painting snow, especially with the changing lighting as spring dawns.

Walter J. Phillips
(1884–1962)
Rundle through a Screen of Poplars, 1952
This painting shows Mount Rundle in the background, and Tunnel Mountain to the left, probably viewed across from the second Vermilion Lake. Phillips sketched in various locations throughout the Rockies, but the Bow Valley held a special attraction for him. In later years he built a home at the base of Tunnel Mountain, overlooking the Bow Valley. Viewed through a foreground of fall-ripened leaves, the contrasts of distant blues, purples, and greens against yellows make this image compelling in its use of colour.

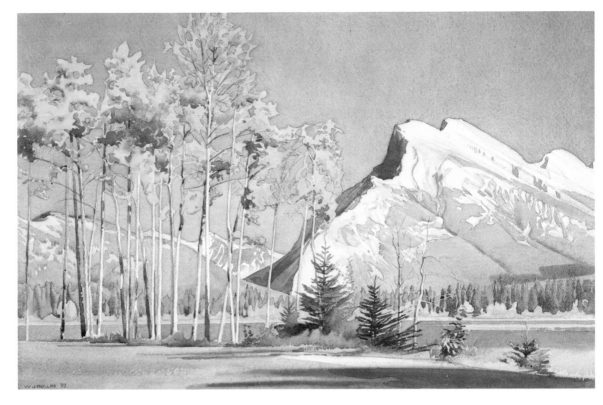

E.J. Hughes (b. 1913)
Mount Rundle and Vermilion Lakes, 1963
This image is one of many views of the spectacular Mount Rundle, so often depicted and photographed by travellers to this area. Tunnel Mountain, an equally well-known peak, is situated to the left, with the Vermilion Lakes in the foreground. This exacting drawing is typical of Hughes' meticulous working process which produced drawings so complete in themselves that they can almost be considered finished works of art. Yet his notes throughout the drawing indicate his plans to use this as a sketch for something more ambitious. Like many other artists facing the challenges of painting water, he chose a moment where the water was quiet enough to reflect a mirror image of the mountains.

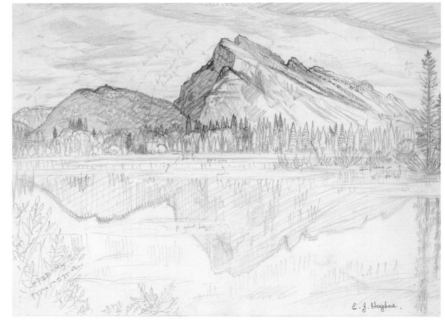

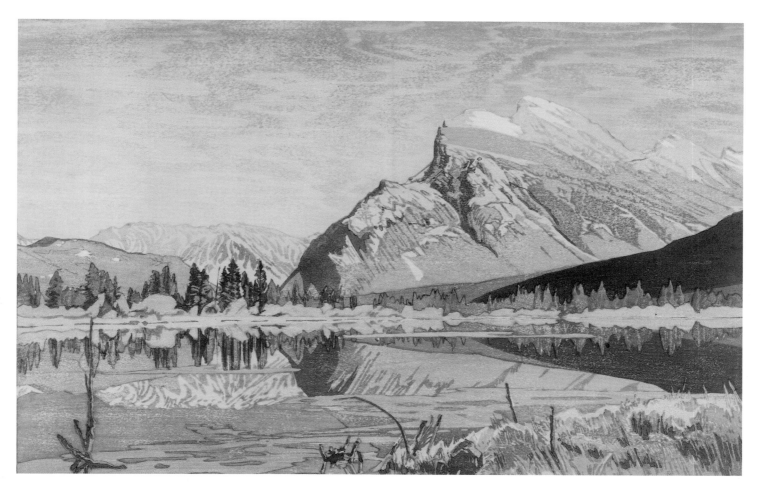

Walter J. Phillips
(1884–1962)
Mount Rundle, 1950
Phillips was internationally recognized for his work as a printmaker. Exceptionally gifted as a technician in the woodcut process, he developed his prints with many colours, each one requiring its own block for printing, as is the case in this print of Mount Rundle. Income from Phillips' woodcuts carried him through the hard years of the Depression and he was one of the few artists of his day to support his family on the sale of his art.

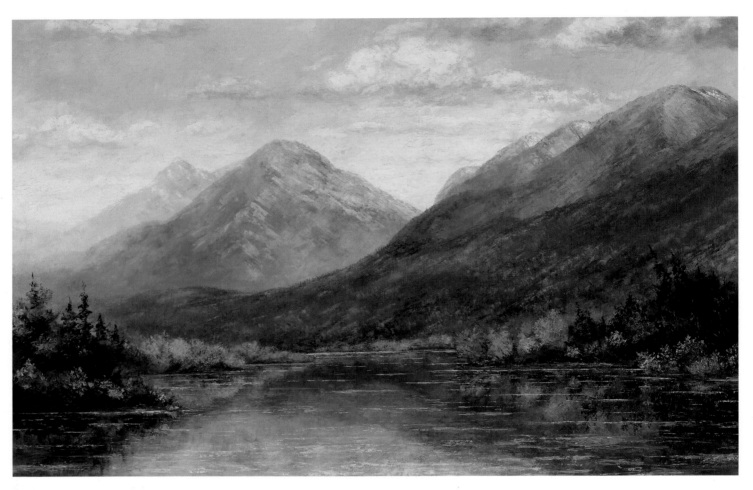

Leonard M. Davis
(1864–1938)
*Mountain Landscape,
Bow Valley*, 1918
This evocative scene of the Bow River with rising mist and fog evokes a serene, idealistic, and sublime feeling for the landscape. It is in keeping with the similarly romantic approach of the CPR artists, three decades earlier. The painting was probably based on a trip Davis made to Banff and Calgary in 1917 following his Alaskan travels.

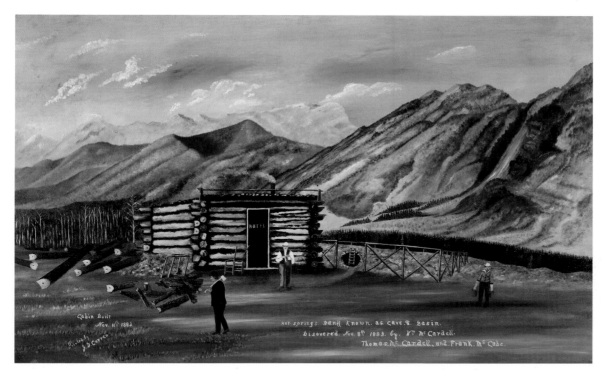

John Donaldson Curren (1852–1940)
Hot Springs Banff, Known as Cave and Basin, n.d.
Curren's painting of the Banff Hot Springs reveals this largely self-taught artist's lack of formal art training. Yet the work retains a charming narrative quality as he documents the discovery of this now famous site in Banff National Park, set aside by an Order of Council in 1885 that established Banff National Park. Because of these distinctive hot springs, this has become one of the best-known destinations in the Bow Valley.

The Bow Valley in the Twenty-First Century

The early Euro-Canadian explorers did not linger in the mountains. It was not until the railway followed the Bow River to Kicking Horse Pass that the area drew much attention. The CPR opened up the valley to mining, logging, and tourism. By the 1920s and 1930s, the road from Calgary had improved and campsites were developed for short-term forays as Banff became Calgary's "playground." The number of park visitors increased exponentially after the Second World War as Canadians discovered a new-found prosperity and an increase in personal recreational time. A growing number arrived by automobile and stayed within easy driving distances of the main highway. This meant, by and large, staying within the Bow Valley corridor. It is here that the impact of development has been the greatest.

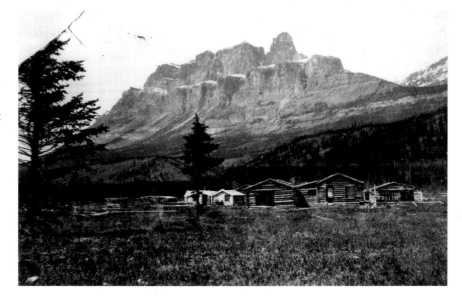

In 1881, Joe Healy, a former whisky trader from Montana, was led to an outcropping of copper by a Nakoda friend (whose name is lost to history). He returned to Fort Benton, on the Missouri River, and soon had financial backing to mine the copper and silver (which, upon closer inspection, was discovered to be sulfide of lead). During the winter of 1883–84, Silver City was home to nearly 1,400 people. Most of the miners had left by the following spring, when it became clear that there were no riches to be found.

The Cave and Basin became very popular. The naturally heated water was diverted to a swimming pool and European-style spa.

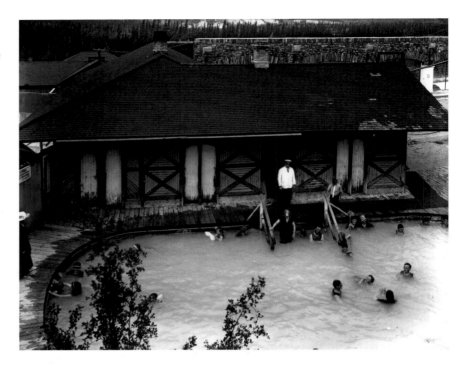

Dr. George Brett established a hospital and sanitorium in the late 1890s. Visitors from eastern North America and Europe travelled to Banff for rest and to "take the waters." Brett bottled "lithium water" for sale to his patients.

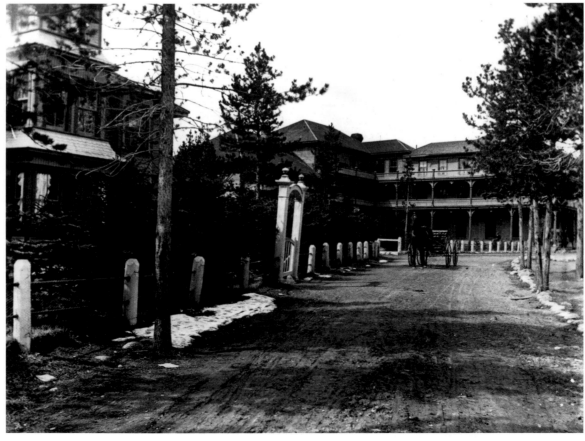

The Bow: Living with a River

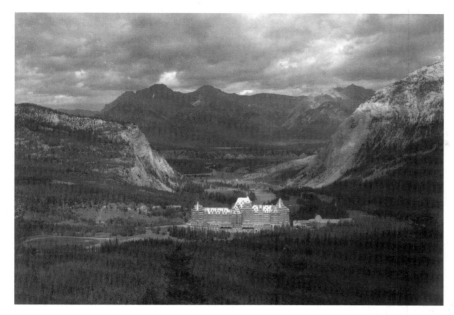

Sir William Cornelius Van Horne, general manager of the CPR, recognized the potential of the Bow Valley as a tourist attraction. Under his direction, the Banff Springs Hotel was built to accommodate wealthy tourists. The "million-dollar view" from the hotel's balcony encompasses a breathtaking vista of the remarkable Bow Valley.

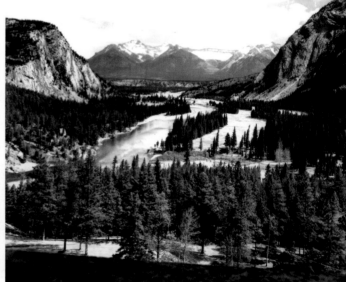

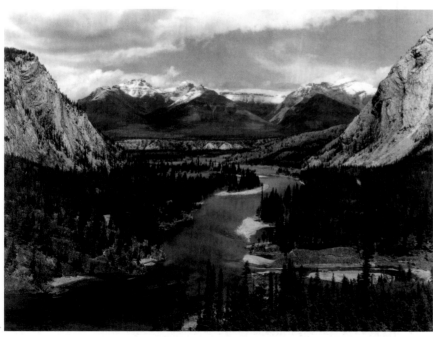

Bill Peyto (right), one of the group of guides in the early days of Banff, later became the first warden in the Park.

Jimmy Simpson (far right) was undoubtedly Banff's best-known guide and outfitter. Originally from England, he spent his early days in the mountains working for Tom Wilson. His reputation as an excellent guide and storyteller brought him clients from around the world.

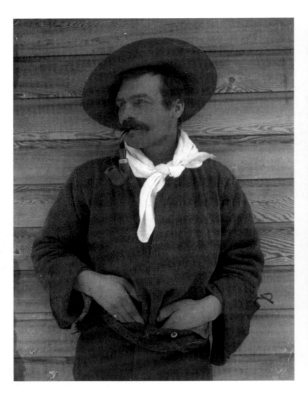

Tom Wilson (left) was one of Banff's first outfitters. Although most tourists were content with day trips, some wanted to travel farther afield. Wilson was the first non-Native to visit Lake Louise.

After they had "taken the waters," many of Banff's visitors were anxious to explore the wilderness that was so close at hand. Trailriding became a popular pastime (above).

The Bow: Living with a River

As Banff began to attract more Calgarians, automobiles became a common way to make the journey. The roads were often in poor condition and it may have taken all day to complete the trip. Today, the drive takes less than two hours.

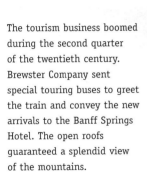

The tourism business boomed during the second quarter of the twentieth century. Brewster Company sent special touring buses to greet the train and convey the new arrivals to the Banff Springs Hotel. The open roofs guaranteed a splendid view of the mountains.

Mountain sheep are frequently seen along the roadside in the montane ecoregion of the mountain forest. Road disturbances encourage the growth of grass-like plants, a preferred diet of these animals.

The montane ecoregion of the Bow Valley has long been an important wintering ground for elk and, consequently, for the wolves who feed on them. Growth of the town of Banff has intimidated the wolves, who are wary of humans, but encouraged the elk. In the absence of a key predator, elk populations have grown to levels that cannot be sustained by the ecosystem. The animals have also become such a danger to tourists that significant numbers have been forcibly removed to other areas of the park.

The four-lane Trans-Canada Highway and the CPR main line are further threats to the wildlife. Leakage from grain cars encourages herbivores to graze the track, resulting in numerous animal deaths each year. Recently, the railway has begun vacuuming the track to reduce the amount of grain left by the trains and thereby discourage the elk herds. Because the highway transects herd ranges, it also poses a barrier to animal migrations between the two sides of the valley. Fencing keeps cars and animals apart while underpasses and overpasses allow animals to safely cross the highway. Unfortunately, some animals, such as grizzly bears and wolves, refuse to use these transportation bypasses and seem to be abandoning parts of their traditional ranges.

The sheer size of the human population has become an important threat to the Bow Valley ecosystem. Several important initiatives have followed from studies in the 1990s that predicted

The open meadows in the montane forests provide lush forage for elk (centre) and mule deer (bottom)—often in the same areas that are important tourist attractions. People and animals have frequently come into conflict in the past. Today, the managers of the park are trying to separate the animals from the visitors.

dire consequences for the wildlife if modern human use did not change. The lower Bow region in the park has been divided so that human use is largely confined to one side of the valley, leaving the other side more open for animals. A small airport has been closed, a cadet camp removed, and intentional burning initiated to create better grazing land. The Trans-Canada Highway twinning is being extended to allow travellers to move safely and quickly through the valley. Limits to growth have been imposed on the town of Banff to ensure that the municipal "footprint" does not expand any further.

So far, there have been positive changes in human/non-human interaction in the Bow Valley. Continual monitoring and careful planning will be necessary to ensure that this relationship continues to evolve for the benefit of all.

The open stands of aspen and grass in the montane ecoregion are prime habitat for elk, deer, sheep, and the wolves that prey upon them. Unfortunately, it is also a region that has attracted most of the human activity in Banff National Park.

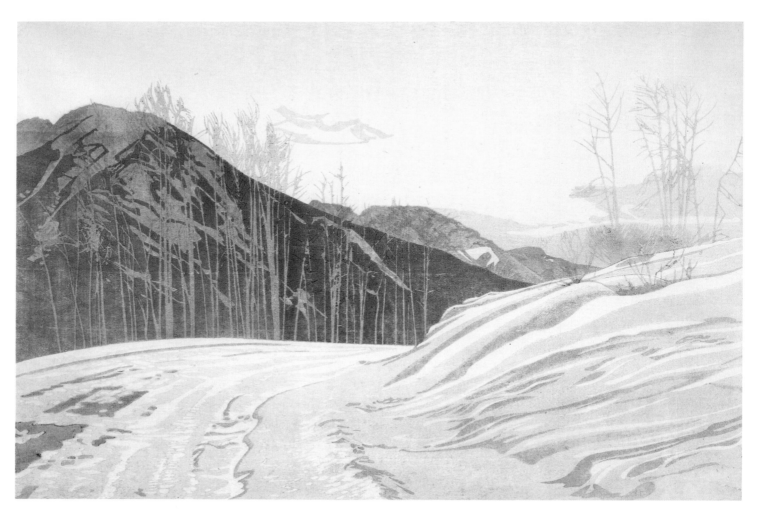

Walter J. Phillips
(1884–1963)
Mountain Road, 1942
Mountain Road depicts the peaceful highway known as the Bow Valley Parkway (1A), which is now a side road extending from Banff townsite to Lake Louise. The highway is busiest during high-summer tourist season but is here shown in a moment of solitude. Phillips delighted in the patterns and reflections formed by the water coursing over rocks and snow on this brilliant sunlit winter day.

The Bow: Living with a River

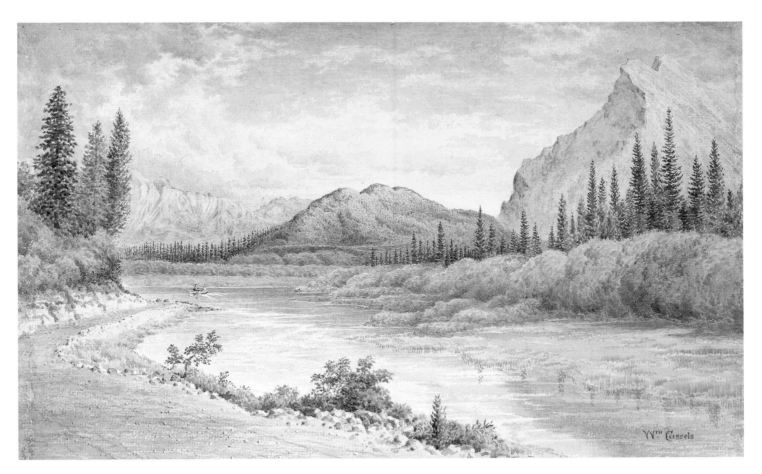

Walter Cassels (dates unknown)
Mount Rundle in Banff with the Bow River, c. 1860–70
This image is one of the earliest painted views of Mount Rundle. Including Tunnel Mountain on the left, Cassels shows the extensive greenery that once graced this well-forested mountain. His view across Vermilion Lakes to the steep, almost smooth ascending slope was a perspective that would be shared by many subsequent painters.

Ecosystems and Ecoregions

The term "ecosystem" describes the interactions among plants, animals, weather, topography, soil, and water to determine the differences between landscapes over very broad areas. It is an abstract concept that is useful for developing general theories about ecological change, but is not easily seen "on the ground." Ecologists working in the field are more likely to look at ecoregions, that is, landscapes that are characterized by observable communities, usually of plants.

In Banff National Park, the Bow Valley includes three important ecoregions. The alpine ecoregion, is found at the highest elevations where cold temperatures, high snowfall, and short growing seasons limit the vegetation. The landscape is mainly rock and ice, although some soil development occurs in isolated pockets. The predominant plants are heathers, low shrub willow, birches, and sedge, with bog sedge and fescue growing wherever soil development allows.

The subalpine ecoregion occurs at lower elevations, but is still characterized by cold temperatures and high precipitation. The closed forests are dominated by Englemann spruce, subalpine fir, and lodgepole pine. The pine is adapted to survive fire and flourish in its aftermath, and it is especially common in the lower part of this ecoregion, where frequent fires may account for its abundance. The steep slopes of the subalpine are scarred with avalanche paths and are often the site of spring and summer alluvial outwashes as spring runoff swells the streams. In the valley bottoms, this ecoregion often has broad, braided streams and poorly drained sedge wetlands.

The montane ecoregion occurs on the lower slopes and in the broad valleys. The temperature is milder than the other mountain ecoregions and the

In the mountains, the Bow Valley provided both a transportation route and resources for people who stayed there. The complex ecology includes alpine, subalpine, and montane ecoregions.

The alpine ecoregion, found at the highest elevations, has little soil development. Heathers, low shrub willows, and birch struggle to survive in the long winters and short summers. Lower down the slopes, spruce, fir, and pine dominate this zone.

precipitation is lighter. The vegetation is characterized by white spruce and poplars near rivers and Douglas fir and lodgepole pine on drier sites. Expansive grasslands also occur, possibly as a result of frequent fires, and wetlands are found in some locations.

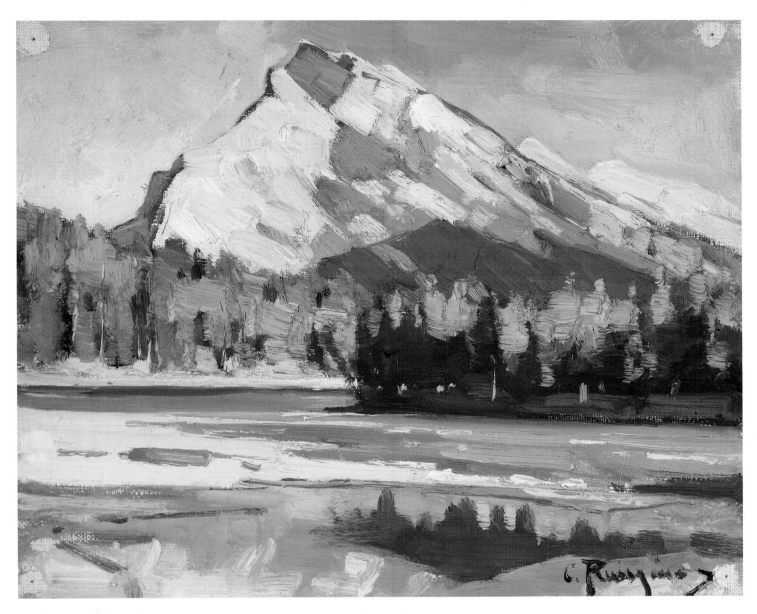

Carl Rungius (1869–1959)
Mountain Peak from the River,
[*Mount Rundle*], n.d.
After Carl Rungius' first trip to the Rocky Mountains in 1910, he returned every year and the region captivated him for the remainder of his long and prolific painting career. By 1922, he had built "The Paintbox," a Banff-based studio he maintained until 1957 so that he could make annual summer trips to the Rockies. From his base in Banff, numerous areas of the Bow Valley were accessible. Mount Rundle was one of many readily available subjects in the region and a favourite of numerous artists. In this sketch, Rungius has studied the mountain from the angle that best shows its enormously steep slope and unique topography.

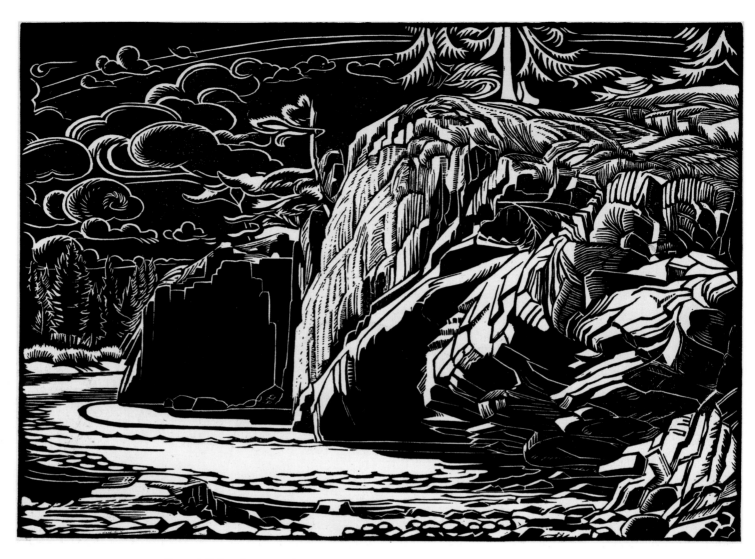

Margaret Shelton (1915–1984)
Rocks Below Bow Falls, 1947

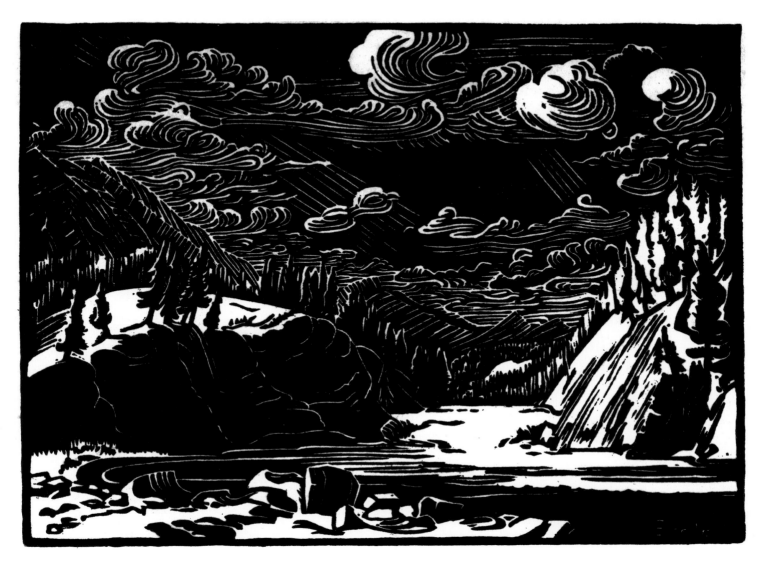

Margaret Shelton (1915–1984)
Bow Falls from the South,
1941
The Bow Falls at Banff remains a popular tourist spot and a subject of interest to several artists. Close at hand to the present day Banff Centre, where countless artists have come to study since the 1930s, this charming site presents many pictorial opportunities for artists. For Shelton, the movement of the water created a playful rhythm and interplay of light and dark contrasts. Her two versions of the falls—*Rocks Below Bow River* (opposite) and *Bow Falls from the South* (above)—are unique because of the wonderful sense of moving water and the nearly abstract patterns she's created from the river, rocks, and sky.

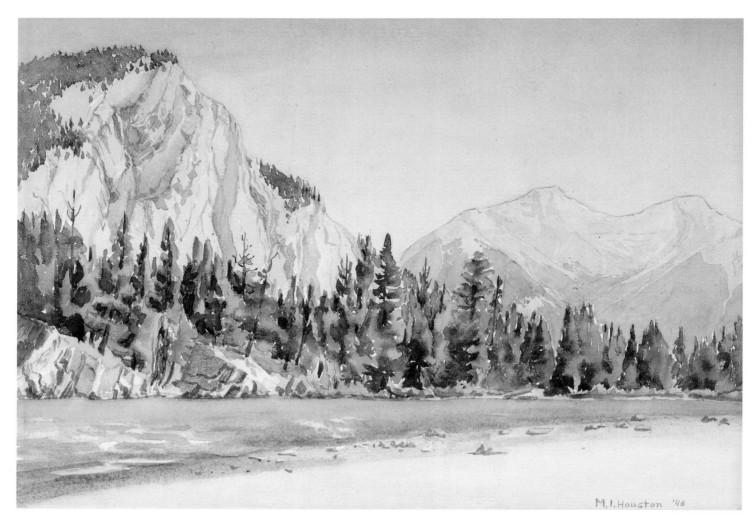

Martha Isabel Houston
(1896–1983)
Below Bow Falls, 1946
Martha Houston studied at the Banff School of Fine Arts for eleven summers under W.J. Phillips, H.G. Glyde, and others. It was probably during this time that she sketched the nearby Bow Falls depicted in this watercolour. Working in her preferred medium, her gently applied washes of watercolour paint suggest a sense of the river's endless movement.

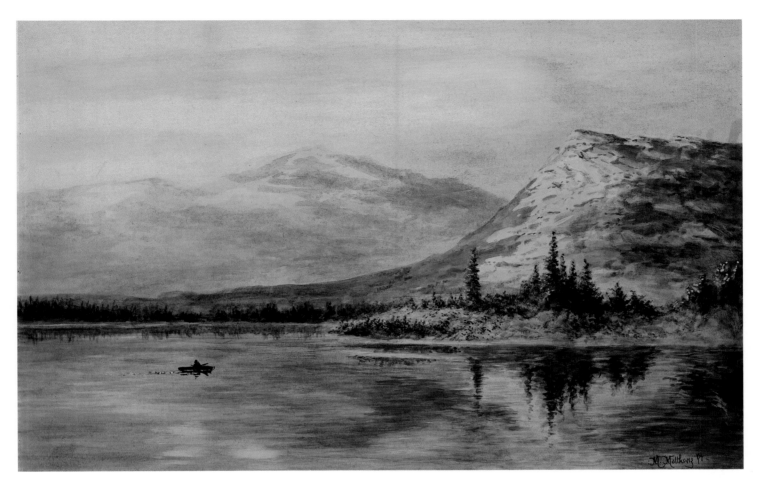

Marmaduke Matthews
(1837–1913)
*South Bank of the Bow
Near Laggan*, n.d.
Marmaduke Matthews' first trip to the Rockies was in 1887 with F.M. Bell-Smith and T. Mower Martin, and a second trip quickly followed in 1889. Probably drawn from one of these adventures, this serene view of the Bow River depicts the area at Laggan, CPR's station near Lake Louise. Impressive in scale for its day, this work was once shown at Toronto's Canadian National Exhibition. Matthews worked frequently in watercolour, a medium he excelled at and promoted throughout the late nineteenth century in Canadian art circles.

The Gateway

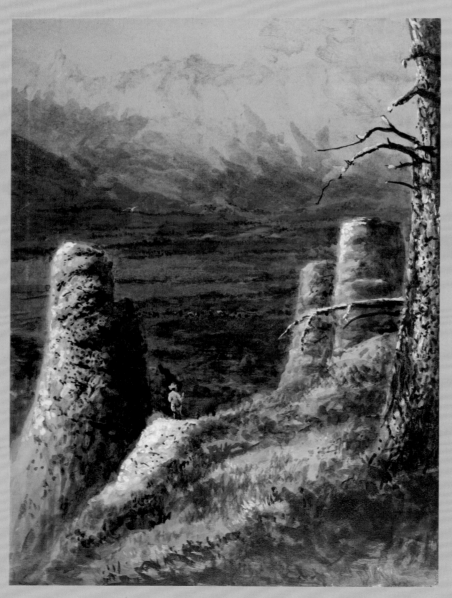

Before there was skiing, hiking, tourists, and conservation, there was coal, lumber, and hydroelectricity. Throughout it all, there has been the river.

The Gateway has undergone a remarkable identity change in the last quarter-century. As recently as the early 1980s, the town of Canmore seemed to have little or no future. For much of its history, the area had been a source of coal, timber, and hydroelectricity. Now the coal was played out, the timber industry had faded years before, and the electricity was coming from thermal plants further north. People had little reason to stay.

Marmaduke Matthews (1837–1913)
Sunrise in the Hoodoos, Canmore, n.d.,
Marmaduke Matthews quickly recognized some of the Bow Valley's most unique features when he developed this stunning image from the Canmore area, showing the unusual hoodoo formations carved by thousands of years of rain and wind. The tiny figure in the foreground offers the viewer a sense of the scale and presence of the hoodoos. Matthews has chosen the dawn of day as his ideal time to represent the hoodoos, since it brings out their almost haunting, ghost-like quality as they stand like figures or apparitions against the deep valley below.

Coal

One of the benefits of the southern railway route through the Bow Valley was the presence of coal deposits along the way, particularly in the area around Canmore. Trains ran on steam power produced through the consumption of fuel and water. Both required frequent replenishing at major divisional points every 201 kilometres, a journey of approximately nine hours. Canmore had fuel and water, and so became the divisional point on the eastern slope of the Rockies. The first regular train passed through town on May 11, 1884, travelling 21 kilometres per hour. From then on, the relationship between Canmore and the CPR would continue to be very close, if not always amicable.

The Cascade Coal Basin is an area of coal-bearing rocks 4 kilometres wide and 75 kilometres long stretching from Mount Blane to the north end of Cascade Mountain. As described by George Wallace Tough in his 1968 study of the Casade Coal area, "The streams and rivers of the Bow Valley served as natural stripping and trenching tools, easing access for prospectors." Between 1883 and 1979, these deposits would be mined by an

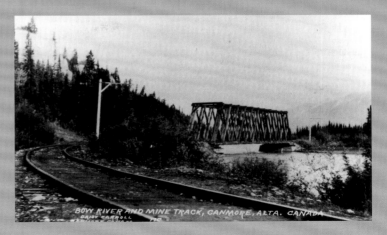

BOW RIVER AND MINE TRACK, CANMORE, ALTA. CANADA
DAISY CARROLL

As the mine and the railroad were on opposite sides of the river, during the summer months coal and men were transported across the river by barge and during the winter across the ice by wagon and sleigh. A bridge was built in 1892 and the coal was eventually moved along spur lines.

array of companies, many of which were interconnected in complex arrangements.

In 1884 a coal seam was uncovered near what would become Canmore Mine Number 1. The Canadian Anthracite Coal Company, established at that time, began operations in Canmore in 1887. The entire output was sold to the CPR. Water from the Bow was used to produce steam power for the mine and to wash the coal brought to the surface.

Coal and the railway were the foundations of Canmore, and the town developed accordingly, divided by the Bow. Settlement on the north side of the river was centred around the railway. Settlement on the south side of the river, known as Mineside, was focused around mining. Mineside had its own shops and its own post office and was populated almost exclusively by coal miners.

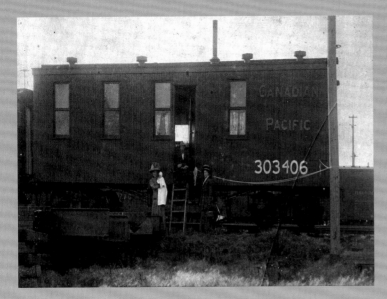

Hansen family, beside boxcar home, Canmore, 1910. Mr. J.P. Hansen (centre), was a gang foreman on Canadian Pacific Railway construction. When the railway and the town of Canmore were being constructed, railway cars served a variety of purposes. In this instance it was someone's home. The first train station was also a boxcar.

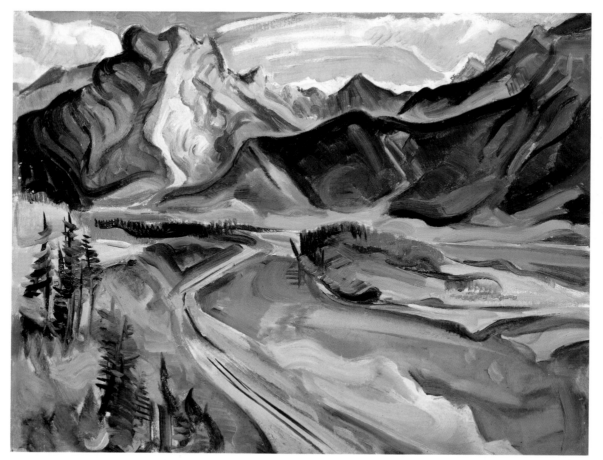

Kathleen Daly Pepper
(1898–1994)
The Bow Valley (Canadian Rockies), n.d.
Pepper was fascinated by Canmore's mining population, and determined to make this a focus during her eighteen-month convalescence from polio between 1941 and 1946. In keeping with the modernist tendencies of Canadian landscape painting at the time, her work shows a concern for textures, bold colouring, and abstraction of form.

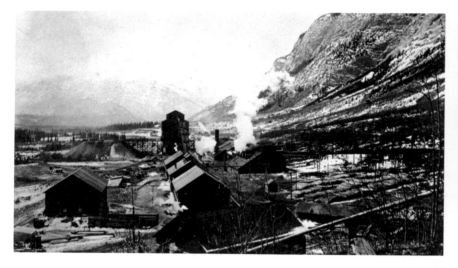

Mining at Bankhead, 1908–12. In 1902 the CPR opened a mine at Bankhead, near Banff, in an effort to control an ongoing supply of coal. By 1911 Bankhead employed almost 500 men.

Following the development of the mines at Anthracite and Canmore, it took little time for other companies to become interested in the coal of the Canmore corridor. Over twenty mines operated within the Gateway and various areas of the Kananaskis. The Canmore Number 2 mine, opened in 1918 after Canmore Number 1 expired, led to the settlement of Prospect, east of Mineside. British investors financed a mine and the development at Georgetown on the south side of the Bow River west of Canmore in 1910. Unfortunately for Georgetown, in spite of the increased demand for coal arising from the First World War, rising production and transportation costs overwhelmed the investors. In 1916 the property was transferred to the Canmore Coal Company and the houses moved to Canmore to join houses moved there following the closure of Anthracite in 1904.

Coal mining in and around the Cascade Basin was difficult and dangerous. The seams were often steep and were very "gassy," containing a great deal of methane. Because of the pitch (steep angle) of the seams, the mining was done by hard physical labour in hot, cramped spaces. Effective machinery was not developed until the early part of the twentieth century.

Profits in the coal business were marginal, and mines such as those in the Bow Valley were particularly vulnerable. Eastern markets were reluctant to purchase western anthracite. In addition, distances were long and freight costs were high. Although there was a western domestic heating market, most mines in the Bow Valley and other parts of the west were in the uncomfortable position of being solely dependent on the CPR for transport and as the chief consumer of their product. New railways, and the extension of the CPR line through the Crowsnest Pass to the west coast, contributed to the fragility of the coal economy in Canmore and the surrounding

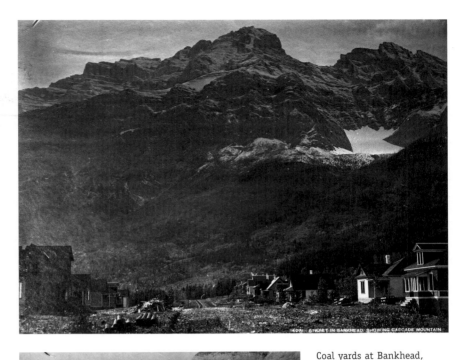

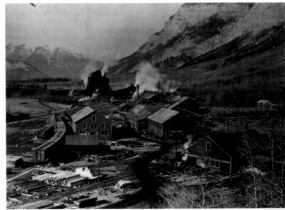

Coal yards at Bankhead, c. 1910 (left).
Street in Bankhead (top). Although it was considered the CPR's "model mining community," production at the Bankhead mine was expensive because of the design of the mine itself and because much of the coal had to be made into briquettes to make it suitable for use. Bankhead closed in 1922, following the last of several strikes.

area. As these alternative routes through the mountains developed, the pace of development in the Bow Valley slowed.

Although by 1930 Canmore had become the commercial centre of the western end of the Canmore corridor, the Depression was a difficult time for the town. The mines around Canmore operated at less than half capacity through the 1930s. The market improved with the coming of the Second World War, and production peaked at the mine in 1944, when 300 men were employed there. But the upsurge was temporary. Oil, gas,

Canmore Company houses at Prospect, 1916.
This settlement was built for workers at the Canmore Company's Number 2 mine.

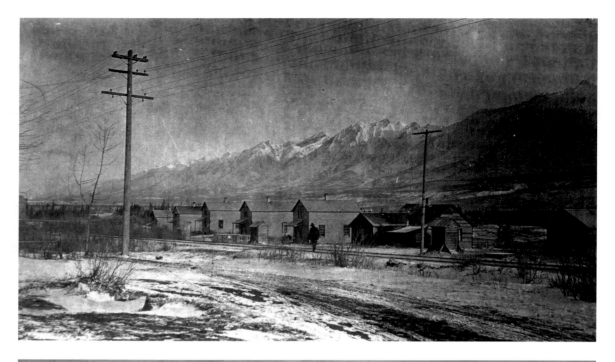

Walter J. Phillips
(1884–1962)
Canmore, Alberta, 1958
This work, done late in Phillips' career, shows the emerging town of Canmore, Alberta, near 10th Street, north of today's new civic centre. The old mining houses depicted on the right are no longer standing. Concerned always about maintaining a public audience for his work, Phillips steered clear of modern trends toward abstraction that were becoming popular around him. Holding on to a more realistic style, he emphasized the importance of craftsmanship, technique, and skill throughout his practice.

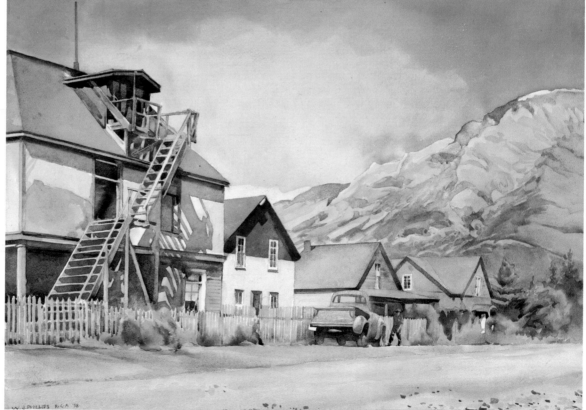

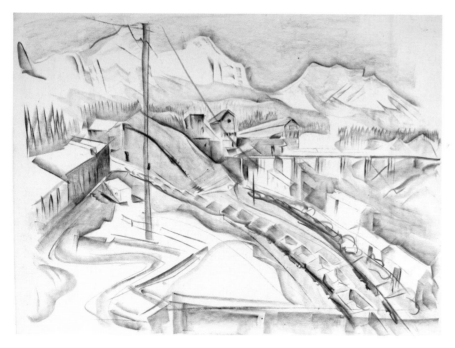

Kathleen Daly Pepper (1898–1994)
Briquette Plant, 1944
This image depicts the briquette plant at Canmore, where particularly friable or crumbly coal was transformed into briquettes. The mine train visible in the foreground was used for transporting coal. Pepper's unusual litho-crayon drawings show a deep understanding of the medium's potential as she presses firmly on the edges and sides, rather than the end, to create shading and depth of form. Much of the paper is left uncoloured and so becomes an intrinsic part of the image.

Kathleen Daly Pepper (1898–1994)
Miners at Beer, Canmore, 1944
It was the people of Canmore's mining community that interested Pepper. There, early settlement was divided between the north and south sides of the Bow River, a division that resulted from the railway line. The miners lived on the south side, known as Mineside. The town had its own shops and services. This image, probably based on a scene at the Canmore Hotel bar, reflects the more casual side of miners' lives.

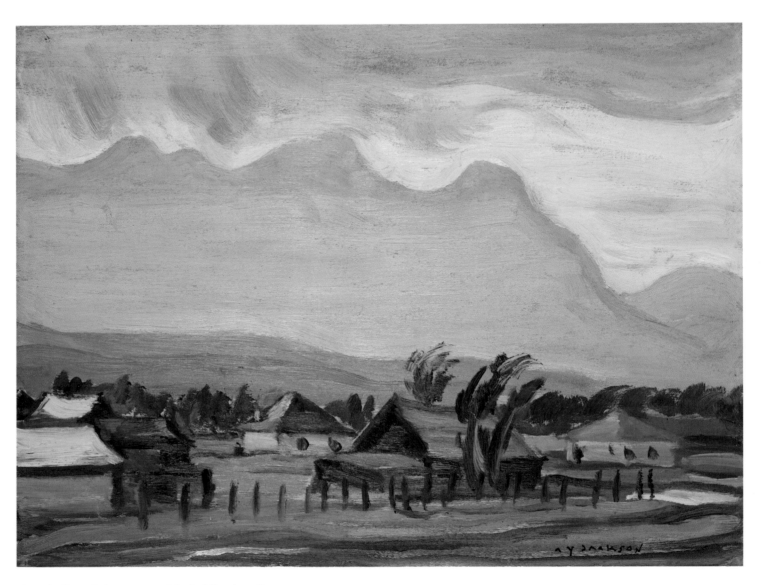

Alexander Young Jackson
(1882–1974)
Rain Squall, Canmore, Alberta,
1947
This image of the Bow Valley
was probably done during
one of Jackson's sketching
excursions to Canmore with
his students from the Banff
School of Fine Arts. The
changeable weather depicted
in this scene was one of
Jackson's favourite subjects.
On this overcast, rainy, and
windy day, Jackson was
offered the opportunity to
explore colour, lighting, and
atmospheric change.

and natural gas were being used in an increasing number of industries, and Canmore was a long way from the few industries still using coal. The CPR, traditionally the key market for Gateway coal, switched to diesel. In 1968 Canmore Mines, like other Canadian coal mining companies, moved into the Japanese market. However, the cost of modernization was overwhelming and in 1969 the company was sold to Hawaii-based Dillingham Corporation. After a few more years of struggle, the Canmore mine closed in 1979. Between 1886 and 1979, Canmore Mines had produced 16 million tons of coal.

Coal Formation

Coal formed in swampy areas where plants decayed into extensive peat deposits. If the peat accumulated too quickly, it would rise above the surrounding water and oxidize in the air. If the accumulation was too slow, the surrounding water would have flooded the swamp, creating a lake and drowning the peat. The peat compressed as it accumulated and, when altered with the addition of heat, formed coal. The greater the compression and the heat, the more substantial the transformation of the peat. However, the process was very slow and 1 metre of mid-grade or bituminous coal may have taken 6,000 years to accumulate. Some of the large coal seams in the Bow Valley may have taken over 50,000 years to form.

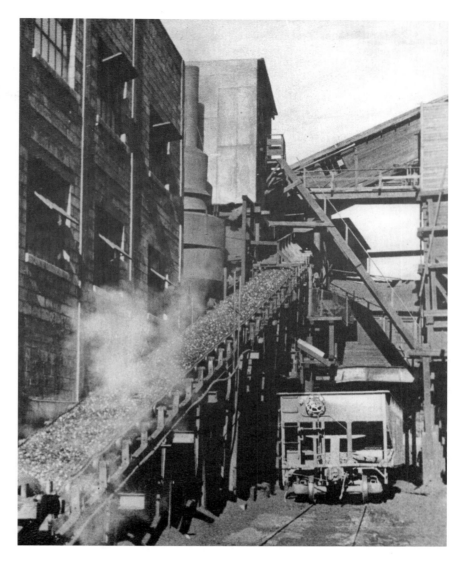

Briquettes are made when particularly friable coal is mixed with either asphalt or tar. The resulting briquettes are easy to transport and burn more efficiently, making them popular for domestic use. In this photograph, the briquettes are on the cooling chain, following their formation.

Mine manager's residence, Canmore, Alberta, c. 1915. The house was known as "The Cabin."

THE CABIN
MINE MANAGER'S RESIDENCE, CANMORE ALTA. CANADA
DAISY CARROLL
CANMORE CANADA
18C

No. 1 Mine, Canmore, c. 1915 The Canadian Anthracite Coal Company operated the mines at Canmore until 1891. At that time they leased the Canmore Mine, along with a mine at Anthracite, to H.W. McNeill Co. In 1911 the Canadian Anthracite Coal Co. became Canmore Mines Ltd. and assumed management of the mines.

Relying on timber for supports and track for coal trains in tunnels, the mines were a major consumer of timber and often operated their own mills.

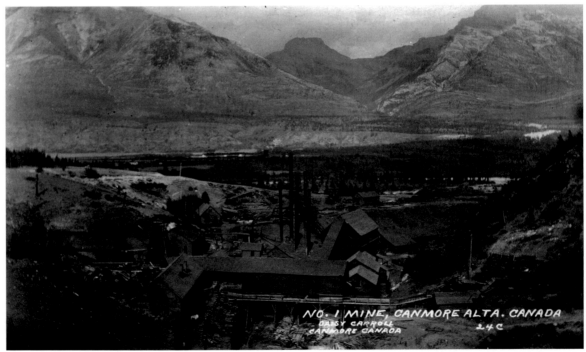

NO. 1 MINE, CANMORE ALTA. CANADA
DAISY CARROLL
CANMORE CANADA
14C

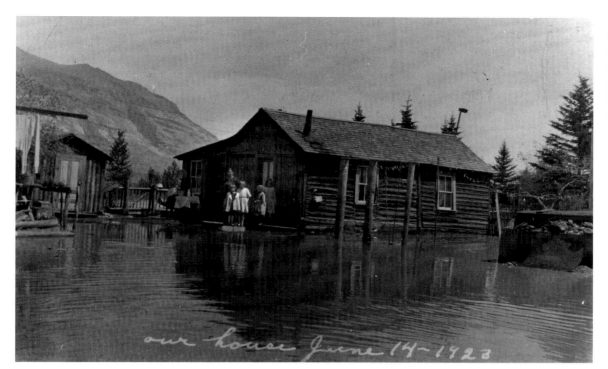

The Bow River often flooded its banks, flowing through parts of Canmore. In 1923 the Reinkka family were stranded when their home became an island surrounded by water.

our house June 14 - 1923

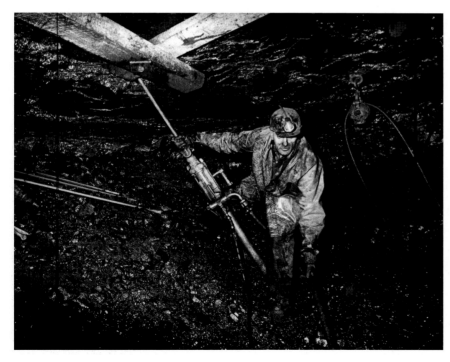

Mining became more mechanized with time. However, it still took place in small, cramped spaces and involved hard physical labour.

Tall Timber

As it had been for the coal industry, the CPR was the first major customer for the Bow Valley timber industry. A single kilometre of track required 1,600 railway ties.

The first sawmill west of Winnipeg was started in 1883 by James Walker, a retired officer of the North-West Mounted Police and the former manager of the Cochrane Ranche. He bought the mill that had been used at the ranch and set it up at Padmore in Kananaskis. It would operate until 1886, and Walker would cut 2 million feet of logs, to be used primarily by the CPR.

The Eau Claire and Bow River Lumber Company was formed in 1883 by Kutusoff McFee and three colleagues from Wisconsin. McFee, a lawyer from Ottawa, saw the potential value in the timber stands along the Bow River and throughout the Gateway area. In 1882 he travelled to Wisconsin to attempt to interest American investors. By September of 1883, following a trip to the area, they were convinced and used McFee's insider knowledge of Ottawa to apply for, and obtain, ten timber berths—an area of 1,238 square kilometres—for the Eau Claire and Bow River Lumber Company. The president of the company was Isaac Kerr and the manager for thirty years would be Peter Prince. Camps were set up at Silver City on the Bow River and at Ribbon Creek in Kananaskis. The building and settlement boom of the 1890s was good for the lumber industry.

Between 914,000 and 1,524,000 metres of timber were cut every winter and floated down the Bow River every spring for milling in Calgary. The first log drive took place in 1887. Although some logs would be transported into Calgary on flatcars, the river would be the primary method of transport, and for the next fifty years the arrival of the logs in Calgary was an annual event. The 1887 drive took all summer and six men were killed when their raft went over Kananaskis Falls. In the following years, the drives would require thirty to forty men to oversee them and would take two months. The log booms extended for up to 16 kilometres and moved between 3 and 4 kilometres per day.

By the end of the First World War, logging in the Canmore area was beginning to slow down, although there were large salvage operations following forest fires. Older berths (leases) had been logged out and the federal government was imposing harvesting regulations. Lumber companies also faced competition from individuals who cut trees within their berths. The Canadian government allowed individuals with permits to cut wood for buildings, for fence rails, and for firewood from within those berths, and most families in the area had such timber limits. By the 1920s, the timber berths that Eau Claire harvested were close to being bare. The final log drive to Calgary took place in 1943 and the Eau Claire mill ceased operations the same year. A smaller mill continued operations in the Kananaskis for a few more years. In 1956 the company was dissolved.

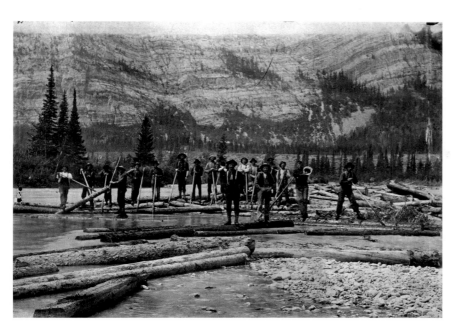

Eau Claire and Bow River Lumber Company lumber crew, Bow River, Kananaskis area.

Eau Claire Lumber Company logs in river west of Calgary, c. 1890s
Floating the logs down the river was not always a straightforward process. The Bow varied in speed and depth, and tended to throw logs up on shore.

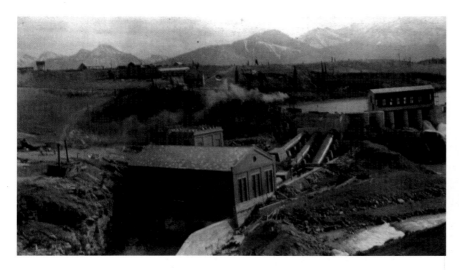

Calgary Power Company's power house on the Bow River at Horseshoe Falls, c. 1912
One of the challenges in extracting power from the Bow was the drastically differing rates of flow over the course of a year. The natural flow during spring floods sometimes exceeded 50,000 cubic feet per second, while the flow in the depth of the winter might be as low as 200 cubic feet per second. Storage basins were built to try to overcome this problem.

Power to the People: Damming The Bow

As the Bow River leaves the mountains, it begins to fall at an increasingly rapid rate. As it does, the river becomes a valuable source of hydroelectric power. This potential was recognized in the late nineteenth century, and in 1911 M.C. Henry began a series of surveys to identify potential sites along the Bow for power generation. The right to control and develop the river waters was often a contentious issue as provincial, federal, and private interests exerted their influence.

At the turn of the century, growing Alberta industry and the burgeoning Alberta population needed power. In 1911 Calgary Power, an offshoot of Eau Claire Lumber, installed a plant at Horseshoe Falls, 80 kilometres west of Calgary. In 1912 they built a dam at the western end of Lake Minnewanka in an effort to regulate the flow into the Bow River from the Cascade system. They subsequently built two more dams at Minnewanka, raising the lake level by more than 50 per cent. In 1913 the company installed a power plant on the Bow River at Kananaskis. The federal government power plant on the Cascade River, a tributary of the

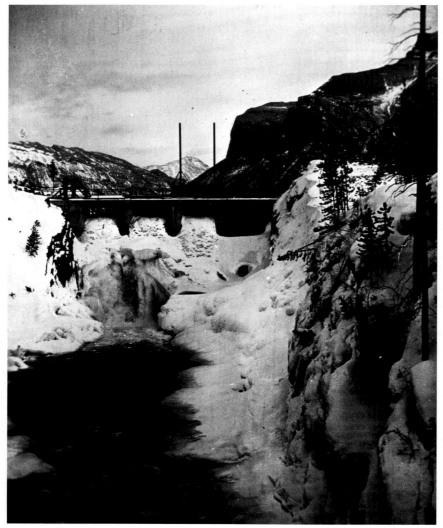

Devil's Creek Canyon, outlet of Lake Minnewanka, c. 1910
This was the first power plant on Lake Minnewanka. Originally built to raise the water level for supplying power to nearby resorts, Calgary Power eventually transformed it into one of the elements in the production of power for Calgary's burgeoning population.

The Bow: Living with a River

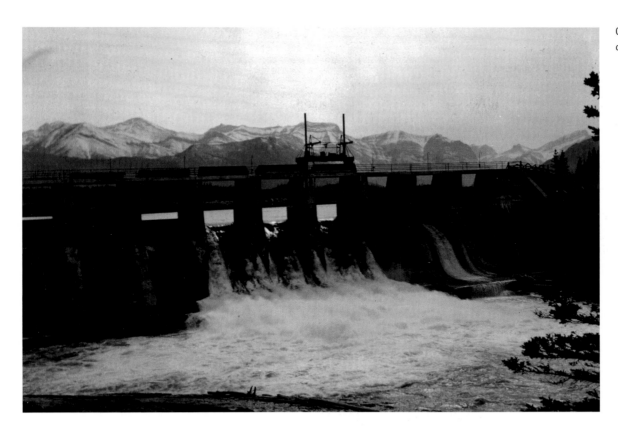

Calgary Power Company dam on the Bow River, Kananaskis

Bow, provided power to the national park. The plant was taken over by Calgary Power in 1942.

In 1928 Calgary Power again found itself short of capacity and began work on the Ghost River Power project, downstream from the Horseshoe and Kananaskis dams. It began producing power in 1929.

In 1947, following a pause in development during the Second World War, Calgary Power built one of the first remotely controlled hydroelectric plants in North America on the Kananaskis River 11 kilometres upstream from the Bow at the Barrier Generating Station. During the 1950s, six more hydroelectric plants would be added along the Bow River and upgrades would be carried out on the existing power plants.

The power plants on the Bow are still in use, but they provide only a small fraction of the power used in southern Alberta, supplementing the power grids during periods of peak demand.

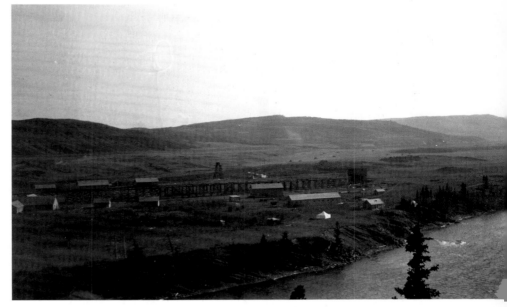

Construction of Ghost River hydroelectric dam, Bow River, 1928

Exshaw

Edwin Loder arrived in the Canmore area in 1886 with the intention of cutting timber. Instead he became interested in a group of kilns that had been started earlier by a Scotsman named McCaniesh. Loder and his brothers incorporated as the Loder Lime Company after 1890 and, with funding from investors in Ireland and Winnipeg, began producing lime. The Loder Lime Company would operate until 1952.

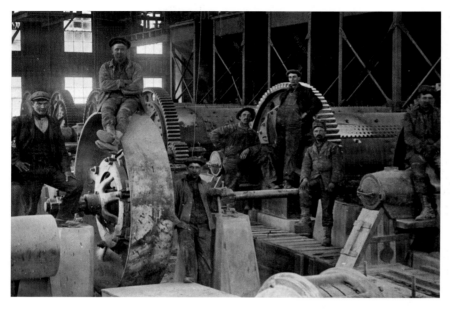

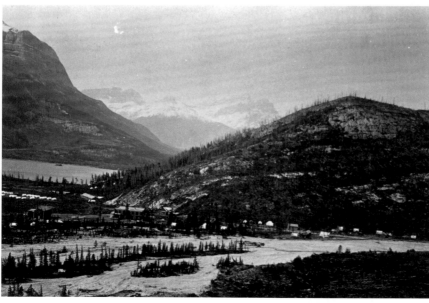

Today in the Gateway

A coal miner or logger from the 1930s would find a very different place, if transported to today's Gateway. Canmore has transformed itself from a working town to an affluent community focused almost solely on recreation. People live there for the "experience" of living in the mountains, and the focus is on conservation and the sustainability of their natural surroundings. They care deeply about their construct of the nature around them. Chalet-style bungalows have replaced small miners' houses on the streets of Canmore, while the new gated subdivisions are expanding up the mountain slopes on top of the old coal mines. The Bow remains a hard-working river, but it is an emotional resource for the spreading population in the Gateway and southwestern Alberta.

Exshaw under construction, near operational.

Exshaw under construction. The CPR decided to take advantage of a mountain of limestone located on the north shore of Lac des Arcs. In 1905 CPR-owned Western Canada Cement and Coal Company chose the site to manufacture Portland cement. Production in Exshaw began in 1906 using Canmore coal to power the kilns and to provide steam for the generation of electricity. Their initial success was short-lived. There was a glut of cement in Canada and in 1910 the plant closed. The setback was temporary. The Canada Cement Company, owned by Max Aitken (Lord Beaverbrook), was buying cement companies in eastern Canada. They added the Exshaw plant to their roster and the plant survived as one element in a far-reaching corporation.

The Bow: Living with a River

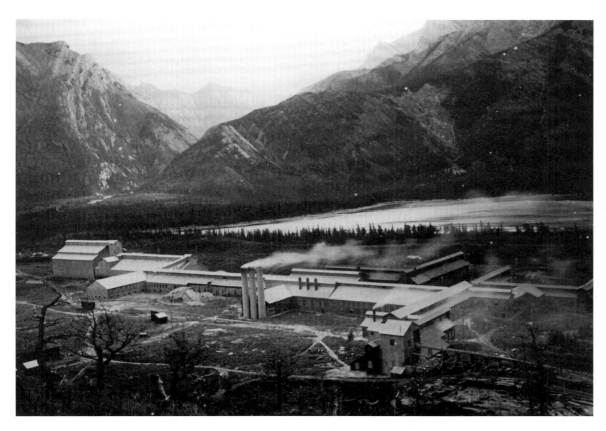

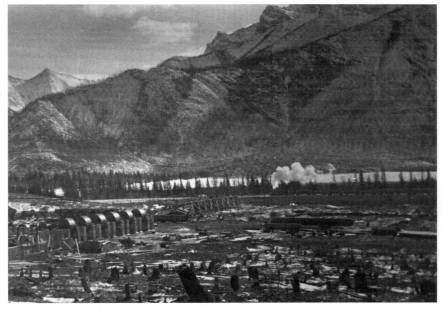

Exshaw town site under construction.

The Foothills

As the Bow River leaves the angular landscape of the mountains, it enters a rounded and dissected topography. This is the ancient edge of the continent where, 400 million years ago, the plates of the earth's crust collided, creating mountains. Wind, water, and ice have subsequently eroded and incised the land surface.

The river carves a very different kind of valley

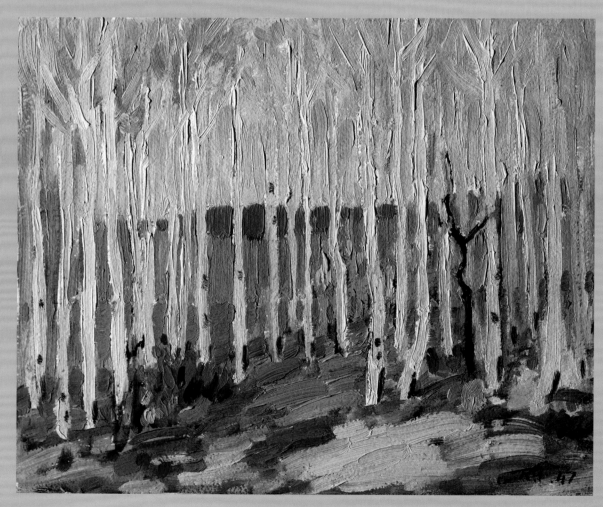

Roland Gissing (1895–1967)
Bank of Ghost Lake at Artist's Home, 1947
This sketch owes much to the iconic Canadian painter, Tom Thomson. Here, Gissing freely borrows the motif of a thick screen of trees through which the distant landscape is revealed. The heavy growth of trees along the banks of the river easily lends itself to this pictorial strategy.

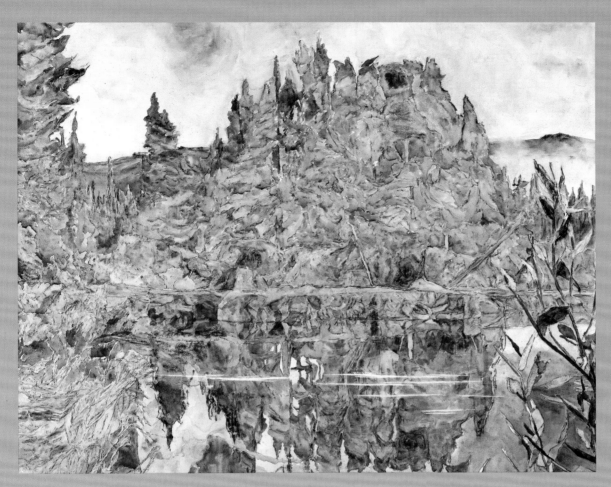

The Bow River came to occupy a special place for Dorothy Knowles in the late 1980s and early 1990s when her daughter Catherine (also a painter) took up residence in Calgary. During family visits, Knowles camped in Bow Valley Provincial Park west of Calgary, where this painting was based. It is a unique interpretation of the spectacular reflections on the river, possible only when the water is nearly still. With no hint of the surrounding mountains, Knowles has celebrated some often overlooked aspects of the Bow, such as its rich riverbank vegetation. The large scale of her canvases physically embraces us in this close-up view of brush, stubble, and low-lying plants. Her complex, expressive brushwork enables us to appreciate the land's variegated textures.

outside of the mountains. It swells as important tributaries, such as the Kananaskis, Spray, and Cascade rivers, add large volumes of water. The river's course becomes more sinuous, flowing through glacially deposited gravels and channeling around localized pockets of resistant bedrock. Its broad valley with shallow banks develops a narrower path with steeper and higher sides.

This is the foothills region of southwestern Alberta.

Lars Jonson Haukaness
(1862–1929)
Bow Valley at Morley, n.d.
Lars Haukaness discovered the Rockies in 1926 and frequented the Ptarmigan Valley near Lake Louise. He does not appear to have painted many images of the Bow Valley, but this atypical view of the Morley area shows Haukaness' sensitive approach to the land's colour and texture and the rolling rhythm of the foothills.

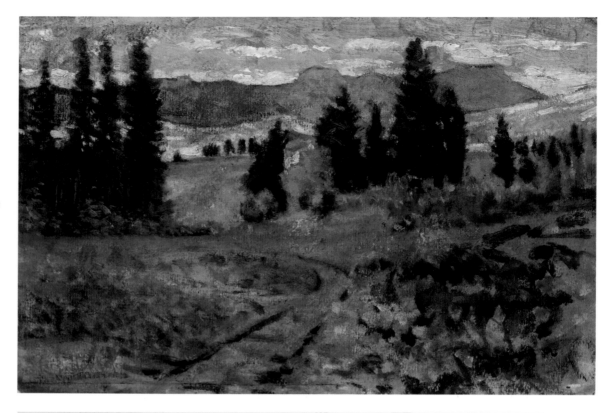

Anonymous
Camp and Village of the Stoney Indians on the Bow River, Morleyville, 1875 (printed 1882)
During the nineteenth century, many artists joined exploration parties in the service of the British government to document the Canadian land. Their original artwork was often transferred to engravings for reproduction in popular journals like the *London Illustrated News* and the *Canadian Illustrated News*. The pictures provided readers with information about the prospects of settlement in new lands, but often, the identities of these artists who created them remain unknown.

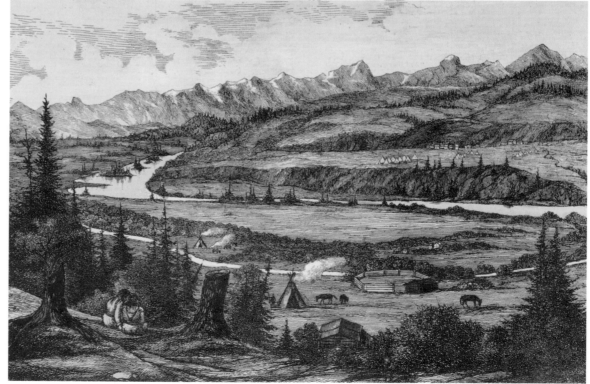

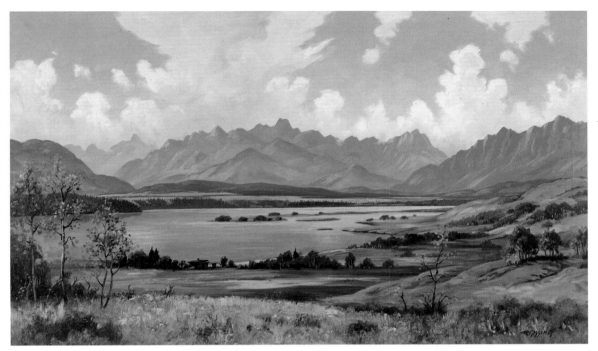

Roland Gissing (1895–1967)
Ghost Lake, 1956
Roland Gissing's first years at the Ghost River were during the winter of 1924–25, which he spent with his brother doing odd jobs. The Ghost was Gissing's home from 1935 until 1944, when a violent fire destroyed virtually everything he owned. A very successful painter during his day, Gissing was especially fond of the rich array of colours characteristic of the fall season. He was one of the few artists to depict the Ghost area, and this painting gives us a panoramic view of this reservoir, created by the Ghost Dam.

Richard Barrington Nevitt (1850–1928)
Below Falls, Bow River, 1876
As part of his responsibilities as a North-West Mounted Police officer stationed in Fort Macleod between 1874–1875, Nevitt supervised neighbouring Mounted Police posts, which took him to other parts of the region. Residing there, writing passionate letters to his fiancé at home, he learned much about the area and its First Peoples. While most of his work is concentrated on Fort Macleod, his travels allowed him to make a few stops along the Bow River.

James Nicoll (1892–1986)
Farm on the Bow, 1939
Nicoll's *Farm on the Bow* draws our attention to the high contrasts of light and shadow that so readily define the foothills. In the foreground he shows us the lush river vegetation contrasted in the background by the arid, rolling foothills. With its triangular bales of hay strewn across the field at the left, it also celebrates agricultural activities along the Bow River.

A Land of Many Cultures

For thousands of years the foothills region was an area of contact, and sometimes conflict, among Native peoples. The Piikani are Blackfoot-speaking people whose traditional territory extended along the foothills from the North Saskatchewan River, south to the Yellowstone River in Montana. The Tsuu T'ina are Dene who travelled from a northern homeland, possibly in central Yukon or Alaska. Once in the south, they adopted some traditions and the lifestyle of the Piikani, with whom they often camped. The Nakoda share a language with the Lakota and Dakota of the eastern plains. They have a long tradition of living in the foothills.

All of these people relied on the bison. The foothills were important wintering grounds for the bison that provided food, shelter, and many other items necessary for human life. The dis-sected topography provided shelter from storms and the chinooks scoured the ground of snow, exposing grass and other plants for winter food. The Bow River and its tributaries were vital watering places in a dry land.

This landscape also supported many other important resources. Deer, elk, and moose abounded. Beaver and other fur-bearing animals lived throughout the foothills. The diversity of plants added to the region's importance. Lodgepole pine, with its extremely straight though relatively small-diameter trunk, was

James Nicoll (1892–1986)
Working drawing for oil painting "Farm on the Bow," c. 1939

Nicoll's two drawings for *Farm on the Bow* provide insight into his working process. The simpler of the two is obviously his initial sketch. On it he noted the types of trees and shrubbery to be depicted—buffalo willow, poplar, and black birch. The subsequent image shows us his process of enlargement to the oil painting, including a superimposed grid that allowed him to transfer the image square by square. Here, the artist's colour notes are much more specific as he records detailed instructions for the large painting.

sought for tipi poles. People often made special trips to the foothills to cut these poles.

The first Europeans to visit the area were interested in acquiring fur by trading with the Native peoples. While fur-bearing animals were abundant, the Piikani and other Blackfoot people to the east harassed the traders and made it difficult for them to establish trading posts. One post was built at a crossing place of the Bow River. However, Bowfort, as it was known, was short-lived.

Many of the missionaries who followed the traders only visited for brief periods of time. The McDougalls, however, chose this as a place for a more permanent settlement. Their establishment of a church and mission at Morelyville was an attempt to persuade the Nakoda to adopt a settled way of life and become farmers and ranchers.

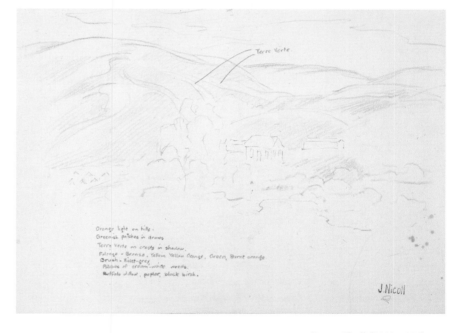

James Nicoll (1892–1986)
Working drawing for oil painting "Farm on the Bow," c. 1939

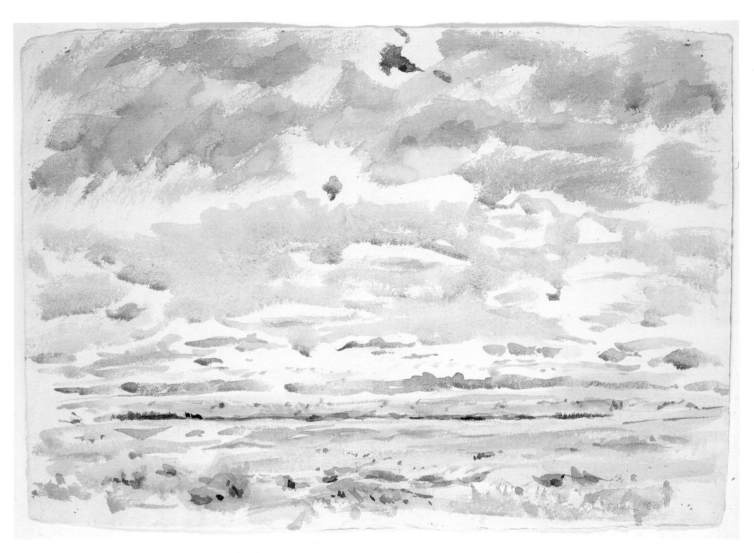

Ken Christopher (b. 1942)
Bow River Valley,
1980s
Ken Christopher holds a special place for the prairie landscape in his painting practice. In this view of the Bow River valley, west of Calgary, his non-descriptive, expressive, and seemingly spontaneous application of paint effectively conveys a sense of the spaciousness and panoramic qualities of the Bow Valley foothills. During his long residence in Calgary, the Bow Valley figured prominently in his work from 1972 to 1997.

The Bow: Living with a River

The Growth of Ranching

Cattle ranching began in southern Alberta soon after the arrival of the North-West Mounted Police in 1874. It was a perfect fit for an area that was too dry for cereal agriculture. Many of these early ranchers were former policeman who had served out their contracts and chose to remain in the West.

Ranching began to change in the late 1870s as eastern businessmen became interested in the West. The completion of the transcontinental railway made it easier to ship cattle to market. These markets expanded when a British embargo on American beef increased the demand for Canadian beef. As well, treaties made with Native peoples required the government to provide supplies in times of hardship. With the disappearance of the bison, the government urgently needed large amounts of meat to distribute as rations. When the Dominion Lands Act was amended, the businessmen became eligible to lease large blocks of land for long periods of time without actually settling on the land.

From the start, the large ranchers were in conflict with smaller ranchers and homesteaders. At issue was the right of access to water. Homesteaders invariably chose land that abutted rivers and streams. However, their fences excluded cattle from the water. Water reserves, which ensured cattle access to the streams, prevented settlement on or near the watercourse.

The cattle boom was over by 1900. Over 12,000 newcomers streamed into Calgary in 1901–02 and nearly 1,500 homesteads were established in the area.

An amended federal government land policy now favoured homesteaders over the large ranches. The very severe winter of 1906–07 led to a further change in the ranching pattern. Cattle that could find shelter in the foothills had a much better survival rate than herds on the plains to the east. The corporate owners from eastern Canada and Great Britain who had expanded their holdings now withdrew onto smaller ranches. These too were eventually sold to local people.

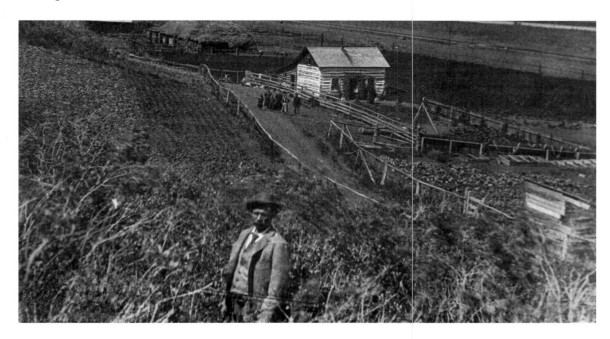

Many of the ranches along the Bow River were small and owned by one or two men. Thomas Edworthy, shown here in the 1890s, located his ranch between the CPR tracks (in the background) and the river. This is now part of Edworthy Park in west Calgary.

As the ranching industry grew, cowboys became a common sight along the Bow River. These hired hands were not ranch owners but worked for larger operations.

The Bow: Living with a River

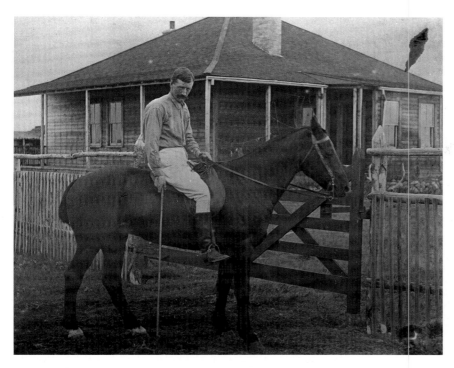

Arthur Rawlison, like many of Alberta's ranchers, had roots in Britain. Social customs, such as playing polo, brought a sense of civilization to the West. The matches were also an opportunity to exhibit one's horses and to demonstrate equestrian skills.

Access to water for livestock, crops, and domestic use was critical. Alfred Welsh, who ranched near Millarville, southwest of Calgary, hauled water to the first trees near his house.

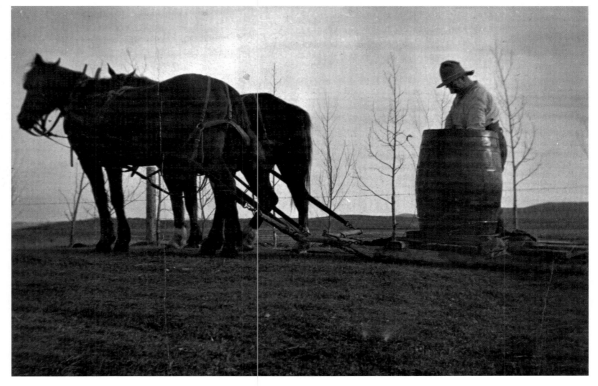

Sheep, as well as cattle, grazed the fields along the Bow River. There was often animosity between the sheep ranchers and the cattlemen, who believed that sheep destroyed the range by cropping the grass too close to the ground. Pat Burns, who owned both a cattle ranch on Fish Creek and a meat-packing plant, kept sheep west of Calgary.

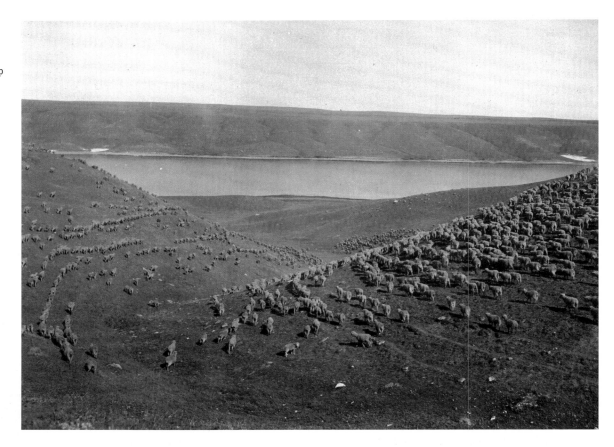

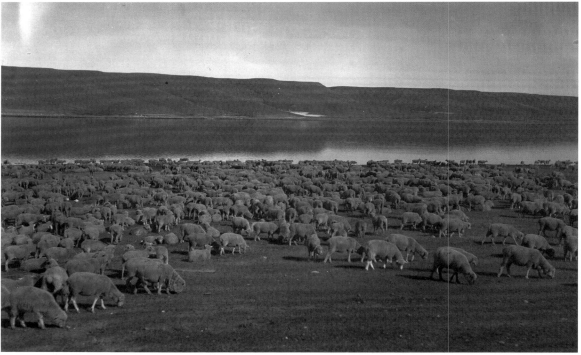

The Bow: Living with a River

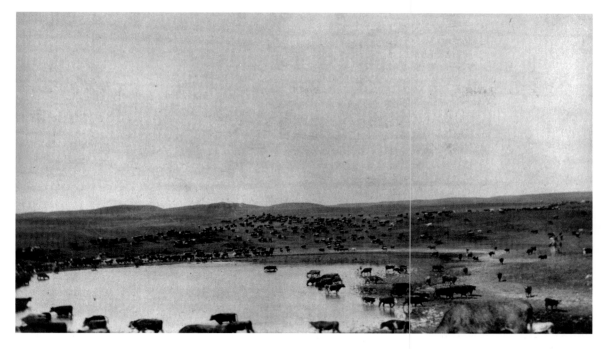

The cattle industry changed greatly in the 1890s, and by 1900 the golden age of the Canadian cowboy was almost over. The last roundup of the big herds took place at Cochrane Lake, west of Calgary, in 1908.

Today's Ranchers

Successful ranchers must manage more than their cattle. They must be stewards of an environment that provides food and water for the animals. There is a growing awareness that the ecology of the watersheds must be actively protected if they are to remain healthy and capable of supporting a variety of plants and animals.

The Jumping Pound Creek meets the Bow River just west of the city of Cochrane. At one time it flowed exclusively on land owned or leased by the Cochrane Ranche Company. Today, it is the source of water for numerous smaller ranches. Three of these, the Quarter Circle X, the Wineglass, and the Lazy J, are working together to ensure a healthy riparian environment and the longevity of the stream's ecology.

When the bison dominated the plains and foothills, they grazed the pastures bald, trampling streambeds and muddying the water. But after wreaking havoc, they moved on, and the grass and watercourse then had time to recover.

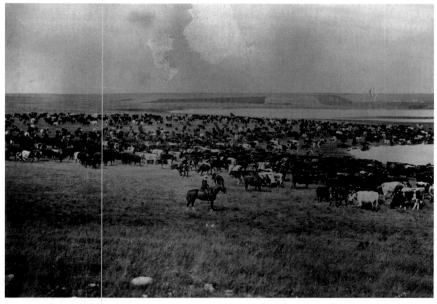

Cattle have a very different impact. Fences keep them from wandering and focus their use of the streams. This concentration is unhealthy. Frequent visits to the same place on a watercourse wears away the ground cover on the banks and, in turn, leads to increased erosion and siltation. The water becomes less hospitable to fish

fence, also powered by solar cells, is erected adjacent to the stream. This prohibits the animals from trampling the fragile banks. As a result, the creek bank is covered with a thick grassy mat and poplar trees have once more begun to grow along the stream.

Urban Encroachment

The growing urban sprawl of Calgary and Cochrane pose a special threat to these efforts of environmental stewardship. As land is removed from agricultural use, there has been a tendency to ignore natural drainages and habitats. Too often, riparian areas have been filled in and paved. Owners of the acreages may keep several horses that quickly overgraze their tiny pastures and require water that must be brought in. Coyotes and deer find friendly habitats in these urban neighbourhoods, where hunting is not allowed. Some of the more recent housing developments have been required to plan for conservation easements along the creek. This means that houses and roads must make allowances for the natural environment.

With the houses come people. As the city moves closer, the ranchers' pastures become desirable recreational destinations. While intruders can be kept out of the fields, the creek beds are the property of the Crown and no one can be denied access. Recreational snowmobile users, cross-country skiers, and snowshoers all use the creek bed. Unfortunately, they are not always careful about maintaining the integrity of the banks and may cause more damage than the cattle.

A solar panel-powered pump draws water from the creek to a water trough.

and other aquatic animals and may be less useable for the people and stock downstream.

Careful management of riparian areas involves extensive planning cattle are moved among pastures more frequently and care is taken to keep the animals from over-using the stream banks. Using solar power, water is pumped from creeks into troughs where cattle have access without entering the stream. As the cattle are moved among the pastures, a portable electrical

Foothills Gas

Vast reserves of natural gas lie beneath the foothills. After it is pumped from the ground, pipelines carry it to processing plants along the Bow River where products such as butane and propane are extracted. This refinement is done through a distillation process. Water is added to the gas and the mixture is heated to extreme temperatures. Various components of the natural gas are separated from the mixture as it cools. The process is repeated until only unwanted byproducts remain. These are sent to a flaring tower where they are ignited and thereby broken down into smaller chemical compounds.

Water is essential to this process. Shell Canada's Jumping Pound Gas Plant uses 600 cubic metres of water each day. A weir on the creek diverts the water and a pump pulls it into the plant. Riparian impact has been minimized by locating all of the operations well back from the creek's bank. At the end of the gas-extraction process, 400 cubic metres of water are sent into the atmosphere through the flaring (burning) of waste material and 200 cubic metres are returned to the environment by pumping it into Pile-of-Bones Creek.

The water that is to be returned to the creek is collected in settling tanks, along with any rainwater and snow melt that has been drained from the plant site. Algae that bloom in these tanks use the residual chemicals as food and break them into non-toxic substances. In turn, the algae are consumed by water fleas, or "daphnia." The water is circulated through a series of tanks until the combination of algae and daphnia leave the water clear. The process is closely monitored by a plant worker who spends 70 per cent of his time testing and circulating the water.

Hydrocarbon Reservoirs

Petroleum is composed largely of hydrogen and carbon that have been removed from invertebrate shells through intense temperature and pressure. These hydrocarbons occur in the microscopic spaces between grains in sedimentary rocks that act as source beds. When the structure, tilt, or pressure within the source rock changes, the fluids and gas migrate through the rock toward a trap. A cap on the trap keeps the hydrocarbons from moving further and creates a reservoir of oil or gas. Petroleum extraction requires drilling to find these reservoirs and then pumping the product from the ground. As the resources in a reservoir become depleted, oil globules adhere to the surrounding matrix. Fresh water may then be forced down the well at extreme pressure to scour the cavities and force out the remaining oil.

In the Alberta foothills west of Calgary, the Cretaceous Cardium Formation is the major oil- and gas-bearing reservoir. The source of this petroleum is not known, although it may be the Early Mississippian Exshaw Formation.

Calgary

Anonymous
North-West Territories: Fort Brisebois, on Bow River, 1876, This early view of the Bow River shows us Fort Calgary (formerly Fort Brisebois—so named by Inspector Ephraim Brisebois of the North-West Mounted Police) with British flag waving vigorously in the wind. In this image we are located at the junction of the Bow and Elbow rivers, east of present-day downtown Calgary.

They followed the wooded banks of the Elbow River northward toward its confluence with the Bow River. The broad floodplain slopes gently down to the larger river, making it easier for the dogs to pull the travois to the water's edge. Along the stream edges, there was also wood for fuel, and berries and other plants for food, medicine, and tools.

For thousands of years, the Niitsitapi (Siksika, Kainai, and Piikani) and, later, the Tsuu T'ina used this crossing place. Nearby, circles of stones record places where people camped, using rocks to anchor their tipis. Bison were driven over the steeper slopes in large numbers or killed a few at a time in the coulees.

By the 1870s, life had changed dramatically for the Niitsitapi. Traders from the United States had come north to exchange rotgut whisky for bison hides. Before long, violence erupted on the Canadian plains.

When the North-West Mounted Police (NWMP) arrived in 1874, most of the whisky traders retreated to Montana. Over the next few years, the NWMP built a series of outposts to discourage those traders who continued to make forays into the "British Territories." One of these, Fort Calgary, was located at the confluence of the Elbow and Bow rivers. Traders soon established themselves near the post and ferrymen found a lucrative business conveying people and property across the river.

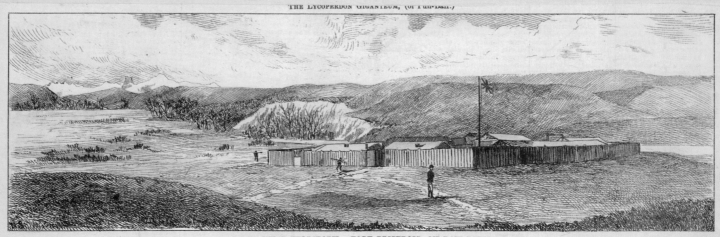

NORTH-WEST TERRITORY:—FORT BRISEBOIS, ON BOW RIVER.

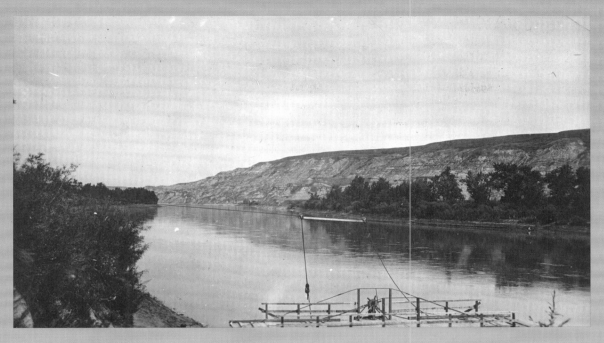

Wagons, pulled by long trains of oxen, transported goods northward from Fort Benton, Montana. These heavy vehicles sank to their axles in the soft bed of the Bow River. Ferries operated near Fort Calgary to carry the freight across the water.

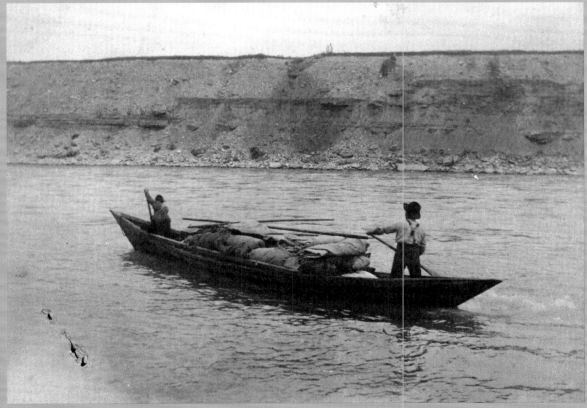

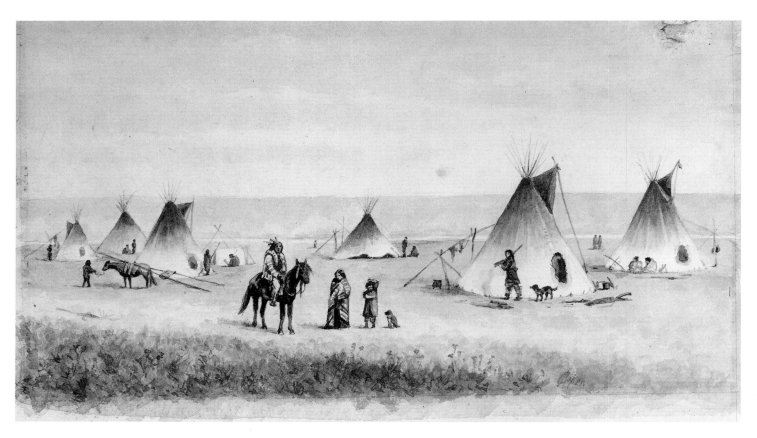

Edward Roper (1857–1891)
A Band of Blackfoot Indians Camped on the Bow River near Calgary, c. 1887
A painter, illustrator, and keen naturalist, Roper travelled to the Rockies in 1887 for about a six-month trip, during which he focused on painting landscapes of the mountains, including the flora and fauna. A well-known illustrator during his day, he may have intended this image for publication. It is notable for the fact that the tipis are represented as consistently facing east. The Bow River reaches across the background.

A Growing Settlement

Tradesmen, merchants, and land speculators flooded into Calgary after the 1881 announcement by the Canadian Pacific Railway (CPR) that its tracks would follow the Bow River into the mountains. While they awaited the "arrival of steel," these newcomers camped in a shanty town of tents in the vicinity of the NWMP fort. Some even bought parcels of land east of the Elbow River, where they anticipated the railway would build its station. As there were no traffic bridges across either the Bow or the Elbow rivers, proximity to the train station would be a definite business advantage.

The train arrived in 1883, and a year later the CPR built its station on the west side of the Elbow. Most of the population shifted across the river, occupying a confined space between the tracks and the Bow River. Calgary's downtown continues to be shaped by the configuration of the river and the railway tracks.

Prosperity arrived with the train, and the canvas shelters were soon replaced with wooden structures. Unfortunately, there were very few trees in Calgary in 1884. As the scattered copses disappeared and the demand grew for houses, offices, and warehouses, some men looked west and calculated the feasibility of floating logs down the Bow River from the mountains to sawmills operating within the town. One of the most successful lumber mill operations was the Eau Claire and Bow River Lumber Company.

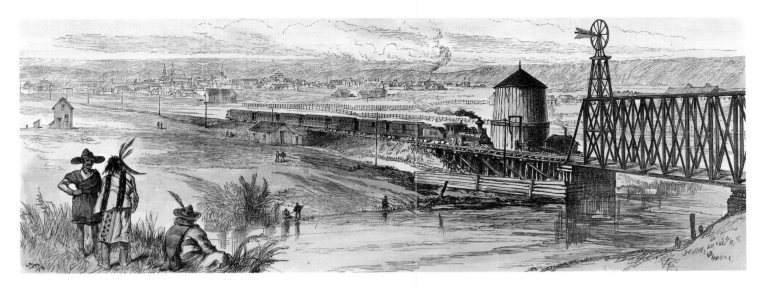

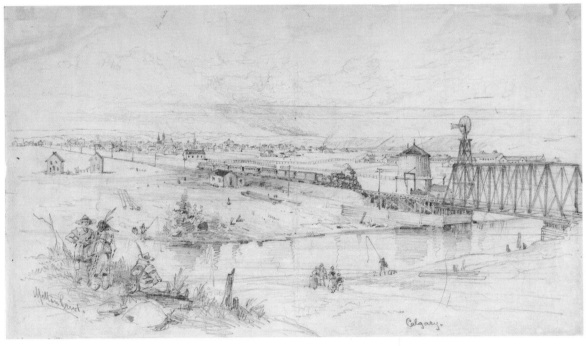

Melton Prior (1845–1910)
Calgary at the Foot of the Rocky Mountains, 1887
Based on Melton Prior's original drawing, this engraving was developed for inclusion in the *Canadian Illustrated News* in its November 10, 1888, issue. The reproduction of artists' drawings in popular media like this one encouraged settlement and immigration in the West and promoted the notion of an ever-expanding civilization. Note the engraver's slight changes throughout, which include giving the train a different number than the one Prior had originally assigned it.

Melton Prior (1845–1910)
View of Calgary, 1887
Information on Prior's travels to western Canada is scant, but it seems the CPR engaged him as "special artist" in 1887–88, when he probably made this drawing. The location represents the Elbow River in Inglewood near the 9th Avenue Trestle Bridge. The Bow River is in the background, and we are looking to the west. Among the signs of rapid change the city was facing is the inclusion of the CPR train, carefully noted by the artist as engine number 378, and the windmill that feeds the water tower. The source of the smoke is probably the Eau Claire and Bow River Lumber Company, built in 1886. Also included are the North-West Mounted Police barracks.

The decision by the CPR to follow the Bow River west, toward the mountains, determined the fate of Calgary. Almost overnight, the town changed from an NWMP outpost to a place of commerce.

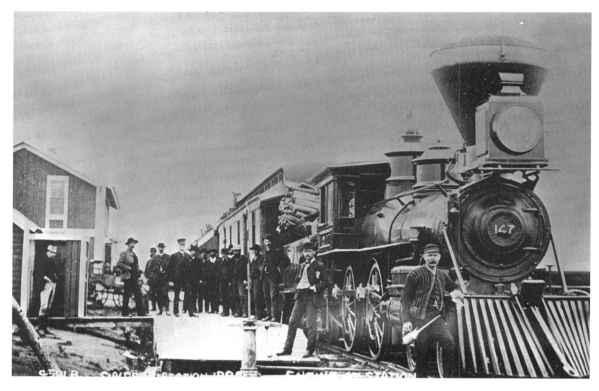

The trade in bison hides was rapidly declining by the time the train reached Calgary. This 1888 photograph of ox carts laden with $75,000 worth of furs and hides depicts one of the last large shipments. Within a few years, the bison had almost disappeared from the plains.

The venture was started by I.W. Kerr, a sawmill owner from Eau Claire, Wisconsin. After negotiating a timber lease with the federal government, he turned over the planning of the operation to his associate, Peter Prince. Prince dismantled a Wisconsin sawmill and shipped it by rail to Calgary, where it was reassembled on the south bank of the Bow River. He then had a channel dredged along the riverbank to hold the logs before they were brought into the mill. The island he created became known as Prince's Island and remains a focus of activity in downtown Calgary.

The Bow: Living with a River

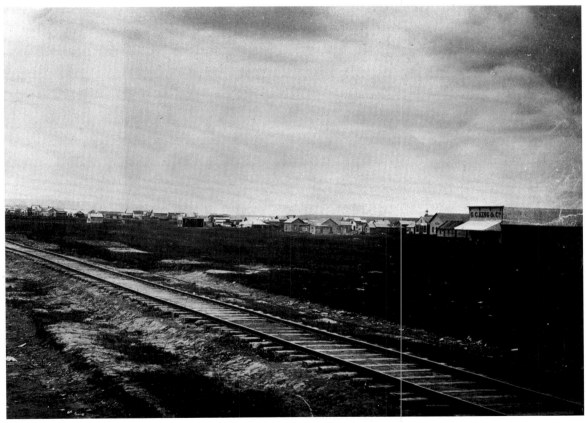

Proximity to the CPR was an important advantage for businesses. Once the railway built its station west of the Elbow River, the new town of Calgary spread between the tracks and the Bow River.

Richard Moore (date
unknown)
Logging on the Bow,
[*The Drive*], n.d.
This charming etching once
served as a Christmas
greeting card. With its soft
and gentle lighting and
pastoral subject, it evokes a
more European setting than
the harsher conditions of
Southern Alberta's climate.

Joseph Abraham Taylor
(b. 1904)
Eau Claire Spillway, 1933
The little-known artist
J.A. Taylor's painting of the
Eau Claire spillway depicts
the log chute between
mainland and island where
logs were forced into
processing.

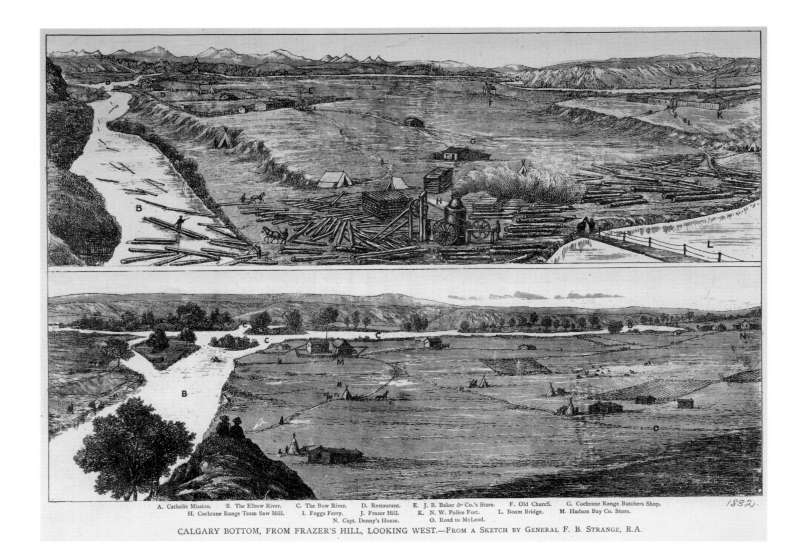

A. Catholic Mission. B. The Elbow River. C. The Bow River. D. Restaurant. E. J. B. Baker & Co.'s Store. F. Old Church. G. Cochrane Range Butchers Shop.
H. Cochrane Range Team Saw Mill. I. Foggs Ferry. J. Frazer Hill. K. N. W. Police Fort. L. Boom Bridge. M. Hudson Bay Co. Store.
N. Capt. Denny's House. O. Road to McLeod.

CALGARY BOTTOM, FROM FRAZER'S HILL, LOOKING WEST.—FROM A SKETCH BY GENERAL F. B. STRANGE, R.A.

Thomas Strange (1831–1925)
Calgary Bottom from Frazier's Hill, 1882
The military artist and soldier Thomas Strange prepared several images for transfer to popular engraving. This "two scenes in one" composition provides details of the area around the Elbow and Bow River junction, with Fort Calgary in the upper right (top image). Also visible in the centre is a small footbridge that is thought to have been Calgary's first bridge. The James Walker Sawmill, located on the east side of the Elbow prior to the building of the railway, provides an obvious reference to the logging industry, which sent logs downstream from the Kananaskis and Spray rivers to this Calgary mill.

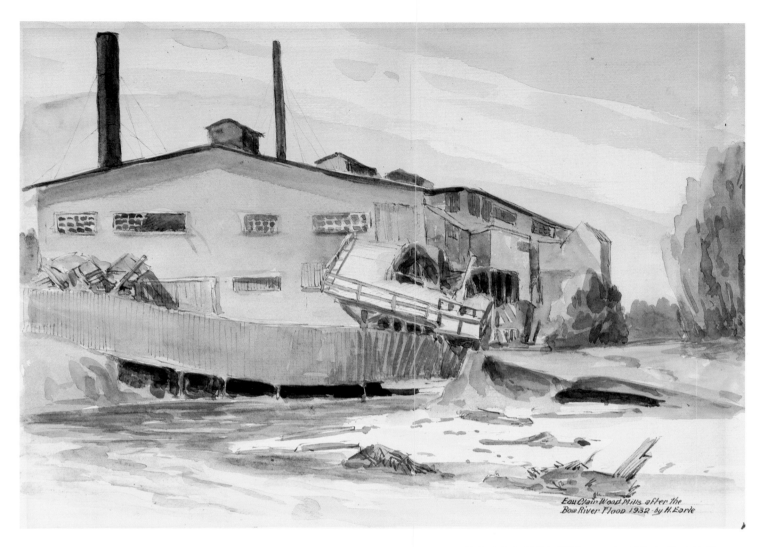

Eau Claire Wood Mills after the
Bow River Flood 1932 by H. Earle

Herbert Earle (1884–1975)
Eau Claire Woodmills, after the Bow River Flood, 1932
The image shows the destruction resulting from the 1932 flood on the Bow River. As can be seen here, much damage was done to the buildings. Prince's Island is visible to the left. The channel on the right would have been dredged out to allow logs to float down it for processing. This sawmill—constructed in 1886—was operated by the Eau Claire and Bow River Lumber Company.

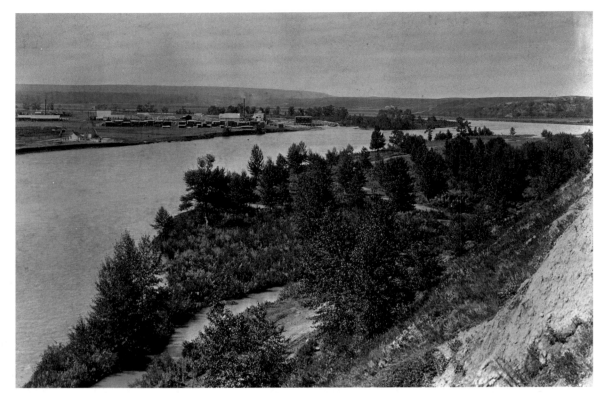

The Eau Claire and Bow River Lumber Company sawmill was built on the south bank of the Bow River, at the western edge of the business area. Peter Prince had arranged to dismantle a mill in Wisconsin and ship it by rail to Calgary.

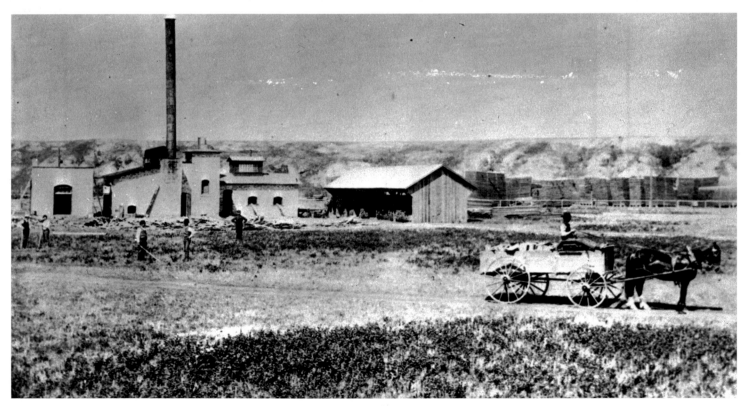

The Bow: Living with a River

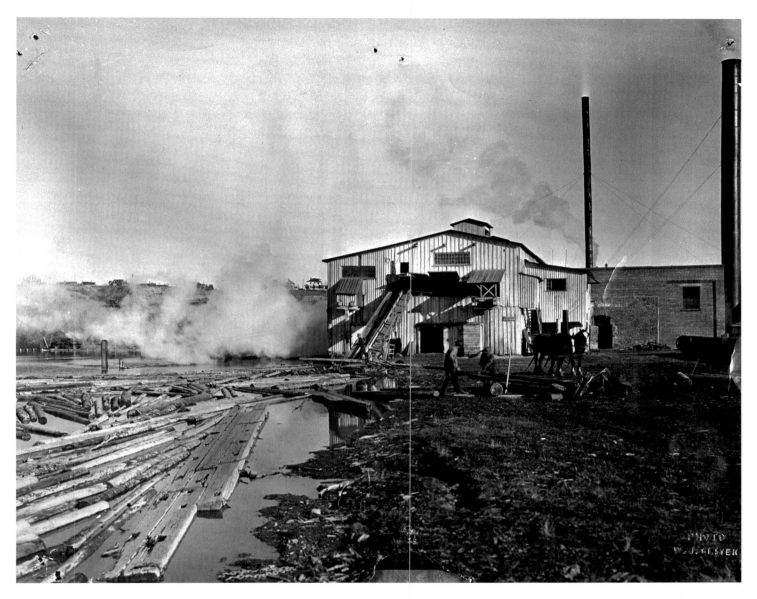

Logs were floated
downstream from the
mountains to Calgary. Prince,
the mill manager, ordered a
"log channel" dug next to
the mill. This created
"Prince's Island," which
continues to be a feature of
downtown Calgary.

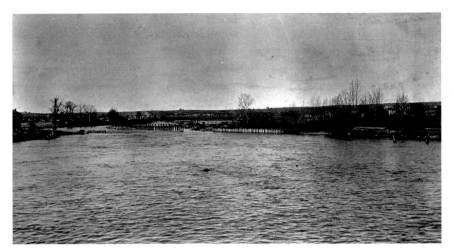

The Calgary Water Power Company engineered the river to ensure that enough water would flow at a great enough rate to create power in their new plant. A flume, built upstream of Prince's Island, funnelled water toward the log channel.

Electrifying Calgary

The Eau Claire and Bow River Lumber Company had very little competition in its early years of operation and, as it prospered, the company became involved in other enterprises. The saws and planes were powered by steam-generated electricity fuelled by the waste from the mill. Prince realized that, if the generators ran twenty-four hours a day, electricity could be sold to Calgarians at night, when the mill was shut down. Demand soon exceeded supply. By 1893, he had formed the Calgary Water Power Company and built a water-generated powerhouse at the downstream end of the log channel to increase the generating capacity. Substantial alterations to the riverbed were needed to create a current strong enough to generate the electricity required by the growing city. The north bank of the channel was reinforced westward for almost a mile. In addition, an L-shaped weir was built in the Bow, upstream of today's Louise Bridge.

The Bow River did not cooperate. In October 1893, as the weir was being built, an ice jam upstream broke. A wall of water and ice surged downstream, snapping the 10.5-metre timbers

The Calgary Water Power Company built a generating plant at the downstream end of Eau Claire mill's log channel. The power it produced operated the mill and was also sold to Calgarians.

The Bow: Living with a River

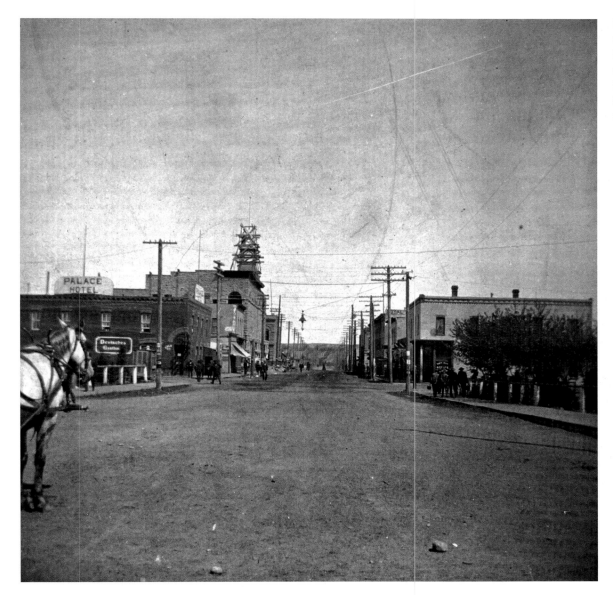

Calgary was one of the first settlements in western Canada to make extensive use of hydroelectricity. By 1903, power lines had become a prominent feature of the city's skyline.

that were being put into place. When the plant was finally in operation, fluctuating water levels made the production of electricity unpredictable. Low flow rates often left customers angry as their electric lights grew more and more dim.

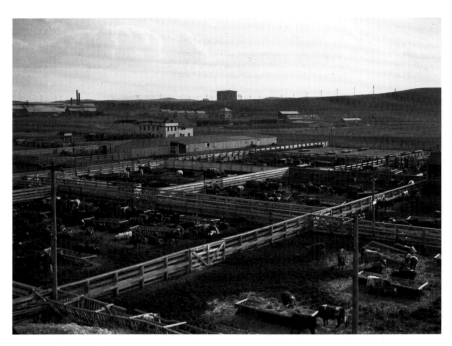

A Growing City

Calgary continued its phenomenal growth throughout the early years of the twentieth century. By 1910, a quarter of the population worked in construction and over 800 men were employed at nine industrial plants located east of the Elbow River. These sites included a brewery, a stockyard and meat-packing plant, a cooperage, and the CPR repair shops. The Bow River was both a source of raw material and the recipient of waste material.

Between 1901 and 1911, Calgary's population jumped from about 4,000 to nearly 44,000. The people needed houses with a steady, reliable supply of potable water. Although the first water mains were laid in 1899, the waterworks were

Colonel James Walker persuaded Calgary council to reserve land east of the city for a stockyard. Soon after, Pat Burns built a meat-packing plant and feed lot. Water was crucial to supply the animals awaiting slaughter and to clean the abattoir.

By 1906, the area north of the railway tracks and east of the Elbow River had become the focus of industrial development. Calgary Brewing and Malting Company (left), Wilson Milling Limited (centre), and Alberta Iron Works (right) all used the Bow River as a source of water and as a place to dump their refuse.

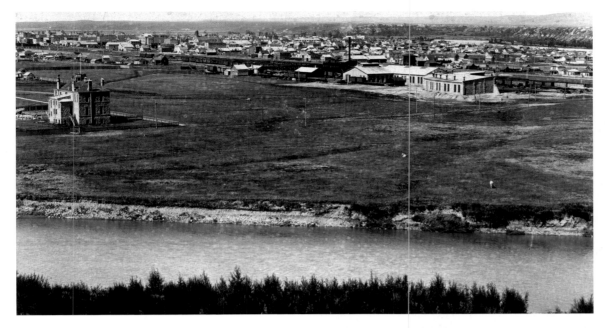

CPR's decision to locate its divisional shops in Calgary was a great boost to the economy. The operation on the right covered 2.5 hectares and employed 5,000 men. In 1911, when the shops were fully operational, the engines were steam-driven and a consistent supply of water was vital. The Bow, once more, was readily at hand.

steam-driven and the pressure was unreliable. This problem was resolved by the construction of the Glenmore Reservoir and Water Treatment Plant in 1929. That year, construction also began on 434 kilometres of new water mains.

As the city expanded, it became clear that bridges were needed to link the north and south sides of the Bow. The early bridges were private ventures, often financed by landowners hoping to increase the value of their property. The Bow River Bridge Company was a partnership of three men who owned land on both sides of the river. With a fund of $18,000, they built the Centre Street Bridge, believing that their costs would be repaid through tolls and the enhanced value of their land. The bridge opened in 1907, and by 1911 the city had begun operating it for a fee of $500 per year.

During Calgary's early days, the use of steam-powered pumps made water delivery unreliable. This 1890 drawing of a pumping station appeared in *Prairie Illustrated*.

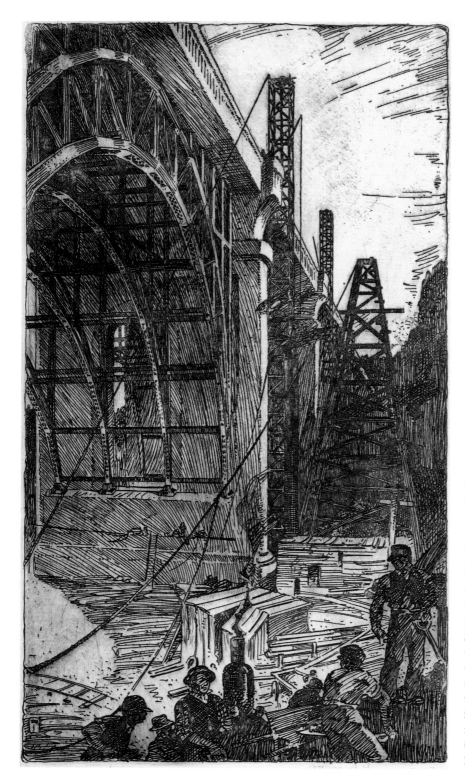

Stanley Turner (1883–1953)
Centre Street Bridge, Calgary,
1917
A resident of Toronto for
most of his career, Turner
also homesteaded near
Yorkton, Saskatchewan, and
worked as a mail clerk and
mural artist for the CPR. He
probably based C*entre Street
Bridge, Calgary* on these
western Canadian
experiences. It is one of
Calgary's oldest bridges, as
well as one of the most
important links between the
north and south sides of
Calgary, as divided by the
Bow River.

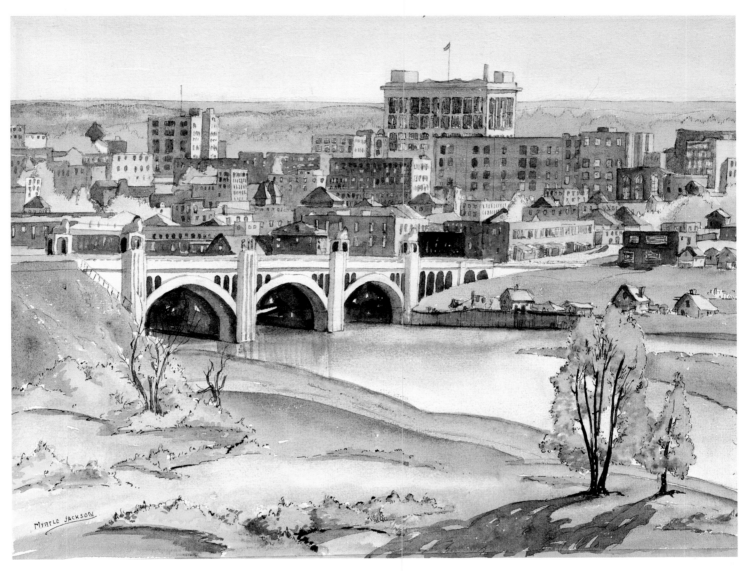

Myrtle Jackson (b. 1920)
Calgary, 1932
This work, by a virtually
unknown artist, shows the
area of the Bow River where
the Centre Street Bridge links
the north and south sides of
Calgary. Probably viewed
from the north hill around
the Crescent Heights and
Hillhurst neighbourhoods,
the scene offers a
Depression-era view of
Calgary and provides many
insights into the city's
architectural history.
Abundant throughout the
buildings to the south are
the sandstone and brick so
popular as construction
materials during the first
quarter of the twentieth
century. At this time, one of
the city's tallest buildings
was the CPR's Palliser Hotel,
seen toward the left side of
the image. Today, most of
these sandstone buildings are
gone. Visible also in this
image are the concrete lions
based on a carved model by
James L. Thomson, based in
turn on Admiral Nelson's
monument in London's
Trafalgar Square.

Margaret Shelton (1915–1984)
Centre Street Bridge, Calgary,
1940
It was probably during Shelton's student years in Calgary that she created *Centre Street Bridge, Calgary.* Her vision of it is unique, thanks to the sharp contrasts of light and dark that she created by setting the dark, brooding sky against the light, reflective concrete. Her rendition of the fast-moving water as it makes its way around the massive bridge pillars also conveys a dynamism not present in other depictions of the Bow River at this location.

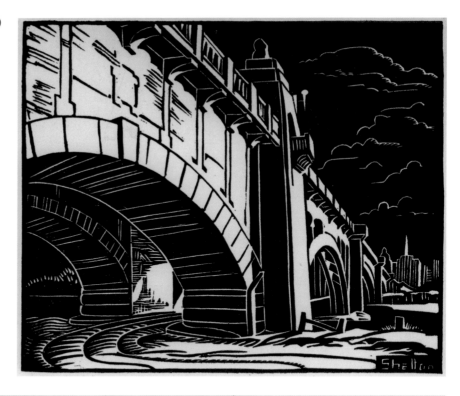

Frederick George Cross (1881–1941)
Untitled (Bow River, Calgary),
1913
Frederick Cross took up painting as a hobby and was largely self-taught. His passion for the Bow River thus embraced two perspectives—that of engineer and painter. As part of his work for the CPR, he would have travelled to and from Calgary and Brooks. This image of the Bow River depicts the irrigation diversion weir toward the east side of Calgary around the historic Inglewood area.

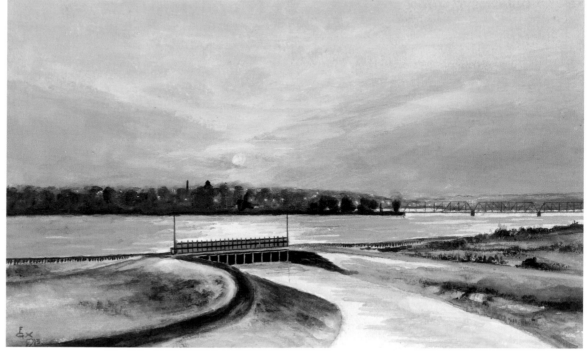

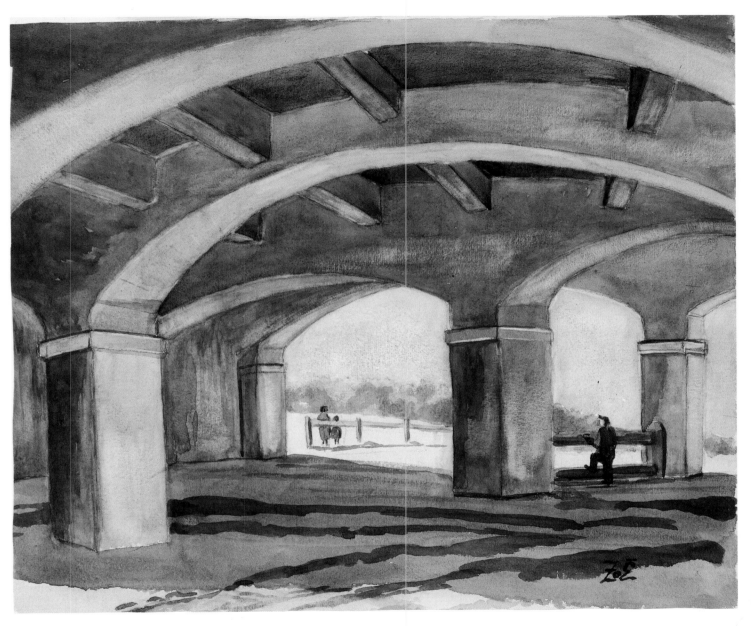

Zoe Dunning (1877–1962)
Underpass, Centre Street Bridge, Calgary, n.d.
Dunning is a little-known artist whose work is scarce in public collections. The underpass on the Centre Street Bridge is now used for traffic flow across the river, but was originally designed as a footpath, which explains its narrowness, often causing problems for today's traffic.

By the early twentieth century, Calgarians were ready to move the city beyond the status of a frontier town. In 1913 the city council commissioned Thomas H. Mawson to develop a comprehensive plan to accommodate future growth. Mawson, an English landscape architect, believed that Calgary should be centred at the island Prince had created in the Bow River, with radiating arteries feeding traffic in a smooth flow around the city. Recognizing the importance of uniting people with their natural environment, his plan also included much green space. Unfortunately, the economic depression of 1914 made his ideas financially impossible to develop. Still, his plans have delighted, amused, and inspired generations.

Thomas H. Mawson, shown above (front row, centre) with his staff in Lancaster, England, proposed an imaginative plan for Calgary. The civic centre focused on Prince's Island. Streets followed a Roman plan, radiating outward from the core.

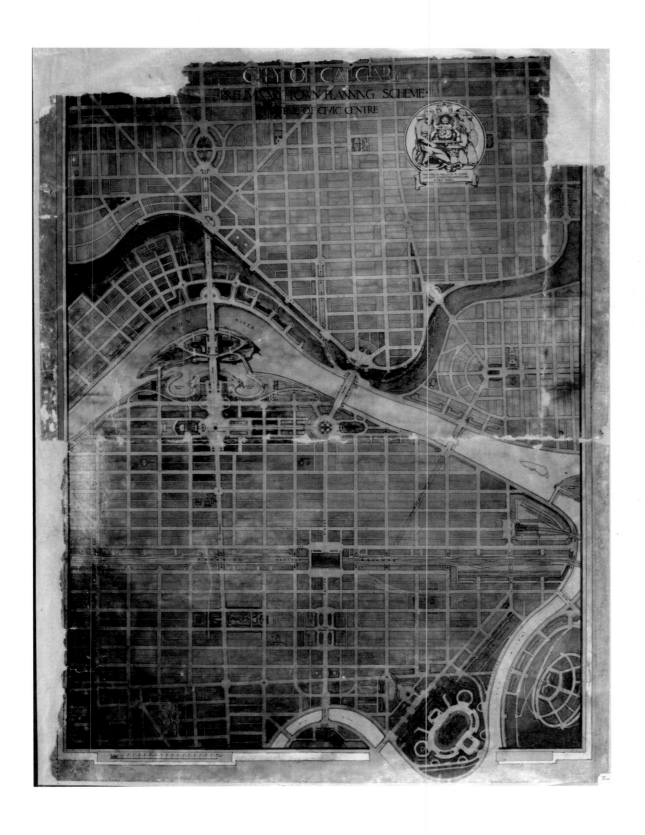

Margaret Shelton (1915–1984)
Louise Bridge, Calgary, 1972
This image represents the bridge at 10th Street southwest in downtown Calgary, which joins the downtown core to the Kensington, Sunnyside, and Hillhurst communities. It remains one of the main city-centre bridges over the Bow River. Having had several different names over the years, it was officially named after Louise, the daughter of Queen Victoria. Constructed in 1921, its architecture echoes the grace of the Centre Street Bridge. Here, Shelton is viewing it from the west side, looking east into the downtown core. Big, curved cumulus clouds at the top of the image are echoed by the shape of the currents in the river below.

(Opposite page)
Reginald Harvey (1888–1973)
Bow River from Spruce Cliff, Calgary, n.d.
Reginald Harvey made the city of Calgary a focal point in the mid- to late 1920s while developing an exhibition primarily comprised of city views. Although undated, this work may well relate to that project. The artist has seated himself on the south side of the Bow River looking north across it from the Spruce Cliff neighbourhood, which is just west of today's downtown Calgary.

Calgary and the Bow River Today

As the population of Calgary approaches one million, the health of the Bow River is one of the crucial issues for the city. The availability of sufficient, clean water is a concern, as is the need to ensure that downstream users have enough water to meet their needs. The water being returned must be treated to remove dangerous materials that might negatively impact the river's ecology. The Bow has also become an important recreational and inspirational resource for the city.

Each day, Calgarians use enough water to fill the Saddledome. This rate doubles, and even triples, during the summer. The water is drawn from the Elbow River at the Glenmore treatment plant and from the Bow River at the Bearspaw treatment plant. At each location the sediment is filtered out and chlorine added to kill micro-organisms and viruses. The purified water is pumped through over 4,000 kilometres of pipes to houses and businesses throughout the city.

R. L. Harvey

Coping with the Bow River

Calgary has always had an uneasy relationship with its river. People have siphoned the water for domestic and industrial use, returning the waste water along with various contaminants. They have dredged the riverbed and wrapped the banks with concrete to enhance its utility for factories. They have changed the current as bridges spanned the river to carry citizens from one bank to the other.

The Bow has not always cooperated with these changes. As the ice breaks up in the upstream reaches of the river, ice dams hold back the water, lowering the flow and creating water shortages downstream. When the dam collapses, a wall of water and ice surges downstream with tremendous force, flooding low-lying areas and washing structures away.

The Bearspaw Dam was built to control the amount of ice and slush flowing into Calgary. Its reservoir is probably not large enough to hold back a significant flood.

The Bearspaw Dam was built in 1954 to control these unpredictable floods. The dam also holds back the slush (semi-frozen ice) that used to flow downstream, gradually damming the river as it aggregate along bridge footings and saturated the banks and neighbouring developments.

Seepage is one aspect of the river that has not been remedied. The glacially deposited gravel that prevails in the Calgary region is an excellent flow channel for water. Buildings constructed near the river often have pumps in their basements to keep the water from rising

The flood of 1897 stranded Calgary residents who had built homes and businesses near the Bow River. Rising water has been a continual problem throughout the city's history.

James Nicoll (1892–1986)
Backyard, Bowness, 1958
Modest homes and buildings
fascinated Nicoll. This is an
honest and frank portrait of
a local backyard, cluttered
with leftover junk, bottles,
cans, and an old stove,
among other detritus.
Portrayed through a rich
palette of colours, the scene
reflects the many domestic
chores, routine maintenance,
and cleanups that we rarely
have enough time to keep up
with in our busy lives.

Once the water has been used, it returns through the sanitary sewer system to the Bonnybrook and Fish Creek waste water treatment plants. There, it is held in tanks where large particles are removed by settling or skimming. The water then circulates through bioreactors, where microbes break down dissolved nutrients such as phosphorous and ammonia, and then to secondary clarifiers, where the microbes settle to the bottom and are recycled. Next, the treated waste water is sent to enclosed tanks, and ultraviolet light sterilizes any microbes that are still present, ensuring that they do not reproduce and infect downstream consumers.

The sediment and sludge from the settling and skimming process is held in enclosed tanks where anaerobic (oxygen-less) decomposition breaks them down into biosolids and gas. The gas fuels the production of heat and electricity at the plants, and the biosolids are pumped to lagoons for further settling. Eventually, these are transported to farms for use as fertilizer.

The river also serves our spiritual needs. A citizen-based movement began in the 1970s to revitalize the valley, transforming it from a site of industrial development to a space for recreation and reflection. Local communities took responsibility for rehabilitating various sections of the riverscape. There are now over 700 kilometres of pathways, stretching along both banks

from the western edge of the city to Chestermere Lake. The river valley has truly become a place of physical and emotional rejuvenation.

Stewardship of the river is an important civic priority. Over 90 per cent of the water that is taken from the river is returned, although evaporation lowers this rate during the summer. The use of domestic water meters and a proactive program that encourages the use of water-efficient toilets, showers, and lawn sprinkler systems have all led to a reduction in water consumption. The city's water treatment system has garnered international recognition for its effectiveness. While Calgary has a major impact on the river, its citizens strive to ensure that there will be clear water for the future.

(Opposite page) James Dichmont (1877–1957)
Bowness Park, n.d.
Little is known about James Dichmont, but he is thought to have worked mainly in the watercolour medium and exhibited with the Canadian Society of Painters in Water Colour in 1934. Alongside Jim and Marion Nicoll, he is among only a handful of artists to have shown an interest in the Bowness neighbourhood in west Calgary. This almost pastoral view reveals an unusually sheltered part of the river, where it is surrounded by trees and there seems to be no wind.

(Above) E.J. Hughes (b. 1913)
Calgary, Alberta, 1957
In the fall of 1956, Hughes made a trip across Canada that had been encouraged by his Montreal dealer, Max Stern. *Calgary, Alberta* is rich in colour, with its splendid showing of yellow autumn foliage from the poplars, contrasted in the background areas with red-brick cladding and variously coloured rooftops. The scene looks across the Bow River, including the Centre Street Bridge in the middle ground. Probably on the far left is the CPR's Palliser Hotel. Hughes' masterful use of watercolour paint shows his meticulous control over this most fluid and unpredictable medium. Forms are clearly defined, creating a scene that seems completely frozen in time. He views the city from the north hill, which offers a somewhat more panoramic and bird's-eye perspective than other "bridge" images.

The Bow River Downstream

Marquis of Lorne (1845–1914)
Blackfeet Indians Camp on the Bow River, 1881
This image was based on the Marquis of Lorne's 1881 trip west. It depicts Blackfoot Crossing, and appeared in the December 10, 1881 issue of the *London Illustrated News*. This historic site on the Bow River east of Calgary shows an encampment of the Siksika on the north side of the river. His Excellency's campsite was on the south bank "where a so-called Council of the tribe was held for conference with the Governor-General." At these occasions there were government distributions of rations, which attracted large numbers of people. The voyeuristic gaze of the government officials standing on top of the hill was not an uncommon attitude for this era.

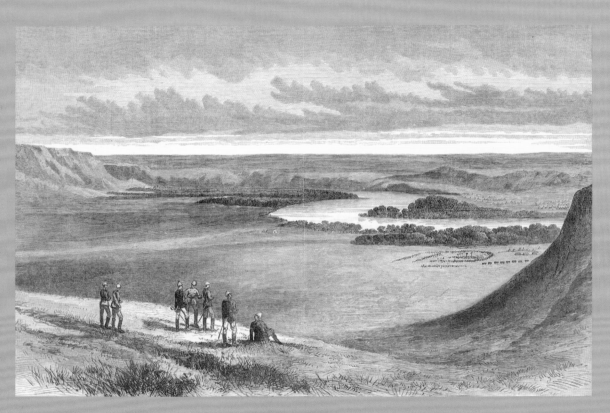

Captain John Palliser was not impressed with the prairies of southern Alberta. After a year on the plains in 1847–48, he had returned in 1859 with a scientific expedition to explore the region between the Red River settlement and the Rocky Mountains. On his second visit, he observed that vegetation was sparse and water, when it could be found, was brackish and barely drinkable. In Palliser's opinion, this was not a place where humans could live and prosper.

Homeland Of Niitsitapi

These plains were a homeland, not a wasteland, for the Niitsitapi, the Blackfoot-speaking people. The native prairie grasses were abundant feed for the vast herds of bison that dominated the plains and were the staff of life for the people.

The Bow River was one part of this landscape. Trails running parallel to the river intersected with others that led to crossing places. One

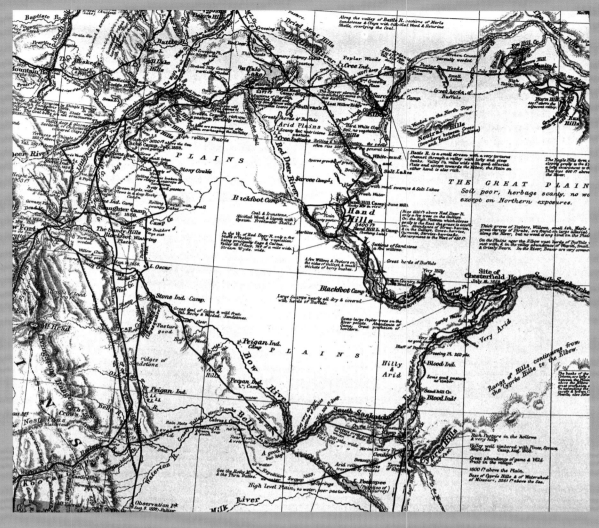

Palliser described a large area of the plains as dry, barren, and unsuitable for agriculture. This characterization of "Palliser's triangle" sparked a debate that has continued for over 150 fifty years.

important ford was at Soyo-powah'ko, or Ridge-under-the-Water, later called Blackfoot Crossing by the Euro-Canadians. Here, the raised riverbed linked two broad, low floodplains that were covered with stands of cottonwood trees. Long, wide coulees sloped gently to the north and south of this crossing place, and it became a favourite winter camping place for the Moccasin Clan of the Siksika. In 1877 their leader, Crowfoot, chose it as the place to meet government officials and discuss making a treaty between the Niitsitapi and the newcomers.

Opening the New Land

In 1670, King Charles II of England had granted the Hudson's Bay Company exclusive rights to trade for furs in all lands that drained into Hudson Bay. By 1869, however, the fur trade was becoming less profitable and the company wished to divest itself of the responsibility for administering such a large region. Sir John A. Macdonald, prime minister of the newly confederated Dominion of Canada, recognized the importance of acquiring this territory to unite the country from coast to coast.

In 1856, Captain John Palliser organized an expedition to record the climate and environment of western Canada. This was the first scientific study of the Canadian plains.

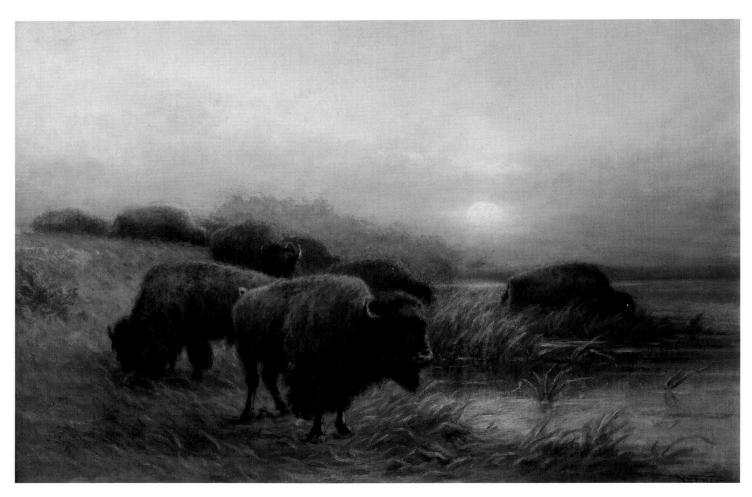

Frederick A. Verner
(1836–1928)
Buffalo on the Bow, 1914
Verner was much inspired by
the paintings and writings of
the Canadian artist, Paul
Kane (1810–1871) and
modelled his own career after
Kane's studies of First
Nations and buffalo subjects.
Verner's *Buffalo on the Bow*
may have been developed
from photographs as we have
no record of his actually
visiting the Bow. What is
significant about this
nostalgic, skillfully painted
scene is Verner's sentiment
for the buffalo. These
peaceful-looking creatures
evoke a time before their
survival was endangered by
colonization's extensive late
nineteenth-century buffalo
slaughters. The setting sun
in the distance is suggestive
of the end of a bygone era
when buffalo once freely
roamed the prairies in great
numbers.

The Canadian Pacific Railway, Macdonald's
plan to link the confederation physically, was
slowly progressing across the country, but the
construction costs were rising dramatically. The
sparsely populated prairies meant that there was
no immediate return for the money invested in
the railway. Financial backers were becoming
wary of the venture.

As an incentive to the CPR, and an assurance
to their investors, the federal government granted
the company the rights to all odd-numbered
sections within a 39-kilometre distance from the
rail right-of-way. Both the government and the
CPR expected the company to profit from the sale
of this land to settlers. These settlers would, in
turn, become a market for rail services, which

The Bow: Living with a River

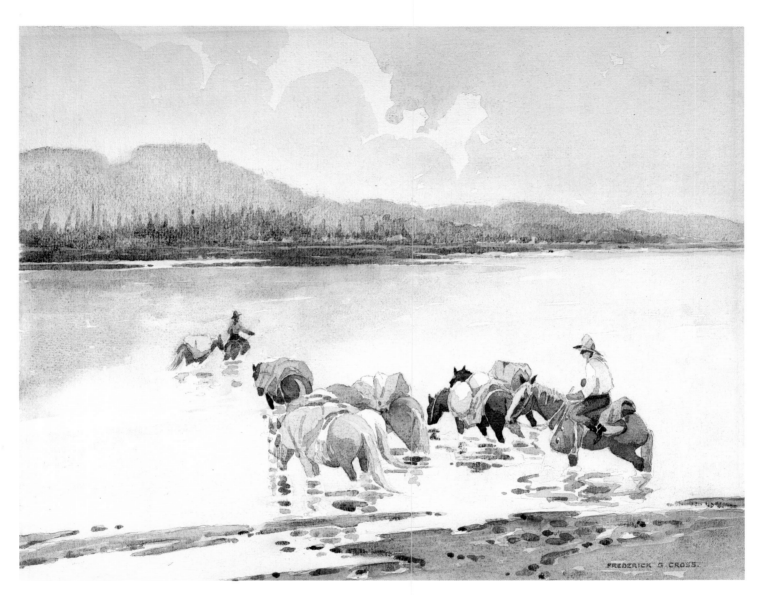

FREDERICK G. CROSS.

would carry manufactured goods to the new settlements and convey agricultural produce to markets in more densely populated regions of the country.

Frederick George Cross (1881–1941)
Fording the River, 1935
This image is thought to depict the important Blackfoot Crossing. The artist's personal friend C.H. Gooderham said of the image "His work as an engineer brought him in touch with the Blackfeet band, since the Indian Reserve went east as far as Bassano and was divided by the Bow River.... It would seem that these wanderers were caught in this view as they were crossing the Bow, as the banks are distinctly those created by this fast-flowing river." (November 16, 1971)

Thomas Strange (1831–1925)
Blackfoot Crossing, Bow River, N.W.T., 1882
This image is one of several depicting the important site on the Bow River used by the Siksika as a crossing. In several of Strange's illustrations, he used a figure standing on a promontory to situate the viewer in space. In this image, that same icon is the ground for the "noble savage" to stand on. In the setting sun, looking westward, the figure's hands are clasped, suggesting the passing of an era.

Thomas Strange (1831–1925)
The Meeting of the Bow and High Rivers, N.W.T., c. 1882
Like other military officers who were trained in basic art techniques, Strange did original artwork for translation to popular illustration. This image, and other examples of his work, was included in the *Canadian Illustrated News*. This image depicts the Bow southeast of Calgary, at the confluence with the Highwood River.

Richard Barrington Nevitt
(1850–1928)
*Fort Macleod and Environs
(Map of the South
Saskatchewan and Missouri
River Systems)*, n.d.
Many nineteenth-century
immigrant travellers of
European ancestry brought
with them to North America
a desire to map out the land
according to their traditional
forms of representation. This
bird's-eye view of the
landscape of southern
Alberta, Saskatchewan, and
Montana shows the artist's
desire to transpose a
European vision of the
landscape as mapped terrain;
the Bow River is marked on
the upper left side of this
drawing. Nevitt's attention to
it in this context underlines
the Bow's key role as part of
a complex water system that
feeds a vast terrain.

Watering The Garden Of Eden

By the time the railway was completed in 1885, the great land rushes in the United States had come to an end. Settlers were now being drawn to western Canada, encouraged by a government that advertised the region as a "Garden of Eden."

Unfortunately, the land rush coincided with drought conditions, and new arrivals soon found their crops devastated and their dreams in tatters. On the parched prairies, water was the key to successful settlement, and the government soon developed measures to insure that sufficient quantities of the resource were available to everyone. The Northwest Irrigation Act, passed in 1894, suppressed all individual rights in any stream that could be used for irrigation, and centralized the control and regulation of water use. In conjunction with this, the government undertook extensive surveys to determine the nature of the soil and the feasibility of constructing irrigation works.

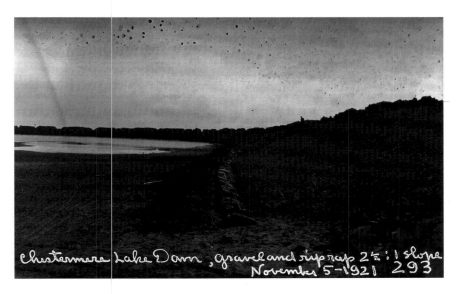

Earth and gravel were used to build a dam at a small pond east of Calgary. Water diverted from the Bow River created Chestermere Lake, the main reservoir for the western irrigation block. Today, the lake is a recreation area and home to over 5,000 people, many of whom commute to work in Calgary.

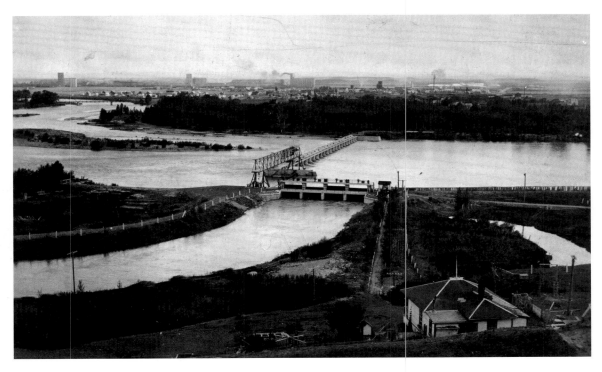

CPR's western block was irrigated with water diverted through a weir just east of Calgary (now well within the city). This diversion has been used for over a century to deliver water over a very large area.

Water flowed from Chestermere Lake, through canals, to farms throughout the region. Changes in elevations, or "drops," kept the water flowing. Gates at these "drops" controlled the amount of water in the system. Unfortunately, these controls did not function well when the system was in full flood.

The Canadian Pacific Railway Irrigation Blocks

The 1882 agreement that granted land to the CPR stipulated that the railway was required to accept only land that was fit for settlement. The company argued that much of the land in the Canadian "dry belt" was unfit for agriculture and therefore not suitable for settlement. By 1889, the CPR had still not selected all of its appropriation.

William Pearce, the federal Inspector of Land Agencies, was an advocate for the necessity of irrigation on the plains. Usually, irrigation works were constructed by land-development corporations or independent water companies who then charged farmers for using the water. Often, these irrigation companies were unable to pay the high initial construction costs and went bankrupt before collecting any fees for the water.

The CPR irrigation canals were excavated and maintained using Ruth dredges. The machines were driven along the canal while buckets on a conveyor belt removed sediment. For many years, these dredges were made at the Calgary Iron Works.

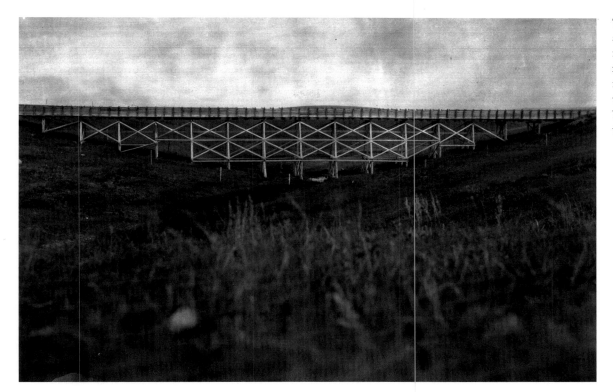

Pearce proposed that, instead of small irriga-
tion operations, there should be regional
development programs covering hundreds of
square kilometres. He also realized that, in late
nineteenth-century Canada, only the federal gov-
ernment and the CPR had the resources to
initiate such large developments.

At Pearce's urging, the government and the
CPR agreed to consolidate the land grant into one
large block. This open, prairie plateau stretched
for 225 kilometres eastward from Calgary and
northward from the Bow River for 66 kilometres.
In the western area, heavy black loam soil lies
over clay subsoil, undulating in a gentle, rolling
topography with an average elevation of 1,066
metres above sea level. At the eastern extreme,
the land is almost flat and the soil is more sandy,
with a clay and hardpan base. The average eleva-
tion in the east is 762 metres above sea level.
Between these, the central section is generally

higher than either the eastern or western
regions. This height, together with a more
convoluted topography, made it unsuitable for
irrigation, as more energy would have been
needed to pump water and more flumes would
have had to be constructed to carry the water
across the landscape.

Irrigation of the eastern section was complex.
The completion of the Bassano Dam in 1912
diverted water from the Bow River at a southward
turn in the river known as Horseshoe Bend. From
there, canals carried water to several reservoirs
and irrigated land east of Medicine Hat and as far
north as the Red Deer River Valley.

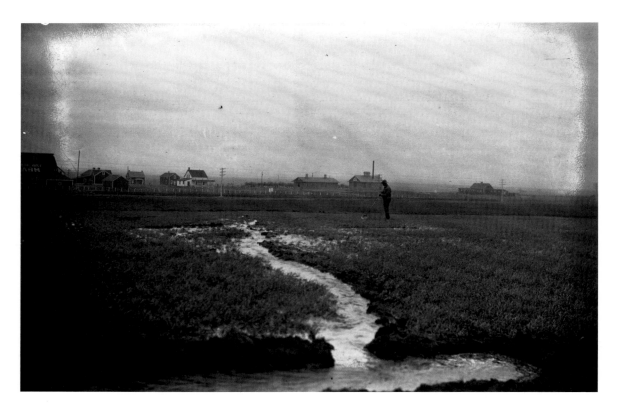

At first, flood irrigation distributed water across the fields. Water flowed from canals to ditches, where it was diverted over the crops. Furrows between rows of plants needed to be kept clear to allow the water to saturate the field.

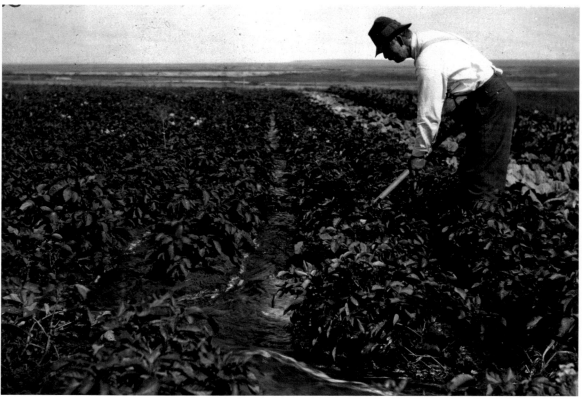

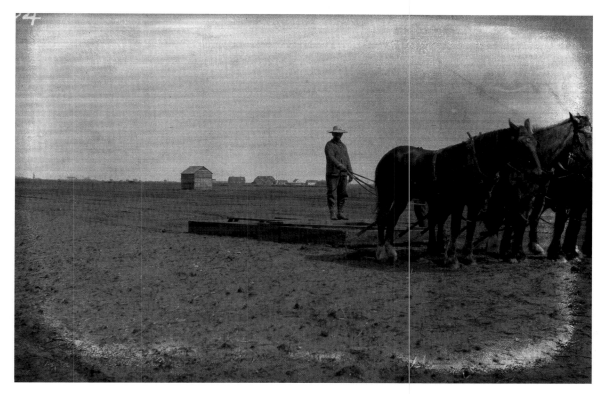

The land needed to be flat and level for flood irrigation to work well. Every small variation in relief was an impediment to the flow of water. Smoothing the land was accomplished by using a team of horses to pull a leveller.

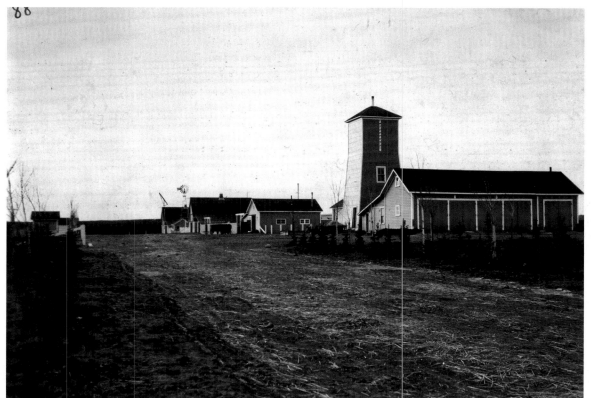

By 1912, farmers were voicing concerns about the CPR's ability to either deliver enough water or drain excess volumes. They also believed that the water was too cold for the plants. The CPR responded by creating experimental farms, such as this one near Strathmore, where farmers could be taught proper techniques of irrigation agriculture.

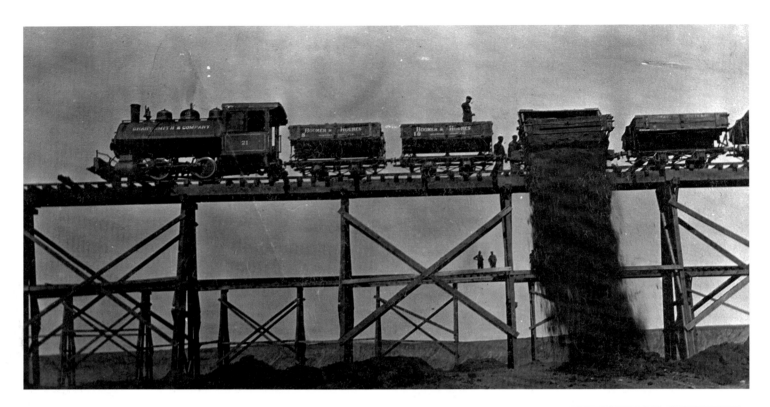

The embankment at the Bassano Dam required 1 million cubic yards of earth. A special rail line was built to carry this material to the construction site.

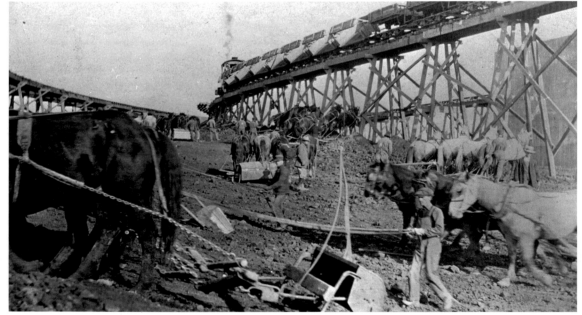

Water for the eastern irrigation block was diverted from the Bow River by means of a dam at Horsehoe Bend. The construction, completed in 1914, used horse-drawn equipment.

The Bow: Living with a River

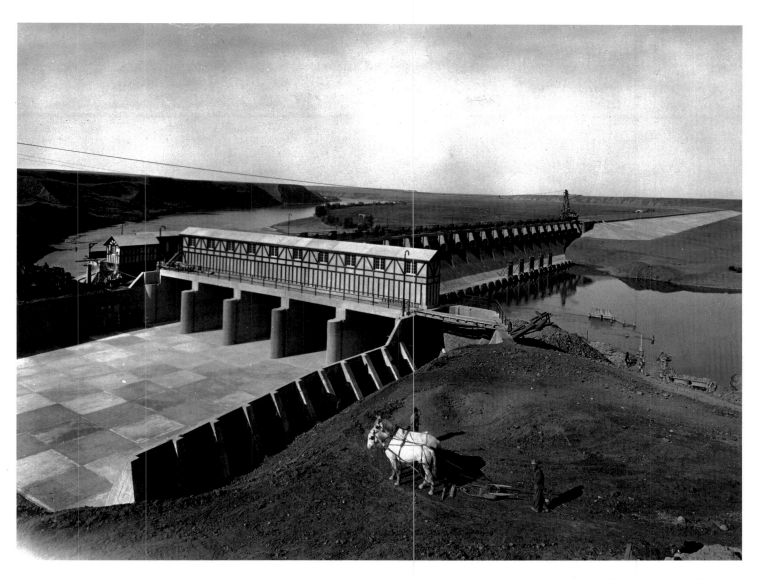

The Bassano Dam spillway contains 40,000 cubic yards of concrete and 1,134,000 kilograms of reinforcing steel. As the water leaves the river, it flows through headgates and into a main canal (in the foreground) to Barkenhouse Lake, 8 kilometres to the northeast.

The Bow River Irrigation District

As the CPR proceeded with its irrigation plans, others began to see a new potential in the arid West. The area south of the Bow River attracted several private companies and reflects the complex nature of developing irrigated agricultural land in the early years of western settlement.

Access to water greatly affected the value of land. In 1906 the Robbins Irrigation Company's plans to divert water from the Bow River drew the attention of several British land-speculation companies, who purchased large blocks of land in anticipation of a boom in land prices. When Robbins failed to develop these plans, the Southern Alberta Land Company, one of the British land companies, began construction of

an irrigation system that would stretch from Carseland to Suffield. This, in turn, led to more speculative land purchases by other companies.

The Southern Alberta Land Company had a great deal of difficulty completing its plans and diverting water to farms. As Pearce had predicted, the sparse population and enormous construction expenses prevented the company from making any profits, and without an inflow of money, new construction could not be undertaken and older works could not be maintained.

In 1935 the federal government created the Prairie Farm Rehabilitation Administration (PFRA) to address the agricultural disaster that had been spreading across the plains for more than a decade. Initially, it provided financial assistance to irrigation companies. However, in 1949 it

The Southern Alberta Land Company advertised southern Alberta as a "Garden of Eden" where crops were bountiful.

purchased all of the irrigation works that were held by private companies. These canals were revitalized and expanded between 1952 and 1958.

By 1979, 53,800 hectares were under irrigation in the Bow River Irrigation District. They were administered by the federal government until 1973, when the province assumed responsibility. Irrigation is expensive. Between 1950 and 1979, the Canadian government spent $25 million on development and $23 million on operation and maintenance.

Irrigation Today

A century after the first canals were dug, irrigation has become an integral part of southern Alberta. Although only 4 per cent of Alberta's land is irrigated, it is responsible for 20 per cent of the province's agricultural production. For these farmers, the sprinkler systems have become an essential and expensive component of their operating infrastructure, with a single pivot costing as much as $100,000.

A lingering drought has made everyone aware of the importance of stewarding our scarce reserves of water. Several initiatives are making irrigation more efficient. Lower sprinkler heads distribute larger droplets, reducing the amount of water lost to evaporation. As well, farmers and scientists are collaborating to develop computer simulations that help determine the optimum amount of water to use on different crops under different weather conditions. Farmers will be able to program these variables into their computer-run irrigation systems, ensuring that water is used to maximum effect.

Irrigation affects everyone in southern Alberta. The system of canals and reservoirs has created over 32,376 hectares of critical, drought-resistant wetlands for waterfowl and other wildlife. The reservoirs have been stocked with fish and support a popular sport fishery. The canals and pipelines bring water to over fifty communities that otherwise would rely solely on unpalatable groundwater.

Ensuring a sustainable water supply, which is so critical to the lives and livelihoods of southern Albertans, begins with the maintenance and conservation of watersheds by all who use them. Successful watershed management requires that many groups, with many different perspectives, work together to ensure the resource is sustainable for multiple uses and for future generations.

Reflections on the Bow

The Bow River continues to have a very personal impact on everyone who lives near it or passes by it. The following are some personal reflections of how the river has touched people's lives.

Frank H. Johnston (1888–1949)
On the Bow River, Banff, 1925
Frank H. Johnston made his first trip to the Rockies in the summer of 1924, thanks to a commercial design commission from the CPR to promote the railway's mountain resorts. While on this trip, he began sketching the landscape around him, and probably did this sketch then or soon after. The rich textures of the trees, river, and mountains are expressed through Johnston's deft brushwork, and on an almost perfectly clear day.

The Bow: Living with a River

The pageant from Calgary right up to Banff absolutely...leaves one dumb. The arrangement of the whole thing is truly the work of the Supreme Craftsman. Their beauty is a silent beauty with an exhilarating joy in continually looking, looking, looking.

Frank H. Johnston
July 1924

The Lower Bow works are records of those times I have dreamed myself to be an integral part of the rhythm of the river....

Ted Godwin, 1990.

There was a time when Canadians carried a map around inside their heads of the watersheds upon which they lived and relied for their livelihoods and well-being. Then came the train, the car, and the plane. We lost touch with the sinuous, sensuous nature of our watersheds. For me, the Bow River has been a vehicle for reestablishing this historic connection to place.

Reconnecting to a river is an act of reaffirmation of words. Fishermen talk of reading the surface of the water as if it were a text. The act of reading implies a language that can be read. Words that form the language of water are important.

We speak in hushed and reverent tones about Inuit who possess twenty different names for snow. But snow is just another word for water. If you include the language of science, there are probably 20,000 words that describe what water is and what water does. We must continue to use these words so that the things they describe do not disappear from our world.

Perhaps the best time to begin a study of the language of water is winter. At this time of the year, the Bow River moves the slowest. It is also a time when you can experience water in all of its remarkable forms all at once.

Water exists as liquid in the river, as mist above the open water, as ice, as snow, as cloud, and even as rain. In winter you also experience local ecosystems in their most elemental and most easily understood state.

Robert W. Sandford
Canmore, May 2004

Ted Godwin (b. 1933) (diptyck) *The Gravel Bar*, 1990 Calgary-based artist and fisherman Ted Godwin has had a long association with the Bow River. As he grew up roaming its shores with his father as a young boy, the river became a key part of his identity and sense of belonging. In the early 1990s, he developed a substantial and melancholic body of work featuring the Bow River. Based on the Mackinnon Flats near Carseland, *The Gravel Bar* honours the vital life support that the gravel beds provide for fish spawning. The greys of the rocks also provide rich tonal variation and contrast effectively with the autumnal foliage along the shoreline.

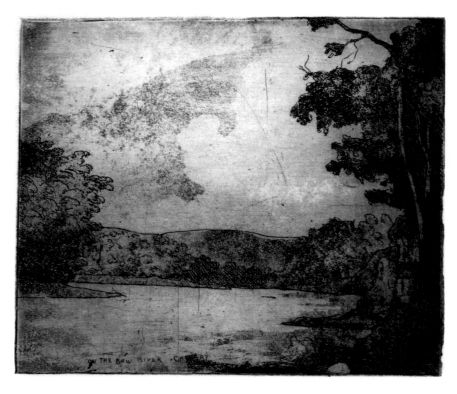

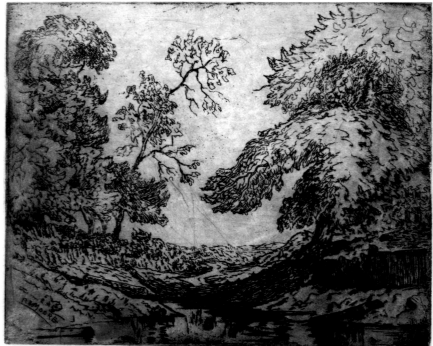

Richard Moore (dates unknown)
Backwater on the Bow River—
East Calgary, 1930

Richard Moore (1893–?)
On the Bow River, Calgary,
1930
This charming group of etchings once served as Christmas greeting cards. Depicting several sites on the river that have become important today, the group includes St. George's Island, where the Calgary Zoo is now located, and Prince's Island, a charming inner-city park unique for its island location on the Bow. These etchings indicate an increasing desire for images of Calgary as the city was growing. With their soft and gentle lighting and pastoral subjects, they actually evoke a more European setting than the harsher conditions that exist here.

It was the fall of 1970. I had just taken up hunting and the waterfowl and upland game bird season was open. A friend and I jumped into my car and headed northeast from Lethbridge to the Brooks region—to hunt pheasants and ducks. I was amazed at all the wildlife we saw as we looked for the perfect hunting spots. It was only later that I came to realize the abundance of wildlife in that part of southeast Alberta was due in large part to the irrigation network that takes water from the Bow River.

In the fall of 1973 I landed my first real full-time job—with Alberta Agriculture. It was the beginning of a career in water and agriculture that has now spanned more than thirty years and is still going. For much of that time, I have worked in the Bow River Basin. My view of the river and its importance has changed over time, and my experiences have also changed me. I find that I enjoy the Bow for many reasons.

As avid campers and hikers, my family and I have spent many nights camping and trudging around Banff National Park and the upper Bow Basin. As a scout leader, I often took the Boy Scouts in my charge into the Bow River back country, for fun and for them to see and experience nature firsthand. I came to understand that the Bow is able to do many things. It is, in many respects, the life blood of much of southeast

Alberta. Canals and reservoirs constructed at the turn of the twentieth century have succeeded in allowing the water in the river to extend its benefits far beyond the river valley.

The waters of the Bow support more than 202,350 hectares of irrigated farmland. The same water that is so important to agriculture is also a boon to wildlife across the dry southeast portion of Alberta, with more than 20,235 hectares of critical wetland habitat supported by diverted Bow River waters. I have come to realize that if I want to show visitors the most watchable wildlife possible in a single day, I travel to the irrigated regions along the Bow River, not up into the mountains.

Our appreciation of water and our responsibility toward it is on the increase. That is a good thing. It is important, even vital, that each of us does what we can to conserve water, to develop the best practices—in watering our lawns or watering our crops; in protecting water from pollution and ensuring that in every sense water is managed with all the care and effectiveness we can bring to it. Everything that lives and everything we do has a connection to water. We cannot take it for granted, and we also cannot allow it to be simply a source of conflict. In truth, we really need to use water to help us bridge our differences and determine the kind of future we want for ourselves and future generations.

Every time I drive over the Bow River I take a glance at it. Most of us have too little an idea of how much this river does for us every day. It is very much part of our culture, our lives, jobs, and economy, and a vital link in our environmental condition. And even with all my experience working and playing in the waters of the Bow, I learn something new every time I connect with it, whether walking with friends along the river in Canmore or seeing ripening crops in a harvest sunset. The Bow River is my river, but I expect it is also yours.

David Hill
Executive Director
Alberta Irrigation Districts Associations
May 2004

The Bow River is a fragile link to southern Alberta's past and future. The consistent feature of this transition is the Bow's fundamental role in providing water for domestic, agricultural, and recreational uses. Its critical role has, however, been obscured by feats of human engineering, which include a transportation network. From the perspective of a moving car, the Bow River, and its role in Calgary, disappears into a maze of freeways and bridges that move people as quickly as possible across one of the defining features of the area's geography. Driving the Deerfoot Trail, for example, provides only fleeting glimpses of the Western Irrigation District's headworks, let alone time to appreciate the Inglewood Bird Sanctuary. We need more than a windshield view of the Bow River to appreciate its role in the environmental and economic welfare of Alberta.

John Gilpin
May 2004

The Bow River nourishes my person in cellular and soul-uar ways.

Sherri Rinkel-Mackay
May 2004

Marmaduke Matthews
(1837–1913)
Bow River, Banff, n.d.
Matthews' first trip to the
Rockies was in 1887 with
F.M. Bell-Smith and T. Mower
Martin; a second trip quickly
followed in 1889. He was a
prolific painter of mountain
imagery and most of his
works are in the watercolour
medium. For Matthews, like
other artists travelling under
the CPR's auspices, the Bow
River was nearby subject
matter and he painted many
views of it.

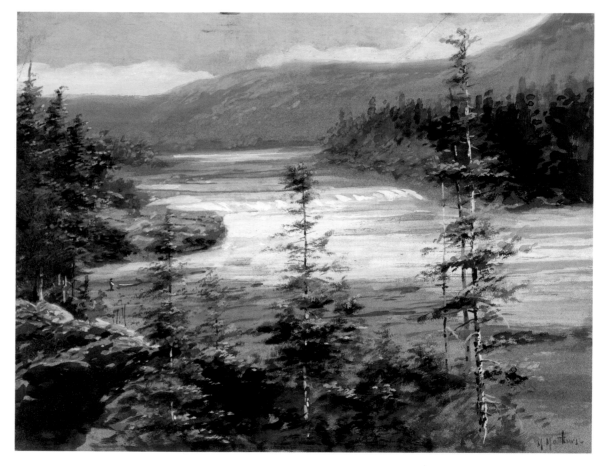

I am a rare Calgarian. I was born here and the
Bow River has been important to me all of my
life. From camping trips along the Bow through-
out my childhood, learning to love and respect all
natural environments from my parents, to sharing
these feelings with my children, the Bow is a
place not only of memory but of the future.

Pat Conway
May 2004

It provides a serene place for me to go and
experience nature and the beauty it creates so
close to home. It shows that it is important for
humans and nature to peacefully coexist. What
a beautiful place we live in!

Heather Walton
May 2004

The sound of the river echoes in my every memory of being in Calgary. Its flow is the heartbeat of our city and its water is part of every one of us. It is special because of its history, its journey, and its connection to all of us.

<div align="right">

Megan Shervey
May 2004

</div>

The river means the earth's "lifeblood" through time.

<div align="right">

Sandra Lamb
May 2004

</div>

When the city forests of concrete and glass and rivers of asphalt close in, I escape to Bowmont natural area. There the river still flows, the seasons still turn, and the universe is set back on its keel. Spring and fall, river mists rise to the morning sun. Winters, mink fish from ice shelves lining its banks. Summers, small boys conduct small boy business in its willow mazes, and dogs paddle in its shallows. The Bow courses through our city and our lives, keeping us whole, in health, and in balance. Now it is our turn to do the same for our river.

<div align="right">

Frances Roback
May 2004

</div>

Brief Biographies of Selected Artists

Bell-Smith, Frederic Marlett

Bell-Smith was one of several painters engaged by the CPR in the 1880s to depict the Rockies for the purposes of tourism, promotion, and immigration. Born and educated in England, he arrived in Montreal in 1866 and Hamilton in 1871, where he worked as a photographer, teacher, illustrator, and arts administrator.

Browne, Belmore

Trained in New York and Paris, Belmore Browne exhibited regularly during his lifetime, including at the 1923 Venice Biennale. From 1921 to 1943 this artist and outdoor enthusiast's principal studio was in Banff and afterwards he established one at nearby Seebe. His paintings focused on Rockies subjects and the Bow Valley figured prominently in his work.

Christopher, Ken

Ken Christopher studied art at the Alberta College of Art from 1960 to 1964, and at the Emma Lake Artists' Workshops in the late 1970s. Currently he lives in his birthplace, Swift Current, Saskatchewan.

Cross, Frederick

Frederick Cross was a professional engineer. He came to Canada in 1906 from Exeter, UK, and in 1907 joined the irrigation department of the CPR at Brooks in 1907. Soon after, he began painting. After the First World War, he was appointed canal superintendent for the company's eastern irrigation block. After retirement in 1936, he moved to Lethbridge and continued painting and exhibiting his work.

Curren, John D.

John D. Curren was a prospector, miner, artist, and photographer who came from his native Airdrie, Scotland, in 1886 to settle in Anthracite. His grandson, Peter Whyte, carried on his artistic tradition.

Davis, Leonard

Leonard Davis, who was educated in New York and Paris, exhibited widely throughout the U.S. Noted for his depictions of mountain scenery, he focused on such sites as Cathedral Mountain, Yoho Valley, and the Bow Valley. He exhibited his work at the Palliser Hotel in 1923 and at the Calgary Stampede in 1929.

Dichmont, James

The relatively unknown English-born artist James Dichmont came to Canada in 1907. He first lived in Winnipeg, and settled permanently in Calgary after 1924. He taught at the Provincial Institute of Technology (PITA) from 1932 to 1935 under A.C. Leighton's leadership and worked at the Banff School of Fine Arts from 1944 to 1947.

Earle, Herbert

This English-born artist joined his family in 1920 in Calgary, where he ran an engraving company until 1959. Active in both the theatrical and visual arts communities, his works are not well known today.

Gissing, Roland

English-born Roland Gissing came to Calgary in 1913 hoping to become a cowboy. He worked as a ranch hand for several years before homesteading at the confluence of the Ghost and Bow rivers. He took lessons from Leonard Richmond in the mid-1920s, and then from A.C. Leighton.

Godwin, Ted

Ted Godwin was born in Calgary and studied at the Southern Alberta Institute of Technology and Art from 1951 to 1955. After a career in commercial art, he participated in several of the Emma Lake Artists' Workshops in the late 1950s to mid-1960s. Godwin's work achieved national prominence when he exhibited with four other painters from Regina, and they subsequently came to be known as the Regina Five. He taught at the University of Saskatchewan until 1985. Since retiring from teaching, he has returned to his hometown.

Hammond, John

Painter, photographer, and teacher John Hammond was one of several artists commissioned by the CPR to paint the Rockies. The Montreal-born artist brought with him experience from William Notman's photographic studio and studied with the well-known British painter James McNeill Whistler. It is unclear when Hammond actually came west, for he travelled extensively throughout the world. In later life, he settled in the Maritimes, where he was director of the School of Art at Mount Allison University in Sackville, New Brunswick, from 1907 to 1919.

Harvey, Reginald

Reginald Harvey, born and educated in England, came to Canada around 1912. By 1917, he had settled in Calgary, where he eventually became supervisor of art for the Calgary school system and then principal of Haultain School. As one of the earliest artists to contribute to Calgary's emerging art community, Harvey was head of the Calgary Exhibition and Stampede's art department for over twenty years. A.C. Leighton greatly inspired him as a sketching companion.

Haukaness, Lars

Lars Haukaness was one of the earliest professional art teachers in Alberta. He emigrated from Norway in 1888, arriving in Canada in 1920. In 1926 Alberta's PITA hired him as its first full-time teacher, and he taught there until his death three years later. His role there provided a cornerstone for today's Alberta College of Art and Design.

Houston, Martha Isabel

Martha Houston was born in Newark, New Jersey. She settled in High River, where she taught high school between 1931 and 1942 and organized the High River Art Club. A watercolourist and printmaker, she held solo exhibits at the Bowman Arts Centre in Lethbridge (1965) and at High River Arts Council (1975).

Hughes, Edward John

E.J. Hughes was born in Vancouver and studied at the Vancouver School of Art from 1929 to 1935. Later he worked as a commercial artist and served as a war artist during the Second World War. In 1946 he settled at Shawnigan Lake, BC, where he still resides. This noted painter, printmaker, and draftsman began a full-time commitment to his art in 1951, celebrating the BC interior, coast, and Gulf Island areas. His works have been exhibited extensively in Canada, including a major retrospective at the Vancouver Art Gallery in 2004.

Jackson, Alexander Young

Painter, commercial artist, and war artist, the French-educated A.Y. Jackson was part of the famous Group of Seven landscape-painting movement that emerged in Toronto during the 1920s. With a relative in Lethbridge, Jackson had a base from which to begin his explorations in Alberta and began regular visits to the West in 1937. Between 1943 and 1949, Jackson made almost annual trips to Banff to teach at the Banff School of Fine Arts and also travelled to the Northwest Territories, the Yukon, and through British Columbia.

Johnston, Frank H.

Frank Johnston was a founding member of the Group of Seven but only associated with them for a short time. His first contact with the West occurred in 1921, when he became director of the Winnipeg Art Gallery and principal of the Winnipeg School of Art. By the fall of 1924, his job had been terminated and he returned permanently to Toronto to pursue a more commercial approach.

Kerr, Illingworth H.

Illingworth "Buck" Kerr was born in Lumsden, Saskatchewan, and studied art at Toronto's Central Technical School and the Ontario College of Art. A key figure in the history of Calgary's Alberta College of Art and Design, Kerr led the art department from 1947 to 1967. During this time, the surrounding foothills and mountain landscapes of Alberta became central subjects in his art.

Knowles, Dorothy

Dorothy Knowles is one of Canada's most important and prolific landscape painters, and has exhibited regularly since the mid-1950s. Between 1956 and 1969, she participated in several of the Emma Lake Artists' Workshops in Saskatchewan.

Leighton, Alfred Crocker

The British-born and -trained A.C. Leighton was first lured here as the result of a CPR commission in 1925. He settled in Calgary in 1929 to teach at the PITA, where he was director of art until 1935. He is one of Alberta's best known and most influential teachers.

MacKay, Allan Harding

Allan Harding MacKay is known for his work as an artist, curator, and arts administrator and is currently curator at the Kitchener-Waterloo Art Gallery. He has exhibited across Canada and is represented commercially by the Paul Kuhn Gallery, Calgary.

The Marquis of Lorne

John Douglas Sutherland Campbell, 9th Duke of Argyll and Marquis of Lorne, was Governor General of the Dominion of Canada from 1878 to 1882. He made a trip to the Alberta and BC Rockies in 1881.

Martin, Thomas Mower

Thomas Mower Martin travelled to the Rockies compliments of the CPR. Born and raised in London, UK, he immigrated to Canada in 1862, settling in the Muskoka district of Ontario and later in Toronto. Martin first visited the Rockies in 1887 and stayed for two months, from August to October. He met and sketched with F.M. Bell-Smith and Marmaduke Matthews while travelling from Banff to Yale, BC.

Marmaduke Matthews

Marmaduke Matthews was another of the artists given free passage west by the CPR in the 1880s. Born in Barcheston, UK, he settled in Toronto in 1860 and began a business as a portrait painter. An influential figure in the early years of arts organizations, he was a founding member of both the Ontario Society of Artists (he became its president in 1894) and the Royal Canadian Academy in 1880.

Millard, Laura

Laura Millard was recently program manager, Creative Residencies, Media and Visual Arts, at the Banff Centre and is now based in London, Ontario. She obtained her art education at Concordia University, the Nova Scotia College of Art and Design, and the Alberta College of Art and Design. She has shown her work widely in Canada and the United States in both commercial and public art galleries.

Nevitt, Richard Barrington

Richard Barrington Nevitt obtained his bachelor of medicine in 1874 from Trinity College, University of Toronto. Fresh out of school, he took the opportunity in July to join the North-West Mounted Police and their great march West. As assistant surgeon, Nevitt spent the winter of 1874–75 stationed at Fort Macleod and sketched in his spare time for the next two years. Following his brief stay in Alberta, he returned to Toronto, where he continued a long and successful career in obstetrical medicine.

Nicoll, James McLaren

James Nicoll was born in Fort Macleod, and trained as a civil engineer. Although he was also a poet and writer, his first love was painting. He met his wife, Marion, through the Calgary Sketch Club and the couple was married in 1940. By 1945, they were settled in Bowness, west of downtown Calgary, where they remained until their elderly years. Their home at 7007 Bow Crescent NW was a favourite meeting place for their circle of artist friends, and the area provided Jim Nicoll with an endless range of subjects.

Nicoll, Marion

Marion Nicoll was born and raised in Calgary. She studied art at the Ontario College of Art in Toronto in 1926–27 and at PITA from 1929 to 1932. From 1933 to 1965 she taught crafts and design at PITA. Nicoll's path to abstraction began in the 1950s, after working with Vancouver's J.W.G. Macdonald, studying with American abstractionist Will Barnett, and studying at the Emma Lake Artists' Workshops.

Pepper, George Douglas

Like many artists of his day, the Ottawa-born painter George Pepper's main source of income was teaching. A student at Toronto's Ontario College of Art and Design, he later became its director of drawing and painting (1941 to 1955) and president (1950 to 1962). His first trip west was in 1928 to the Skeena River in northern British Columbia. He later taught several summer sessions at the Banff School of Fine Arts.

Pepper, Kathleen Daly

This Ontario-born artist obtained her education at Toronto's Ontario College of Art and in Paris. In 1929 she married George Pepper, who was her lifelong sketching companion in numerous regions across Canada. The two discovered Banff in 1942 when George began teaching at the Banff School of Fine Arts. Two years later, when Kathleen contracted polio, she chose Canmore to recover. There she spent eighteen months convalescing with the help of the mineral hot springs.

Phillips, Walter Joseph

Walter J. Phillips was a writer, art critic, teacher, and illustrator. Born in Barton-on-Humber, Lincolnshire, UK, he came to Canada in 1913, settling first in Winnipeg, then Calgary in 1940. He began painting the Rockies in 1926 and continued to do so until 1959. By 1949, he had so fallen in love with the Rockies that he and his family settled in Banff, at the base of Tunnel Mountain. Phillips sketched extensively throughout Banff and Yoho national parks. Phillips was one of Canada's most important watercolourists and an internationally acclaimed printmaker.

Prior, Melton

Melton Prior was a British-born draftsman, journalist, illustrator, and war artist. He first began contributing to the *Illustrated London News* in 1868. For some thirty years, he worked in Europe and South Africa as an eyewitness war artist for the British Army. He made his first trip across Canada in 1887 and a second one in 1901.

Pugh, David

David Pugh was born in Saskatoon, raised in Calgary, and studied for a year at the University of Calgary. During the early 1980s, while living in Canmore, he began to take the mountains in the south from Waterton National Park northward to Rocky Mountain House as his subjects.

Reis, Mario

Mario Reis is an internationally acclaimed artist, currently based in Dusseldorf, Germany. Born in Weingarten, Germany, he studied at the State Academy of the Arts in Dusseldorf from 1973 to 1978. His work has been shown in many countries, including Canada, the United States, Japan, Germany, France, and Norway. Currently he is represented in Calgary by the TrépanierBaer Gallery.

Richards, Craig

The Edmonton-born artist Craig Richards has lived in Canmore for the past twenty-four years and is a pre-eminent photographer of Rocky Mountain subjects. Since 1986, he has been head curator of photography at the Whyte Museum of the Canadian Rockies, Banff. His work has been shown at public and commercial art galleries throughout the world.

Roper, Edward

Painter, author, and illustrator, the British artist Edward Roper made his first trip to Canada in the spring of 1887. Starting in Quebec, his westward journey, most likely by rail, took him to the Rockies. He returned to England that fall and soon began working on a solo show of his Canadian sketches, and in 1891 published a record of his journey.

Rungius, Carl

German-born American artist-sportsman Carl Rungius is considered by many to be the most important North American wildlife painter of the twentieth century. Educated in Berlin, he first discovered the Canadian Rockies in 1910 after Jimmy Simpson had spotted Rungius' *Wary Game* (1908) in a magazine and invited the artist to join him at Bow Lake. In 1921 Rungius established a studio in Banff, which he maintained until 1958.

Shelton, Margaret

The Alberta-born artist Margaret Shelton is best known today for her extraordinary relief prints. In 1933 she enrolled in art studies at the PITA, and between then and 1943 she won numerous scholarships. She also attended the Banff School of Fine Arts summer sessions beginning in 1935. Among her mentors during these formative years were A.C. Leighton, H.G. Glyde, and Walter Phillips.

Simpson, Jimmy

Jimmy Simpson came to Canada in 1898 and first visited Bow Lake in 1902. Simpson fell in love with the area's untouched beauty, and by 1937 had started to build Num-Ti-Jah Lodge and make his living as an outfitter. Many artists visited the lodge, and through the exchange of lodgings for art, Simpson built a significant personal collection that included works by Archibald Thorburn, Carl Rungius, and Phillip R. Goodwin.

Stadelbauer, Helen

Helen Stadelbauer is a Calgary-born artist and an influential teacher. In addition to her studies at the Provincial Institute of Technology in Calgary and the Banff School of Fine Arts, she also received BA and MA degrees in art from Columbia University in New York. She was the first female professor of art at the University of Calgary and spent thirty-one years there, retiring in 1976.

Strange, Thomas Bland

Thomas "Jingo" Strange was a well-known soldier who came to Canada around 1871. Later in life, he established one of Alberta's first ranches. Many of his images were transferred to engravings.

Taylor, Joseph Abraham

J.A. Taylor grew up near Medicine Hat. We know few details of his life and work beyond his studies under W.J. Phillips at the Banff School of Fine Arts and at PITA under A.C. Leighton.

Turner, Stanley

British-born and -educated, Stanley Turner immigrated to Canada in 1901. Settling initially in Toronto, he continued art studies, worked as a commercial artist and illustrator, and focused on printmaking.

Two Gun

Two Gun (Percy Plainswoman), a Kainai, and best known as a bronco buster, was primarily a self-taught artist. He briefly attended the Banff School of Fine Arts and claimed the opportunity gave him "a better conception of perspective and proportion."

Verner, Frederick Arthur

Frederick Verner is a well-known Canadian artist, notably for his many paintings of the buffalo and portraits of First Peoples. He spent much of his life exhibiting his work in Canada and Britain. The details of his travels are much disputed by scholars, and thus the facts surrounding his actual presence in western Canada remain elusive.

Whyte, Catharine

Catharine Whyte was born in Conrad, Massachusetts, and attended the school of the Museum of Fine Arts in Boston from 1925 to 1930. While studying in Boston, she met Peter Whyte, a young, then unknown, and certainly unprosperous painter. The couple was married in 1930 and settled on Peter's home turf, at 130 Bow Avenue in Banff. Both were avid mountain enthusiasts, hiking, skiing, and painting regularly in the Rockies.

Whyte, Peter

Often called "Banff's first local artist," Peter Whyte gained his artistic knowledge from the school of the Museum of Fine Arts in Boston and from sketching outings with noted local artists including Carl Rungius and Belmore Browne.

Note: There is minimal to no information available about some of the artists whose works are illustrated in this publication, and thus individual biographies of them are not included.

Image Credits

Cover and Frontispiece

Margaret Shelton, *Fishing on the Bow*, 1945. Linocut on paper. 12.9 × 15.7 cm. Collection of the Glenbow Museum. Gift of Pat Marcellus, 1988. 988.211.1.29

Acknowledgements

Page 8: Craig Richards, *Vermilion Lakes, Mount Rundle, Banff National Park*, 1984. Silver gelatin, photograph. 26.6 × 34.4 cm. Collection of the Glenbow Museum. Purchased with funds from the Riveredge Deaccessioning Fund, 1994. 994.106.005

Sponsor's Foreword

Page 10: Marion Nicoll, *Bow River*, 1934. Oil on board. 42.5 × 31.3 cm. Collection of the Glenbow Museum. Gift of the Estate of Marjorie Davidson, 1995. 995.020.003

President's Preface

Page 12: Richard Moore, *Eau Claire—Prince's Island*, n.d. Etching. 9.6 × 15.2 cm. Collection of the Glenbow Museum. 70.47.9

Ribbon of Hope, Ribbon of Life

Page 13: A.C. Leighton, *Bow Lake*, n.d. Pastel on paper. 22.6 × 30.0 cm. Collection of the Glenbow Museum. Purchased with funds from the Glenbow Museum Acquisitions Society, 1987. 987.174.1

Page 14: Walter J. Phillips, *Bow Lake*, 2 August 1953. Watercolour on paper. 30.5 × 22.9 cm (sketchbook). Collection of the Glenbow Museum. Purchased 1961. 61.21.47

Page 15 (left): Photograph courtesy of Glenbow Archives, Calgary. NA-2289-6

Page 15 (right): Photograph courtesy of Glenbow Archives, Calgary, NA-339-1

From Serendipity to Deliberation: Artists and the Bow River Valley

Page 16: Allan Harding MacKay, *An Icon for the Independent Spirit*, 1998. Digital still from the video, 29:45 minutes. Projection size varies. Collection of the Glenbow Museum. Purchased with funds from the Collection Endowment Fund, 1999. 1999.010.009

Page 17 (top): Hawksett, *Calgary in 1875*, 1875. Ink wash on paper. 17.1 × 27.2 cm. Collection of the Glenbow Museum. Purchased 1955. 55.29

Page 17 (bottom): T. Mower Martin, *The Bow River from the Banff Hotel*, n.d. Watercolour on paper. 25.1 × 43.6 cm. Collection of the Glenbow Museum. Purchased 1958. 58.44.15

Page 18: Marion Nicoll, *Bowness Road, 2 am*, 1963. Oil on canvas. 136 × 186 cm. Collection of the Glenbow Museum. Purchased 1976. 76.8.1

Page 19 (top): Carl Rungius, *Bow Lake, Alberta*, n.d. Oil on canvas. 40.6 × 50.8 cm. Collection of the Glenbow Museum. Purchased 1959. 57.39.1

Page 19 (bottom): Helen Barbara Stadelbauer, *Tree at Bow Falls*, n.d. Oil on board. 45.3 × 60.8 cm. Collection of the Glenbow Museum. Gift of Helen B. Stadelbauer, 1996. 996.042.004

Page 20: Illingworth Kerr, *Ice and Still Water*, 1969. Oil on canvas. 55.9 × 76.2 cm. Collection of the Glenbow Museum. Purchased 1872. 72.2.4

Page 21: Laura Millard, *An Ordinary Evening*, 1963. Mixed media and photography. 76.5 × 76.5 cm. Collection of the artist, Banff.

Page 22: Frederic M. Bell-Smith, *Morning, Lake Louise*, 1889. 49.7 × 62.0 cm. Collection of the Glenbow Museum. Purchased 1959. 59.34.7

Page 23: John Hammond, *The Three Sisters*, c. 1890. Oil on canvas. 121.9 × 182.9 cm. Collection of the Glenbow Museum. Purchased 1960. 60.79.3

Page 24 (top): James Nicoll, *Bow River*, c. 1940. Watercolour on paper. 43.1 × 53.8 cm. Collection of the Glenbow Museum. Purchased with funds from the Glenbow Museum Acquisitions Society, 1987. 987.101.5

Page 24 (bottom): Margaret Shelton, *Bow River*, 1939. Linocut on paper. 8.8 × 13.0 cm. Collection of the Glenbow Museum. Gift of Pat Marcellus, 1987. 987.203.1.11

Page 25: George Douglas Pepper, *Bow River Valley*, n.d. Oil on canvas. 33.0 × 40.8 cm. Collection of the Glenbow Museum. Gift from the Estate of Kathleen Daly Pepper, Toronto, 1995. 995.098.003

Page 26: Walter J. Phillips, *Mount Rundle*, n.d. Watercolour. 29.0 × 25.3 cm (sketchbook). Collection of the Glenbow Museum. Purchased 1961. 61.21.42

Page 27: Mario Reis, *Bow River, Banff, Alberta, Canada* (from the *Nature Watercolours* series), 1994. 61.0 × 61.0 cm each. Courtesy of Trépanierbaer Gallery, Calgary.

Origins

Page 28 (lower left): Photograph by Byron Harmon courtesy of Whyte Museum of the Canadian Rockies, Banff. V263/NA-71-1984.

Page 28 (top left: Photograph by Byron Harmon courtesy of Whyte Museum of the Canadian Rockies, Banff. V263/NA-71-1987.

Page 28 (right): Photograph by George Noble. Courtesy of Whyte Museum of the Canadian Rockies, Banff. V469/2835

Page 29: Two Gun (Percy Plainswoman), *Bow Lake*, 1954. Oil on canvas. 20.0 × 25.5 cm. Collection of the Glenbow Museum. Gift of Anonymous Donor, 1992. 992.64.1

Page 30: Peter Whyte, *Bow Lake, Crowfoot Glacier*, n.d. Oil on canvas. 63.5 × 76.5 cm. Collection of Whyte Museum of the Canadian Rockies. WyP.02.15

Page 31: James Simpson, *Signs of Spring, Bow Lake*, 1957. Watercolour on paper. 28.3 × 38.0 cm. Collection of the Glenbow Museum. Gift of Eric L. Harvie, 1958. 58.4

Page 32: Catharine Whyte, *North Towards Bow Summit* n.d. Oil on canvas. 26.6 × 43.2 cm. Collection of the Glenbow Museum. Purchased 1959. R554.471

Page 33 (left): Photograph by the Vaux family courtesy of Whyte Museum of the Canadian Rockies, Banff. 653/NA-80-1130.

Page 33 (right): Photograph by Byron Harmon courtesy of Whyte Museum of the Canadian Rockies, Banff. 263/NA-71-123

Page 35: David Pugh, *Bow Falls*, 1982. Graphite on paper. 56.8 × 76.3 cm. Collection of the Glenbow Museum. 983.5.1

Banff

Page 36: Photograph by the Vaux family courtesy of Whyte Museum of the Canadian Rockies, Banff. 653/NA-80-1517

Page 37: Craig Richards, *Douglas Fir, Fog, Bow River, Banff National Park*, 1982. Silver gelatin photograph. 26.3 × 33.1 cm. Collection of the Glenbow Museum. Purchased with funds from the Riveredge Deacessioning Fund, 1994. 994.106.004

Page 38: Frederic M. Bell-Smith, *Vermilion Lakes, Banff, Northwest Territories*, 1887. Watercolour on paper. 46.0 × 63.5 cm. Collection of the Glenbow Museum. Purchased 1978. 78.6.1

Page 39: Photograph courtesy of Parks Canada, Banff National Park.

Page 40 (top): Photograph courtesy of Parks Canada, Banff National Park.

Page 40 (bottom): Photograph courtesy of Canadian Museum of Civilization, photographer Harlan Ingersoll Smith, 1913, negative no. 24019

Page 41: Belmore Browne, *Under the Cliffs of Rundle*, ca. 1929. Oil on canvas. 91.5 × 101.6 cm. Collection of the Glenbow Museum. Purchased 1954. 55.47

Page 42 (top): Walter J. Phillips, *Rundle Through a Screen of Poplars*, 1952. Watercolour and conté on paper. 39.5 × 57.0 cm. Collection of the Glenbow Museum. Purchased 1953. 53.1.9

Page 42 (bottom): E.J. Hughes, *Mount Rundle and Vermilion Lakes*, 1963. Pencil on paper. 22.8 × 30.1 cm. Collection of the Glenbow Museum. Purchased with Alberta 75th Anniversary Fund, 1981. 81.44.1

Page 43: Walter J. Phillips, *Mount Rundle*, 1950. Woodcut printed in colour on white paper. 20.9 × 31.8 cm. Collection of the Glenbow Museum. Gift of Eric L. Harvie, 1960. 60.2.25

Page 44: Leonard M. Davis, *Mountain Landscape, Bow Valley*, 1918. Oil on canvas. 91.4 × 137.2 cm. Collection of the Glenbow Museum. Purchased 1961. 61.2.3

Page 45 (top): John Donaldson Curren, *Hot Springs Banff, Known as Cave and Basin*, n.d. Oil on canvas. 50.2 × 79.1 cm. Collection of the Glenbow Museum. Purchased 1957. 57.18.2

Page 45 (bottom): Photograph courtesy of Whyte Museum of the Canadian Rockies, Banff. NA-66-1989

Page 46 (top): Photograph courtesy of Whyte Museum of the Canadian Rockies, Banff. V469/2769

Page 46 (bottom): Photograph by George Paris courtesy of Whyte Museum of the Canadian Rockies, Banff. NG-5-8

Page 47 (top): Photograph by Byron Harmon courtesy of Whyte Museum of the Canadian Rockies, Banff. V265/NA-71-3737

Page 47 (lower left): Photograph by George Noble courtesy of Whyte Museum of the Canadian Rockies, Banff. V469/2359

Page 47 (right): Photograph by the Vaux family courtest of Whyte Museum of the Canadain Rockies, Banff. V653/NA80-1517

Page 48 (lower right): Photograph by Byron Harmon courtesy of Whyte Museum of the Canadian Rockies, Banff. V263/NA-71-108

Page 48 (top right): Photograph courtesy of the Glenbow Archives, Calgary. NA-1438-2

Page 48 (top left): Photograph courtesy of the Glenbow Archives, Calgary. NA-2943-2

Page 48 (lower left): Photograph courtesy of Whyte Museum of the Canadian Rockies, Banff. V701/LC-107

Page 49 (bottom): Photograph courtesy of Whyte Museum of the Canadian Rockies, Banff. V469/1638

Page 49 (top left): Photograph courtesy of Parks Canada, Banff National Park.

Page 49 (top right): Photograph courtesy of Parks Canada, Banff National Park.

Page 50 (top): Photograph courtesy of Parks Canada, Banff National Park. (sheep on road)

Page 50 (centre): Photograph courtesy of Parks Canada, Banff National Park. (elk)

Page 50 (bottom): Photograph courtesy of Parks Canada, Banff National Park. (mule deer)

Page 51: Photograph by the Vaux family courtesy of Whyte Museum of the Canadian Rockies, Banff. V653/NG-4-754.

Page 52: Walter J. Phillips, *Mountain Road*, 1942. Colour woodcut on paper. 22.8 × 33.1 cm. Collection of the Glenbow Museum. Purchased 1955. 55.26.67

Page 53: Walter Cassels, *Mount Rundle in Banff with Bow River*, c. 1860–70. Watercolour on paper. 20.2 × 32.6 cm. Collection of the Glenbow Museum. Purchased with funds from the Glenbow Acquisition Society, 1984. 984.87.1

Page 54 (top): Photograph courtesy of Whyte Museum of the Canadian Rockies, Banff. Photographer unknown. NA-71-1840

Page 54 (bottom): Photograph by T.G. Longstaff. courtesy of Whyte Museum of the Canadian Rockies, Banff. NA-66-1602

Page 55: Carl Rungius, *Mountain Peak from the River* [aka *Mount Rundle*], n.d. Oil on canvas mounted on board. Collection of the Glenbow Museum. Purchased from Kennedy Galleries, 1959 (New York Studio Collection). 59.7.1063

Page 56: Margaret Shelton, *Rocks Below Bow Falls*, 1947. Woodcut on paper. 18.3 × 24.7 cm. Collection of the Glenbow Museum. Gift of Pat Marcellus, 2000. 2000.005.006

Page 57: Margaret Shelton, *Bow Falls from the South*, 1941. Linocut on paper. 9.7 × 13.0 cm. Collection of the Glenbow Museum. Gift of Pat Marcellus, 1987. 987.203.1.43

Page 58: Martha Isabel Houston, *Below Bow Falls*, 1946. Watercolour on paper. 25.5 × 35.5 cm. Collection of the Glenbow Museum. Purchased 1967. 67.13.2

Page 59: Marmaduke Matthews, *South Bank of the Bow Near Laggan*, n.d. Watercolour on paper. 50.1 × 75.5 cm. Collection of the Glenbow Museum. Gift of Dr. and Mrs. J.M. Goodman, Toronto, 1994. 60.76.7

The Gateway
Page 60: Marmaduke Matthews, *Sunrise in the Hoodoos, Canmore*, n.d. Watercolour on paper. 49.5 × 36.0 cm. Collection of the Glenbow Museum. Gift of Dr. and Mrs. J.M. Goodman, 1982. 82.36.1

Page 61 (lower left): Photograph courtesy of the Glenbow Archives, Calgary. NA-3271-4

Page 61 (upper right): Photograph courtesy of the Centennial Museum and Geoscience Centre, Canmore. MU-32

Page 62 (top): Kathleen Daly Pepper, *The Bow Valley (Canadian Rockies)*, n.d. Oil on canvas, 43.0 × 53.0 cm. Collection of the Glenbow Museum. Gift from the Estate of Kathleen Daly Pepper, 1995. 995.098.009

Page 62 (right): Photograph courtesy of the Glenbow Archives, Calgary. NA-705-1

Page 62 (lower left): Photograph courtesy of the Glenbow Archives, Calgary. NA-1678-4

Page 63 (bottom): Photograph courtesy of the Glenbow Archives, Calgary. NA-1363-5

Page 63 (top): Photograph courtesy of the Glenbow Archives, Calgary. NA-1363-3

Page 64 (top): Photograph courtesy of the Glenbow Archives, Calgary. NA-3333-1

Page 64 (bottom): Walter J. Phillips, *Canmore, Alberta*, 1958. Watercolour on paper. 49.2 × 64.0 cm. Collection of the Glenbow Museum. Purchased 1963. 63.62.3

Page 65 (bottom): Kathleen Daly Pepper, *Miners at Beer*, 1944. Lithographic crayon on paper. 29.4 × 36.8 cm. Collection of the Glenbow Museum. Purchased with funds from the Glenbow Museum Acquisitions Society, 1989. 989.46.6

Page 65 (top): Kathleen Daly Pepper, *Briquette Plant*, 1944. Lithographic crayon on paper. 29.3 × 36.7 cm. Collection of the Glenbow Museum. Purchased with funds from the Glenbow Museum Acquisitions Society, 1989. 989.46.2

Page 66: A.Y. Jackson, *Rain Squall, Canmore, Alberta*, 1947. Oil on wood. 26.7 × 34.3 cm. Collection of the Glenbow Museum. Purchased 1955. 55.30.2

Page 67: Photograph courtesy of the Centennial Museum and Geoscience Centre, Canmore.

Page 68 (bottom): Photograph courtesy of the Glenbow Archives, Calgary. NA-4074-5

Page 68 (top): Photograph courtesy of the Glenbow Archives, Calgary. NA-4074-4

Page 69 (top): Photograph courtesy of the Centennial Museum and Geoscience Centre, Canmore.

Page 69 (bottom): Photograph courtesy of Centennial Museum and Geoscience Centre, Canmore. MU-3

Page 71 (top): Photograph courtesy of the Glenbow Archives, Calgary. NA-1432-11.

Page 71 (bottom): Photograph courtesy of the Glenbow Archives, Calgary. NA-1360-8

Page 72 (top): Photograph courtesy of the Glenbow Archives, Calgary. NA-3544-28

Page 72 (bottom): Photograph courtesy of the Glenbow Archives, Calgary. NA-685-2

Page 73 (top): Photograph courtesy of the Glenbow Archives, Calgary. NA-3384-14

Page 73 (bottom): Photograph courtesy of the Glenbow Archives, Calgary. NA-3078-31

Page 74 (top). page 74 (bottom), page 75 (top), page 75 (bottom): Photographs courtesy of the Centennial Museum and Geoscience Centre, Canmore.

The Foothills

Page 76: Roland Gissing, *Bank of Ghost Lake at Artist's Home*, 1947. Oil on pasteboard. 22.5 × 26.7 cm. Collection of the Glenbow Museum. Gift of Eric L. Harvie, 1958. 58.30.5

Page 77: Dorothy Knowles, *Reflections on the Bow River*, 1991. Acrylic on canvas. 121.9 × 152.5 cm. Collection of the Glenbow Museum. Gift of Dorothy Knowles, 1993. 993.98.2

Page 78 (top): Lars Jonson Haukaness, *Bow Valley at Morley*, n.d. Oil on board. 39.6 × 55.0 cm. Collection of the Glenbow Museum. Purchased with funds from the Glenbow Museum Acquisitions Society, 1984. 984.167.1

Page 78 (bottom): Anonymous, *Camp and Village of the Stoney Indians on the Bow River, Morleyville*, 1875 (printed 1882). Engraving, hand-coloured on paper. 16.5 × 24.1 cm. Collection of the Glenbow Museum. Purchased 1959. 59.40.41

Page 79 (top): Roland Gissing, *Ghost Lake*, 1956. Oil on canvas. 89.5 × 150.5 cm. Collection of the Glenbow Museum. Gift of the Devonian Foundation, 1979. R1060.1

Page 79 (bottom): Richard B. Nevitt, *Below Falls, Bow River*, 1876. Watercolour on paper. 25.0 × 35.0 cm. Collection of the Glenbow Museum. Purchased 1974. 74.7.59

Page 80: James Nicoll, *Farm on the Bow*, 1939. Oil on wood. 75.0 × 60.0 cm. Collection of the Glenbow Museum. Exchange Masters Gallery, 1980. 80.48.1.J

Page 81 (top): James Nicoll, *Working drawing for oil painting "Farm on the Bow,"* c. 1939. Pencil on paper. 20.3 × 27.7 cm. Collection of the Glenbow Museum. 80.31.1

Page 81 (bottom): James Nicoll, *Working Drawing for oil painting "Farm on the Bow,"* c. 1939. Pencil on paper. 20.3 × 27.9 cm. Collection of the Glenbow Museum. 80.31.2

Page 82: Ken Christopher, *Bow River Valley*, 1980. Watercolour on paper. 60.5 × 81.5 cm. Collection of the Glenbow Museum. Purchased with Alberta 75th Anniversary Fund, 1980. 80.63.1

Page 83: Photograph courtesy of the Glenbow Archives, Calgary. NA-1494-1

Page 84: Photograph courtesy of the Glenbow Archives, Calgary. NA-3981-13

Page 85 (top): Photograph courtesy of the Glenbow Archives, Calgary. NA-963-1

Page 85 (bottom): Photograph courtesy of the Glenbow Archives, Calgary. NA-3163-3

Page 86 (top): Photograph courtesy of the Glenbow Archives, Calgary. NB-16-298

Page 86 (bottom): Photograph courtesy of the Glenbow Archives, Calgary. NB-16-299

Page 87 (top): Photograph courtesy of the Glenbow Archives, Calgary. NA-5563-6

Page 87 (bottom): Photograph courtesy of the Glenbow Archives, Calgary, NA-381-1

Page 88: Photograph courtesy of Harvey Buckley, Lorain Lounsberry, Ron Marsh, Gerry Conaty, and the cows

Calgary

Page 90: Anonymous, *North-West Territories: Fort Brisebois, on Bow River*, 1876. Engraving on paper. 7.6 × 24.1 cm. Collection of the Glenbow Museum. Purchased 1959. 59.40.33

Page 91 (top): Photograph courtesy of the Glenbow Archives, Calgary. NA-3559-8

Page 91 (bottom): Photograph courtesy of the Glenbow Archives, Calgary. NA-1432-13

Page 92: Edward Roper, *A Band of Blackfoot Indians Camped on the Bow River near Calgary*, c. 1887. Ink and sepia on paper. 14.2 × 24.0 cm. Collection of the Glenbow Museum. Purchased 1961. 61.46.31

Page 93 (top): Melton Prior, *Calgary at the Foot of the Rocky Mountains*, 1887. Hand-coloured engraving on paper. 12.4 × 33.7 cm. Collection of the Glenbow Museum. Gift of Mrs. Ida Schneider, 1957. 57.20

Page 93 (bottom): Melton Prior, *View of Calgary*, 1887. Graphite on paper. 25.4 × 42.6 cm. Collection of the Glenbow Museum. Purchased 1959. 59.59.1

Page 94 (top): Photograph courtesy of the Glenbow Archives, Calgary. NA-967-12

Page 94 (bottom): Photograph courtesy of the Glenbow Archives, Calgary. NA-3489-42

Page 95 (top): Photograph courtesy of the Glenbow Archives, Calgary. NA-4035-77

Page 95 (bottom): Photograph courtesy of Glenbow Archives, Calgary. NA-1618-1

Page 96: Richard Moore, *Logging on the Bow* [aka *The Drive*], n.d. Etching on paper. 7.3 × 10.3 cm. Collection of the Glenbow Museum. 70.47.1

Page 97: Joseph Abraham Taylor, *Eau Claire Spillway*, 1933. Watercolour on paper. 125.6 × 32.2 cm. Collection of the Glenbow Museum. Gift of Joseph Taylor, 1989. 989.134.1

Page 98: Thomas Strange, *Calgary Bottom from Frazier's Hill*, 1882. Engraving on paper. 11.1 × 33.0 cm. Collection of the Glenbow Museum. Purchased 1961. 61.32.18

Page 99: Herbert Earle, *Eau Claire Woodmills, after the Bow River Flood*, 1932. Watercolour on paper. 27.6 × 37.8 cm. Collection of the Glenbow Museum. Gift of Herbert Earle, 1970. 70.16

Page 100 (top): Photograph courtesy of the Glenbow Archives, Calgary. NA-806-1

Page 100 (bottom): Photograph courtesy of the Glenbow Archives, Calgary. NA-422-1

Page 101: Photograph courtesy of the Glenbow Archives, Calgary. NA-1386-1

Page 102 (bottom): Photograph courtesy of the Glenbow Archives, Calgary. NA-1044-6

Page 102 (centre): Photograph courtesy of the Glenbow Archives, Calgary. NA-1044-5

Page 102 (top): Photograph courtesy of the Glenbow Archives, Calgary. NA-1044-4

Page 103: Photograph courtesy of the Glenbow Archives, Calgary. NA-2031-2

Page 104 (top): Photograph courtesy of the Glenbow Archives, Calgary. NA-16-373

Page 104 (bottom): Photograph courtesy of the Glenbow Archives, Calgary. NA-2307-41

Page 105 (top): Photograph courtesy of the Glenbow Archives, Calgary. NA-5344-1

Page 105 (centre): Photograph courtesy of the Glenbow Archives, Calgary. NA-3442-3

Page 105 (bottom): Photograph courtesy of the Glenbow Archives, Calgary. NA-795-14

Page 106: Stanley Turner, *Centre Street Bridge, Calgary*, 1917. Etching on paper. 26.0 × 14.6 cm. Collection of the Glenbow Museum. Purchased 1962. 62.26.2

Page 107: Myrtle Jackson, *Calgary*, 1932. Watercolour on paper. 26.5 × 34.4 cm. Collection of the Glenbow Museum. Purchased 1957. 57.40

Page 108 (top): Margaret Shelton, *Centre Street Bridge, Calgary*, 1940. Linocut on paper. 11.0 × 12.8 cm. Collection of the Glenbow Museum. Gift of Pat Marcellus, 1987. 987.203.1.37

Page 108 (bottom): Frederick George Cross, *Untitled (Bow River, Calgary)*, 1913. Watercolour on paper. 20.7 x 33.0 cm.

Collection of the Glenbo Museum. Purchased with funds from the Collection Endowment Fund, 2001. 2001.092.001

Page 109: Zoe Dunning, *Underpass, Centre Street Bridge, Calgary*, n.d. Watercolour on paper. 30.5 × 38.7 cm. Collection of the Glenbow Museum. 62.40

Page 110 (top): Photograph courtesy of the Glenbow Archives, Calgary. NA-1908-1

Page 110 (bottom): Photograph courtesy of the Architecture Archives, University of Calgary.

Page 111: Photograph courtesy of the Architecture Archives, University of Calgary

Page 112: Margaret Shelton, *Louise Bridge, Calgary*, 1972. Linocut on paper. 17.8 × 25.0 cm. Collection of the Glenbow Museum. Gift of Pat Marcellus, 2001. 2001.051.008

Page 113: Reginald Harvey, *Bow River from Spruce Cliff, Calgary*, n.d. Watercolour on paper. 33.3 × 44.8 cm. Collection of the Glenbow Museum. Purchased 1963. 63.103.6

Page 114 (bottom): Photograph courtesy of the Glenbow Archives, Calgary. NA-5525-2

Page 114 (top): Photograph courtesy of the Glenbow Archives, Calgary. NA-5600-6677a

Page 115: James Nicoll, *Backyard, Bowness*, 1958. Watercolour. 37.8 × 44.2 cm. Collection of the Glenbow Museum. Gift of the Devonian Foundation, 1979. R856.29

Page 116: James Dichmont, *Bowness Park*, n.d. Watercolour on paper. 24.9 × 30.2 cm. Collection of the Glenbow Museum. Gift of the Horseman's Hall of Fame, Calgary, 1976. 76.3.1

Page 117: E.J. Hughes, *Calgary, Alberta*. 1957. Watercolour on paper. 52.0 × 61.6 cm. Collection of Glenbow Museum, Purchased, 1957. 57.21

The Bow River Downstream

Page 118: Marquis of Lorne, *Blackfeet Indians Camp on the Bow River*, 1881. Engraving on paper. 20.3 × 30.5 cm. Collection of the Glenbow Museum. Purchased 1969. 69.53.1

Page 119 (bottom): Photograph courtesy of the Glenbow Archives, Calgary. NA-808-1

Page 119 (top): Photograph courtesy of the Glenbow Archives, Calgary. NA-789-46

Page 120: Frederick Verner, *Buffalo on the Bow*, 1914. Oil on canvas. 49.2 × 74.3 cm. Collection of the Glenbow Museum. Purchased 1959. 63.78.2

Page 121: Frederick George Cross, *Fording the River*, 1935. Watercolour on paper. 32.0 × 40.2 cm. Collection of the Glenbow Museum. Gift of the Devonian Foundation. R856.75

Page 122: Thomas Strange, *Blackfoot Crossing, Bow River, N.W.T.*, 1882. Engraving on paper. 16.2 × 23.8 cm. Collection of the Glenbow Museum. Purchased 1961. 61.32.21

Page 123: Thomas Strange, *The Meeting of the Bow and High Rivers, N.W.T* c. 1882. Hand-coloured engraving on paper. 23.0 × 33.2 cm. Collection of the Glenbow Museum. Purchased 1961. 61.81.17

Page 124: Richard Barrington Nevitt, *Fort Macleod and Environs (Map of the South Saskatchewan and Missouri River Systems)*, n.d. Ink and pencil on paper. 30.4 × 43.4 cm. Collection of the Glenbow Museum. Purchased 1974. 74.7.77

Page 125 (bottom): Photograph courtesy of the Glenbow Archives, Calgary. NA-2179-27

Page 125 (top): Photograph courtesy of the Glenbow Archives, Calgary. NB-39-293

Page 126 (top): Photograph courtesy of the Glenbow Archives, Calgary. NB-39-75

Page 126 (bottom): Photograph courtesy of the Glenbow Archives, Calgary. NA-2179-9

Page 127: Photograph courtesy of the Glenbow Archives, Calgary. NB-39-4

Page 128 (top): Photograph courtesy of the Glenbow Archives, Calgary. NB-39-95

Page 128 (bottom): Photograph courtesy of the Glenbow Archives, Calgary. NA-2179-39

Page 129 (top): Photograph courtesy of the Glenbow Archives, Calgary. NB-39-94

Page 129 (bottom): Photograph courtesy of the Glenbow Archives, Calgary. NA-2179-3

Page 130 (bottom): Photograph courtesy of the Glenbow Archives, Calgary. NA-407-4

Page 130 (top): Photograph courtesy of the Glenbow Archives, Calgary. NA-407-10

Page 131: Photograph courtesy of the Glenbow Archives, Calgary. NA-3641-1

Page 132: Photograph courtesy of the Glenbow Archives, Calgary. NA-1421-6

Reflections on the Bow River

Page 134: Frank H. Johnston. *On the Bow River, Banff*, 1925. Oil on board. 21.5 × 26.7 cm. Private collection.

Page 135: Ted Godwin, *The Gravel Bar* (diptyck), 1990. Oil on canvas. Each section 149.9 × 165 cm. Collection of Husky Oil, Calgary.

Page 136 (top): Richard Moore, *On the Bow River, Calgary*, 1930. Etching. $3^3/_8$ × 4 in. Collection of the Glenbow Museum, Calgary. 70.47.2

Page 136 (bottom): Richard Moore, *Backwater on the Bow—East of Calgary*, 1930. Etching. 4 × $4^3/_8$ in. Collection of the Glenbow Museum, Calgary. 70.47.6

Page 138: Marmaduke Matthews, *Bow River, Banff*, n.d. Watercolour on paper. 26.3 × 34.7 cm. Collection of the Glenbow Museum. Gift of Dr. and Mrs. J.M. Goodman, Toronto, 1984. 984.175.1

Selected Bibliography for the Art

Ainslie, Patricia. *Margaret Shelton: Block Prints, 1936–1984*. Calgary: Glenbow, 1984.

Bates, Robert H. *Mountain Man: The Story of Belmore Browne*. Clinton, NJ: Amwell Press, 1988.

Baster, Victoria. "The Art of Mario Reis," in *Mario Reis Naturaquarelle: Canada, USA, Mexiko*. Blieburg, Germany: Falke & Kuhn Galerie, 1995.

Boulet, Roger H. *Frederic Marlett Bell-Smith (1846–1923)*. Victoria: Art Gallery of Greater Victoria, 1977.

———. *The Tranquility and the Turbulence: The life and works of Walter J. Phillips*. Markham: M.B. Loates, 1981.

Callahan, Maggie. *Harvest of the Spirit: Illingworth Kerr Retrospective*. Edmonton: Edmonton Art Gallery, 1985.

Christensen, Lisa. *A Hiker's Guide to Art of the Canadian Rockies*. Calgary: Glenbow, 1996

Collinson, Helen. *Lars Haukaness: Northern Vision*. Edmonton: Edmonton Art Gallery, 1991.

Duthie, Peter. *Craig Richards: The Canadian Rockies*. Banff: Sawback Press, 1984.

Evenden, Kirstin. *Source/Derivations VI: Walter J. Phillips; An Exhibition of Works by Allan Harding MacKay*. Calgary: Glenbow, 1998.

Fenton, Terry. *A.C. Leighton and the Canadian Rockies*. Banff: Whyte Museum of the Canadian Rockies, 1989.

Foran, Max. *Roland Gissing: The Peoples' Painter*. Calgary: University of Calgary Press, 1988.

Godwin, Ted. *Lower Bow: A Celebration of Wilderness, Art and Fishing*. Calgary: Hard Art Moving and Storage, 1991

Grenville, Bruce. *Dorothy Knowles*. Saskatoon: Mendel Art Gallery, 1994.

Gribbon, Michael J. *Walter J. Phillips: A Selection of His Works and Thoughts*. Ottawa: National Gallery of Canada, 1978.

Harbert, E.T. *A Memoir on the Life of T. Mower Martin, RCA, OSSA, RBC*. Publisher unknown, 1986.

Hart, E.J. *Jimmy Simpson: Legend of the Rockies*. Canmore: Altitude Publishing, 1991.

Ian Thom. *E.J. Hughes*. Vancouver and Toronto: Douglas & McIntyre and Vancouver Art Gallery, 2002.

Jackson, Christopher. *Marion Nicoll: Art and Influences*. Calgary: Glenbow, 1986.

Joyner, J. Brooks. *Marion Nicoll, R.C.A.* Calgary: Masters Gallery, 1979.

Kim Mayberry, *Romance in the Rockies: The Life and Adventures of Catharine and Peter Whyte*. Canmore: Altitude Publishing, 2003.

Kjorlien, Melanie et al. *Carl Rungius: Artist & Sportsman*. Toronto and Calgary: Warwick Press and Glenbow Museum, 2001.

Lamb, James B. *Jingo: The Buckskin Brigadier Who Opened up the Canadian West*. Toronto: Macmillan, 1992.

Mastin, Catharine M. et al. *The Group of Seven in Western Canada*. Calgary and Toronto: Glenbow Museum and Key Porter Books, 2002.

Murray, Joan: *The Last Buffalo: The Story of Frederick Arthur Verner, Painter of the Canadian West*. Toronto: Pagurian, 1984.

Oko, Andrew. *The Frontier Art of R.B. Nevitt*. Calgary: Glenbow, n.d.

Reid, Dennis. *Alberta Rhythm: The later works of A.Y. Jackson*. Toronto: Art Gallery of Ontario, 1982.

————. *Our Own Country Canada; Being an Account of the National Aspirations of the Principal Landscape Artists in Montreal and Toronto, 1860–1890*. Ottawa: National Gallery of Canada, 1979.

Render, Lorne. *A.C. Leighton*. Calgary: Glenbow, 1971.

————. *The Mountains and the Sky*. Calgary: Glenbow and McClelland & Stewart West, 1974.

Retfalvi, Andrea. *Canadian Illustrated News, Montreal, 1869–1883*. Toronto: University of Toronto Press, 1989.

Roper, Edward. *By Track and Trail—A Journey through Canada with Numerous Original Sketches by the Author*. London: W.H. Allen & Co., 1891.

Stamp, Robert M. *Royal Rebels: Princess Louise & Marquis of Lorne*. Toronto and Oxford: Dundurn Press, 1988.

Tippett, Maria et al. *Phillips in Print: The selected writings of Walter J. Phillips on Canadian nature and art*. Winnipeg: Manitoba Records Society, 1982.

Tovell, Rosemarie. *A New Class of Art: The Artist's Print in Canadian Art, 1877–1920*. Ottawa: National Gallery of Canada, 1996.

Welin, R.A. *The Bridges of Calgary, 1882–1977*. Calgary: City of Calgary, 1977.

The artists' files of the Glenbow Library and Archives and the National Gallery of Canada have provided valuable source information on many of the artists about whom there are few publications.

Selected Bibliography

Alberta Agriculture, Food and Rural Development *Irrigation in Alberta*. Lethbridge: Irrigation Branch, Alberta Agriculture, Food and Rural Development.

Bow River Water Quality Council. *Preserving our Lifeline: A report on the state of the Bow River*. Calgary: Bow River Water Quality Council, 1994.

Buziak, Kelly. *Toiling in the Woods: Aspects of the Lumber Business in Alberta to 1930*. Edmonton: Friends of Reynolds-Alberta Museum Society and Alberta Culture and Multiculturalism Historic Sites and Archives Service, 1992.

Chrismas, Lawrence. *Canmore Miners: Coal Miner Portraits and Stories,* Calgary: Cambria Publishing, 2002.

Evans, Simon, Sarah Carter and Bill Yeo. *Cowboys, Ranchers and the Cattle Business: Cross-border Perspectives on Ranching History*. Calgary and Boulder: University of Calgary Press and University of Colorado Press, 2000.

Foran, Max and Sheilagh Jameson. *Citymakers: Calgarians after the Frontier*. Calgary: The Historical Society of Alberta, Chinook Chapter, 1987.

Hanks, Lucien M. and Jane Richardson Hanks. *Tribe Under Trust: A Study of the Blackfoot Reserve of Alberta*. Toronto: University of Toronto Press, 1950.

Holmes, John D.R. *The Canmore Corridor: The Historical Geography of a Pass Site, 1880 to the Present*. Thesis submitted to the Faculty of Graduate Studies, Department of Geography, the University of Calgary, Calgary, 1978

Jones, David C. *Empire of Dust: Settling and Abandoning the Prairie Dry Belt*. Calgary: University of Calgary Press, 2002.

Lakusta, Ernie. *Canmore and Kananaskis History Explorer*. Canmore: Altitude Publishing, 2002.

MacEwen, Grant. *Calgary Cavalcade: From Fort to Fortune*. Calgary: Institute of Applied Arts, 1958

Mitchner, Dr. E. Alwyn, *The Development of Western Waters, 1885–1930*, Edmonton: University of Alberta Press, 1973.

Morrow, E. Joyce. *Calgary, Many Years Hence*. Calgary: City of Calgary, University of Calgary, c. 1979.

Oltman, Ruth. *My Valley The Kananaskis*, Calgary: Rocky Mountain Books, 1997.

Oltman, Ruth. *The Valley of Rumors...the Kananaskis*. Seebe: Ribbon Creek Publishing, 1976.

Spry, Irene. *The Palliser Expedition: The Dramatic Story of Western Canadian Exploration 1857–1860*. Calgary: Fifth House, c. 1995 (2nd edition).

Tough, George Wallace. *A Study of Coal Mining: Cascade Coal Area*. Thesis Submitted to the Faculty of Graduate Studies, Department of Geography, the University of Calgary, 1968.

TransAlta Utilities. *75 Years of Progress*. Calgary: TransAlta Utilities, 1986.

Worbets, Barry and Loleen Berdahl. *Western Canada's Natural Capital: Toward a New Public Policy Framework*. Calgary: Canada West Foundation, 2003.

Web Sites

http://encarta.msn.com/encyclopedia_761567022/global warming.html

www.wonderofwater.ca

http://www.ewh.ieee.org/reg/7/diglib/library/electricity/pdf/P_one_7.pdf

http://www.geo.ucalgary.ca/~hayashi/geog515/lectures/515_0308.pdf

http://www.waterforlife.gov.ab.ca/

Index